Museums 101

Museums 101

Mark Walhimer

ROWMAN & LITTLEFIELD
Lanham • Boulder • New York • London

Published by Rowman & Littlefield
A wholly owned subsidiary of The Rowman & Littlefield Publishing Group, Inc.
4501 Forbes Boulevard, Suite 200, Lanham, Maryland 20706
www.rowman.com

Unit A, Whitacre Mews, 26-34 Stannary Street, London SE11 4AB

British Library Cataloguing in Publication Information Available

Library of Congress Cataloging-in-Publication Data
Walhimer, Mark, 1964–
 Museums 101 / Mark Walhimer.
 pages cm
 Summary: "Looking for an A–Z, one-stop, comprehensive book on museums? Wish you were able to have one of the nation's leading museum consultants spend a couple of days with you, talking you through how to start a museum, how museums work, how to set up an exhibit, and more? If so, Museums 101 is the answer to your wishes"— Provided by publisher.
 Includes bibliographical references and index.
 ISBN 978-1-4422-3017-0 (cloth : alkaline paper) — ISBN 978-1-4422-3018-7 (paperback : alkaline paper) — ISBN 978-1-4422-3019-4 (electronic) 1. Museums. 2. Museums—United States. 3. Museum techniques. I. Title.
 AM5.W35 2015
 069.0973—dc23
 2015002970

♾™ The paper used in this publication meets the minimum requirements of American National Standard for Information Sciences—Permanence of Paper for Printed Library Materials, ANSI/NISO Z39.48-1992.

Printed in the United States of America

For Anne, Les, Patricia, and Meg

MUSEUMS 101 ADVISORY BOARD

Contents

PART IV: BEHIND THE SCENES

PART V: THE MUSEUM TOOLBOX

Acknowledgments

In 1985, I walked into the Phoenix Art Museum as a scared kid and asked to be a volunteer in the exhibits department. The next day, I was touring the galleries with the curator of the modern art collection. From that morning on, I was hooked. I am consistently impressed and thankful to everyone in the museum field for their generosity and willingness to share their knowledge.

Thank you to my family—my mother Anne Walhimer, sister Meg Joyce, and my wife Patricia Ochoa—for their love and support. Thank you to my second family, Ron and Janice Dong, for their encouragement.

Thank you to Charles Harmon for believing in thinking differently about museums, to John Strand and Lindsay P. Mann for their tireless editing, and to the book's advisory board for their knowledge and commitment to helping people new to the museum field understand the great resources that every museum provides for its community.

—Mark Walhimer

Preface

To many people, museums are simply elegant storage buildings. But more than simple repositories or collections, museums represent an ideal. Each museum is a fully functioning organism that reaches visitors on an emotional level, both within the museum's physical location and beyond.

Museums 101 covers the museum basics, including education and programming, collections management, fundraising, museum planning, museum governance, and exhibition design. This book explores how each of these distinct museum departments can work together to create a dynamic hub of communities built around collections.

There are a few traits that can describe the world's best museums: a visitor-centric approach, a museum without walls, a sense of hospitality, an integrated museum approach with a distinctive voice. In this book, readers will come to understand fully each of these terms and will learn how to incorporate these practices into new and existing museums.

Museums 101 is structured in five parts:

I. Essential Museum Background
II. Creating an Integrated Museum
III. Exhibitions
IV. Behind the Scenes
V. The Museum Toolbox

This structure provides the reader with a basic understanding of the purpose of all museums. The book then leads the reader into the specifics of how to create an integrated museum culture that will support a specific museum mission. This is followed by the basic principles of operating a museum, and finally, creating the visitor experience. The last section of

the book, the Museum Toolbox, is a chapter of quick facts, resources, and museum standard practices.

The sections and chapters of *Museums 101* help readers launch a new museum or revitalize an existing one, while keeping in mind the field's recent paradigm shift toward visitor inclusion. While you can read this book cover to cover, you can also choose to read sections as you need them. If you have a question about fundraising, read the related chapter for an overview, then flip to the back to use the sample documents included. You can also review the Resources section, look up key words in the Glossary, and use the Index to find cross-references to other related topics.

Throughout the book, the word "museum" covers the entire spectrum of museums, including art museums, art centers, science centers, science museums, history museums, historic houses, natural history museums, children's museums, visitor centers, aquariums, zoos, and botanic gardens. Not included in the scope of this book are art galleries (for profit), destinations (for profit), amusement parks, and libraries—although many libraries now include museums.

My hope is that *Museums 101* will begin many conversations and help advance the museum field. The storage, care, prescribed significance, and display of artifacts in the care of museums is ever more important as the boundaries between real and virtual blur.

This book is written for six distinct types of readers: museum founders, new museum staff and volunteers, those wishing to work in museums, new board members, students, and those wishing to contract services with a museum. In the Museum Toolbox are specific guidelines for each of the six types of readers.

All readers should understand the weight of responsibility that every museum has for educating the public, while respecting the existing and evolving museum culture. Even as things change in the profession and in society, museums still rank as the public's number one source of trusted information.[1]

—Mark Walhimer

NOTE

1. *BritainThinks*. (2013). Public survey commissioned by Museums Association, London, England. Perceptions of and attitudes to the purposes of museums in society. Accessed May 1, 2014, from http://www.museumsassociation.org/download?id=954916.

Griffiths, Dr. José-Marie and King, Donald W. (2008). *InterConnections: The IMLS National Study on the Use of Libraries, Museums and the Internet*. Commis-

sioned by The Institute of Museum and Library Services. Accessed April 1, 2014, from http://www.interconnectionsreport.org/reports/IMLSMusRpt20080312kjm.pdf.

Lake Snell Perry & Associates, (2001), Nationwide public opinion survey commissioned by American Alliance of Museums.

Trust, T. W., (2001), "Science and the public: A review of science communication and public attitudes toward science in Britain." *Public Understanding of Science*, 10(3), 315–30. Accessed December 5, 2011, from http://www.wellcome.ac.uk/stellent/groups/corporatesite/@msh_peda/documents/web_document/wtd003419.pdf.

Wolf Consulting, (2008). Public survey commissioned by the American Alliance of Museums, Washington, DC. Accessed May 1, 2014, from http://www.wolfconsulting.us/files/Museums%20Working%20in%20the%20Public%20Interest.pdf.

In addition to the printed book, Museums 101 also features a companion website exclusively for readers of the book. The website includes:

- links to essential online resources in the museum world,
- downloadable sample documents,
- a glossary,
- a bibliography of sources for further reading, and
- photographs of more than 75 museums of all types.

The website is intended for use by museum founders, board members, museum staff, students and museum enthusiasts and is regularly updated.

http://museums101.com

Foreword

The museum field needs a book like *Museums 101*.

I met Mark Walhimer back in 1996 when he was a young talented vice president of exhibits at Discovery Science Center and I was the executive director of cultural affairs at Walt Disney Imagineering. Back then, the idea of creating a narrative for a museum was close to heresy. But museums have come a long way. The 2014 American Alliance of Museums annual meeting was titled "The Power of Story." Visitors want more from our cultural institutions. They want an emotional connection, and they want to belong to a community. "Story" provides the vehicle to transport visitors to very special places.

Mark's book lays out in concrete terms how to connect with visitors emotionally and intellectually through an integrated museum approach. Museum service and mission taken together help create that integrated approach.

Museums 101 is a straightforward, "how to" book for people new to the field of museums and for those interested in entering the field, and is also a valuable reference tool for the more experienced professional. This is the perfect book to hand to a new volunteer, new staff, or new board member and say, "Read this. Here are the basics."

Museums 101 is written in the concise and direct style of a person who has "walked the walk." Mark has been in the museum field for more than twenty years. In this book, he shares with all of us the lessons he has learned and the knowledge he has acquired.

—Van A. Romans
President, Fort Worth Museum of Science and History
Fort Worth, Texas
Board of Trustees, American Alliance of Museums

Part I

ESSENTIAL MUSEUM BACKGROUND

Chapter One

Defining a Museum

Every museum interacts with visitors on multiple levels, but especially through its efforts to educate the public. Although not all museums collect objects, a typical museum is defined as much by its collection as by its visitors. The International Council of Museums defines a museum this way: "a non-profit-making, permanent institution in the service of society and of its development, and open to the public, which acquires, conserves, researches, communicates and exhibits, for purposes of study, education and enjoyment, material evidence of people and their environment."

After years of thinking about museums, I have developed a personal definition.

Museum: an organization in service to society, open to the public, that acquires, researches, exhibits, and interprets objects and ideas for the purpose of education, study, and enjoyment.

A collection is at the core of most museums. These collections may include art, historic artifacts, animals, plants, science experiments (interactive science exhibits), teaching tools (early childhood exhibits), and many other things.

Museum collections sometimes start as the personal collection of an individual. The individual creates an institution to care for, protect, and display the collection in perpetuity. The care and ownership of the collection passes from the individual to the institution. Not only is the collection transferred to the institution, but the vision of the individual is also taken up by the new institution. From this vision, a mission is created for the new institution.

The Isabella Stewart Gardner Museum in Boston, Massachusetts, offers a wonderful example of the relationship between a founder and an institution's mission. Mrs. Gardner's will "created an endowment of [one million dollars]

3

and outlined stipulations for the support of the museum, including that the permanent collection not be significantly altered."[1] Mrs. Gardner, an avid art collector, wished to share her art and her vision with the public in perpetuity. Today the Isabella Stewart Gardner Museum's main galleries—a villa designed in the style of a Venetian palace—are still displayed largely as Mrs. Gardner designed them more than a century ago.

Another example is the Thomas Edison National Historical Park in West Orange, New Jersey. The Laboratory Complex was judged to be of significant importance, having been the home and laboratory of Thomas Edison. Visitors to the park can view many of the objects in the park's possession and visitors can learn about Edison's process. The Luis Barragán House and Studio[2] in Mexico City, Mexico, is another fine example. Barragán's home and studio is maintained just as he left it. Visitors gain an understanding of the personality and process of this fascinating architect.

In museums that are created to uphold the specific vision of the founder, the museum's board of directors translates that vision into a mission statement, an embodiment of the purpose and vision of the institution. Different from the founder's vision, a mission statement can be used to measure the actions of the institution. The responsibility for adhering to the mission belongs to the board of directors. This transfer of vision, responsibility, and care is very significant. The founder is forever entrusting the care, protection, and display of the collection to the museum's board.

The museum's board of directors hires staff to fulfill the mission of the institution and the curation of the museum's collection. The verb *curate* comes from the Latin *curare*, to cure or heal. A Roman *curator* was akin to a legal guardian in English law. A curate, an official of a church, has care of souls. A curator in a museum, then, might be said to care for the "heart and soul" of a museum's collection.

The role of a curator is one of enlightenment, using the museum's collection, or objects borrowed from other institutions, to fulfill the mission. The mission is a general statement, while the curator's goal is specific. The work of the curator is to organize the objects in the collection into a statement, which then becomes an exhibition aimed at educating and enlightening visitors.

The word "museum" comes from the ancient Greek *mouseion*, a temple dedicated to the nine Muses, goddesses of inspiration. The relationship between curator and visitor is a dialogue that has existed for more than two thousand years. Visitors enter the museum to gain inspiration. The curator prepares the content for that inspiration.

There are many types of museum-audience relationships: museum as mentor, audience as student; museum and audience as peers; and museum as authority, audience as passive or active participant. In the following chapters,

the relationship between museum and audience (the visitor) will be covered in greater detail. At their core, museums are public institutions that require the participation of an audience for an educational dialogue to occur.

In many ways, museums are a cycle of trust and inspiration. A founder has a vision, which is entrusted to the museum's board of directors, who then creates an institution to embody the vision. The board of directors creates a mission to guide the museum. The board entrusts the statement of the mission to the staff, who transfer the inspiration of the founder to the visitors.

In the next chapter, we will examine the history of museums since the *mouseion* of ancient Greece.

NEXT STEPS

Become familiar with these leading museum service organizations and their Codes of Ethics (for links, see the Museum Toolbox):

ICOM, International Council of Museums
AAM, American Alliance of Museums
AAMD, Association of Art Museum Directors
ASTC, Association of Science Technology Centers
AZA, Association of Zoos and Aquariums
AASLH, American Association of State and Local History

NOTES

1. From the Isabella Stewart Gardner Museum website, accessed May 8, 2014, http://www.gardnermuseum.org/about/history_and_architecture.

2. From the United Nations Educational, Scientific and Cultural Organization's Luis Barragán House and Studio website, accessed May 8, 2014, http://whc.unesco.org/en/list/1136.

Chapter Two

A Quick History of Museums

For more than two thousand years, museums, in their essence, have remained the same: buildings filled with collections of art and artifacts. I enjoy the quote, "A museum is the memory of mankind," by Philippe de Montebello, former director of New York's Metropolitan Museum of Art.[1] I find this quote so important because memory can hold the best and the worst of mankind's endeavors. Holocaust museums—the memory of atrocities—are as important as art museums, local history museums, or children's museums. Museums sometimes present and share the height of a culture, the highest form of beauty, the most significant events of history, or the most important scientific discovery. They also can share the more mundane, day-to-day events that define popular culture. Archie Bunker's armchair is now part of the Smithsonian's National Museum of American History's collection.[2] This object has entered the collective conscience in the United States and has become an artifact of an era.

The history of archiving predates museums by at least one thousand years. The history of archives (and later libraries) and museums is intertwined: museums traditionally serve as repositories of cultural objects, similar in purpose to archives, which are usually repositories of written knowledge. The public library dates to 1464.[3] For our purposes, archives differ from libraries: an archive has closed stacks while a library has open stacks.[4]

The first of each museum type and museum milestones:

530 BCE: First museum, Ennigaldi-Nanna's Museum, Ur (present day Iraq)
1543: First botanic garden, University of Pisa, Physic Gardens
1576: First cabinet of curiosity, The Kunstkammer, of Rudolf II, Holy Roman Emperor

1660: First museum opened to the public, Royal Armouries in the Tower of London
1671: First municipal museum, The Amerbach Kabinett
1683: First natural history museum, Ashmolean Museum
1734: First public museum, Capitoline Museum
1752: First zoo, Tiergarten Schönbrunn
1899: First children's museum, Brooklyn Children's Museum
1906: First interactive science museum, Deutsches Museum
1906: First association of museums, American Alliance of Museums
1995: First online museum exhibition, Museum of the History of Science, Oxford

Today's public museum dates to the Capitoline Museum, when Pope Sixtus IV donated ancient bronze sculptures to the people of Rome in 1471. The public trust doctrine dates earlier, to 530 and Roman Emperor Justinian's ruling that the seashore was for public use.[5]

IN GREATER DETAIL, A HISTORY OF MUSEUMS TIMELINE

It is imperative that museum founders and leaders be aware of the evolution of museum culture and how it functions today. The museum culture that started two thousand years ago, to protect and analyze cultural heritage, is still very much alive today. But that culture is changing. The paradigm shift in museum culture hinges upon shared authority, technology (including social media), and fundraising tools (including crowdsourcing and crowd-funding). In the West, the church once served as an intermediary in the spread of knowledge. Later, university professors then public school teachers served similar roles. Now the Internet allows direct access to information and the use of crowdsourcing—Wikipedia, citizen researchers, and massive open online courses, for example. People can now take courses in their homes, download books on their phones, and view museum collections online.

Museums also have an important responsibility when it comes to the provenance of cultural objects in their collections. Provenance is the record of ownership, and the transfer of ownership, of an object over time. In some instances, provenance can be lost, mistaken, or forged. Objects that were transferred illegally during World War II, often confiscated by the Nazis, are still being contested in the courts today, seventy years after the war ended. Museums have a legal and moral obligation to acquire only objects that have a clear, authoritative provenance. Online sales of cultural heritage can often obscure a clear ownership history of objects, representing an additional challenge to museums.

It is imperative that museum founders and leaders understand the requirements and responsibilities of today's museum culture and how that culture has evolved over time.

ENTERTAINMENT

It is not possible to discuss the history of museums without exploring world fairs, circuses, and amusement venues. There is a healthy tension between entertainment and education. World fairs, circuses, and amusement venues today are considered entertainment. The role of the museum is different, as Dr. Robert Smith, board member of Discovery Science Center of Santa Ana, California, once said to me, "We [museums] are different from Disney. They make the fantastic real, we make the real fantastic."

Museums are a form of informal education, "places without teachers and tests." Museums are for exploration and discovery, while schools are for formal teaching. Museums often work in collaboration with schools to create field trips, museum education programs, and self-guided tours for students. Museums do have teaching goals in a fashion similar to formal education. But the museum provides content required for understanding, reflection, and inspiration. Museums also exist to inspire. Museums work with schools and educational standards to create "didactic" (teaching) messages as a form of overlap between schools, self-guided learners, and visitors. The word "didactic" often refers to the label or panel next to a painting or artifact, intended to explain the content and context of the object.

Museums have learned from the entertainment industry that a "story" (narrative) can become a vehicle to enhance the didactic content. Museums now create exhibition scripts that include a personal narrative that involves the visitor emotionally with the content. Prior to the 1980s and the opening of Epcot Theme Park in Florida, many museums thought only of a didactic scheme. With the opening of Epcot, museums started to use narrative as a vehicle to convey educational content. It was—and is—a dramatic shift. In 2013, the theme of the American Alliance of Museum's annual meeting was "The Power of Story."[6] Lately, gamification, borrowed from the world of video games, has taken hold in some museums—transforming learning into a game, using in-gallery interactive exhibits and smart phone apps to award badges to visitors and create competition between participants.[7] Visitors are asked for feedback to show that they have understood the content. They receive rewards and can compare themselves with other visitors.[8]

INTERNET

The Internet has affected museums, and all of our lives, more than any other innovation in the last thirty years. In 1992, Liberty Science Center in New Jersey was part of a small network of science centers that shared communication between member science centers and the public. Most science centers had staff scientists who shared and discussed their research via the Internet on public terminals where the public could ask questions. The advances in communication technology changed the relationship between museum and visitor. One of Liberty Science Center's early distance-education programs was about open heart surgery. Visitors could watch and ask questions of the surgeon. Of course, the surgeon has greater knowledge than most visitors, but the dialogue became bidirectional: a surgeon would speak to a visitor, and a visitor could speak to a surgeon. Up to this point, most museum communication was unidirectional, expert to visitor.

CONCLUSION

Although the history of museums dates to approximately 530 BCE, today's museum as a public institution with a collection held in "public trust" dates from 1734 and the Capitoline Museum in Rome: a building open to the public with its museum collection protected, stored, and displayed for the benefit of the public. Earlier museums were either private museums not open to the public or collections owned privately. The significance of the Capitoline Museum is that it protected the collection for the benefit of all. This core ideal is alive in all museums today.

NEXT STEPS

• Contact a local museum and offer to volunteer.
• Review websites of museums mentioned above (links in Museum Toolbox).

NOTES

1. NPR, "A History of Museums: 'The Memory of Mankind,'" http://www.npr.org/templates/story/story.php?storyId=97377145. Website accessed March 16, 2015.

2. The National Museum of American History, "Archie Bunker's Chair from All in the Family," http://americanhistory.si.edu/collections/search/object/nmah_670097. Website accessed March 16, 2015.

3. *Early Public Libraries: A History of Public Libraries in Great Britain before 1850* by Thomas Kelly: "all who wish to enter for the sake of instruction shall have 'free access and recess' at certain times." Library at All Hallows Church, Bristol, England.

4. York University Libraries, "Archival Research Tutorial," http://researchguides.library.yorku.ca/content.php?pid=324268&sid=2931154. Website accessed March 16, 2015.

5. Fordham University, "Medieval Sourcebook: The Institutes, 535 CE," http://www.fordham.edu/halsall/basis/535institutes.asp.

6. American Alliance of Museums, "2013 American Alliance of Museums Annual Meeting & MuseumExpo," http://www.aam-us.org/docs/annual-meeting/fnl2013_merged_program_v2.pdf.

7. Byers, Celina, (2007), "Playing to learn: Game-driven comprehension of complex content," *International Journal of Teaching and Learning in Higher Education*, 19(1), 33–42. http://www.isetl.org/ijtlhe/pdf/IJTLHE148.pdf.

8. Cembalest, Robin, (2009), "Reshaping the art museum," ARTNEWS, http://www.artnews.com/2009/06/01/reshaping-the-art-museum/. Website accessed March 16, 2015.

Part II

CREATING AN
INTEGRATED MUSEUM

Chapter Three

The Integrated Museum

Every museum has a culture and a personality. The best museums carefully craft these to create a fully integrated museum. Every interaction with a visitor is seen as part of the museum experience, and the cumulative effect of these interactions creates a unified museum personality. The approach provides visitors with a level of comfort, knowing what to expect at every touch-point with the museum. At the best museums, the culture and personality of the museum are a well crafted form of communication with the visitor.

An integrated museum approach (IMA) helps to define the museum for the public. To understand how an integrated museum is like a personality, think of a really good friend you have known for years. When you're with this person, you know exactly what to expect. You know how he or she will behave, and you feel relaxed because you know how to behave, as well. Everything is comfortable. Even if you add a third person to the group, there is a base knowledge that helps you gauge expectations and predict outcomes. The IMA creates a comfort level for visitors and provides a reason for a return visit: going to the museum is like visiting a friend.

WHAT IS THE BUSINESS OF MUSEUMS?

Museums make only a small percentage of their revenue from admissions: on average nationally, about 5 percent of annual operating revenue (Source: *Museum Financial Information 2009*, American Alliance of Museums). They have to balance driving attendance with fulfilling the museum's mission. I maintain that museums are in the business of hospitality. Except for school groups, all visitors to museums have chosen to visit. Museums exist to educate and inspire the public. There has always been a healthy tension between

academia and populism. I am not a fan of "edutainment"—the name implies neither education nor entertainment, but rather making education palatable. Museums are in the experience business; they provide an artful, historical, or scientific journey for their visitors. The goal is to aspire to the best, hence the expression "of museum quality."

Museum visitors choose to visit your museum. They decide to transport themselves to your front door, pay, and enter. This is a lot of work, and it is a choice. Thank them and welcome them. Museums are public forums of informal education. If the visitor doesn't enjoy his or her visit, he or she won't return. This is where your IMA creates a "personality" that the visitor has chosen to visit.

Holocaust museums are an example of the vital role museums can play. A holocaust museum collects and exhibits artifacts of atrocities perpetrated because of intolerance. The collection of a holocaust museum is preserved to share this history so that it never recurs. I was moved to tears at the United States Holocaust Museum in Washington, DC. I found myself standing at the back of a theater, crying. I had absorbed the content of the museum emotionally, and there is no greater compliment to any museum. I felt safe, and I felt that I would be understood. I was allowed to be moved.

The IMA combines a museum's mission, collection, values, and vision, and presents them in a way that the visitor can feel safe to learn.

Museums provide a safe, secure environment for visitors to understand art, history, science, and more. Words such as *display, interpret,* and *exhibit* are accurate, but they undersell the power of a museum. Museums move people emotionally to greater understanding and greater aspirations. This, too, is the business of museums.

Most often the culture of a museum can be traced back to the personality of the founder. The founder's personality and vision are imbedded in the culture of the museum as it develops. The IMA is the output of that culture, both intentional and unintentional. "One cannot not communicate."[1] This astute quote from psychologist and philosopher Paul Watzlawick (1921–2007) tells us that even when we don't mean to communicate, we still communicate something. Being aware of this concept allows a museum to take control of its personality.

The IMA is the framework for engaging an audience; it is the message and the method. The IMA touches every aspect of a museum, including:

• Mission
• Community engagement
• Education
• Content and collections

- Research
- Museum programming
- Exhibition evaluation
- Marketing (earned, owned, and paid)
- Exhibitions

I loved the old Exploratorium in San Francisco, California, founded by scientist Frank Oppenheimer in 1969. For me, central to its approach was Oppenheimer's vision of making science accessible. I loved the rough and tumble approach, the plywood exhibits just rolled out of the exhibition shop. At its old location, it was dirty and messy, a place for the passion of science exploration. The old Exploratorium allowed me to take ownership of the content, making it more accessible. I was able to connect and understand the information being presented in my own way, even though I'm not a scientist, because I knew what to expect when I walked through the doors.

It is important to understand that not everyone can or will connect with an exhibition or a museum. People process information differently. But an integrated museum will let people know what to expect before they step foot inside.

ELEMENTS THAT BUILD AN INTEGRATED MUSEUM

Founder: A person or group whose personality is inherent in the museum.
Vision: The founder's intended purpose for the museum.
Mission: The core purpose that will formally guide all museum activities.
Culture: The museum's set of beliefs that informally govern behavior.
Personality: The tone and character of a museum as felt by the visitor.
Marketing: The communication of the IMA.

Museums can craft their IMA. Here are some components:

1. **Founder.** An integrated museum often reflects the personality of its founder(s). Founders tend to surround themselves with people of similar personality types. It is important to add different personalities and styles to the museum culture and to accept and honor different perspectives.
2. **Community.** A museum is required to understand, support, and be an active participant in its community. This in turn helps create support for the museum's vision and goals. We will cover audience in greater detail, but an IMA requires thorough knowledge of the audience.
3. **Segment community.** There are segments of each museum's community. The twenty- to thirty-five-year-old group has different requirements from

the fifty- to sixty-year-old audience. It is important to identify and understand these audience segments.

4. **Creating a loop**. Ask each targeted segment about their needs and expectations. Compile data, test, and make changes. Repeat. The loop can be used for testing all aspects of the museum, from ideas for new exhibitions to on-floor programming, donor requests, and collection acquisitions.

5. **Sharing the vision**. Whether a start-up or an established museum, continue to refine and promote the integrated museum's vision.

6. **Culling**. During the process of building and sharing the IMA, museums may lose staff and even visitors. Have realistic expectations about the time and effort required to establish an IMA.

7. **Staff selection**. When the staff and the museum's vision and personality are in alignment, there is consistency and everyone can sense a genuine museum culture. When I go into a museum, I try to see if the frontline staff is genuinely excited about the museum. Hire and create enthusiasts.

8. **Refine**. Reduce the museum to its core values. Distill each part of the museum until together the parts embody the museum's culture.

9. **Create enthusiasts**. Visitors are happy to promote a museum they love, and they share their excitement with others. A well-crafted IMA has this effect on people: they want to share their enthusiasm. They have a sense of pride by association.

Here are some museums that exhibit the characteristics of a strong IMA (a very partial, arbitrary list; there are many more!).

Small museums:

• Mutter Museum, Philadelphia, Pennsylvania[2]
• Museum Jurassic Technology, Culver City, California[3]
• Museo del Objeto del Objeto, Mexico City, Mexico[4]

Medium-sized museums:

• Santa Cruz Museum of Art & History, Santa Cruz, California[5]
• The American Visionary Art Museum, Baltimore, Maryland[6]
• Museum of the Moving Image, Astoria, New York[7]

Large museums:

• The Guggenheim Museum, New York, New York[8]
• The Getty, Los Angeles, California[9]

- The Smithsonian Institution, Washington, District of Columbia[10]
- The Museum of Modern Art, New York, New York[11]
- San Diego Zoo, San Diego, California[12]
- Monterey Bay Aquarium, Monterey, California[13]
- American Museum of Natural History, New York, New York[14]
- Children's Museum of Indianapolis, Indianapolis, Indiana[15]
- DIA Art Foundation, Beacon, New York[16]

I think of the business of museums as twofold: to provide people with deeper understanding and to move people to higher aspirations. Both require visitors to feel safe and to feel that they are in an environment free of criticism. The entire museum experience is required to create this atmosphere—the architecture, the collection, the exhibits, the customer service, the graphics, and the interior design, to name just some of the elements. Neither the collections nor the mission on its own provides that deeper understanding. It is the entire museum experience that provides an environment for inspiration.

The IMA is at the core of a museum and a museum experience. As the integrated museum is the output of people, it is paramount that the museum's objectives be aligned with the staff members who implement the museum's mission.

NEXT STEPS

- Visit a local museum and write down its mission statement, access a copy of its annual report, and review its staff structure, number of members of board of directors, number of staff, year incorporated, etc.
- Look up the websites of the museums above mentioned as having a strong IMA and compare them to your local museum. What are the differences? What are the similarities?

NOTES

1. Quote credited to Paul Watzlawick, (1972), *Steps to an Ecology of Mind: Collected Essays in Anthropology, Psychiatry, Evolution, and Epistemology*, ed. Gregory Bateson. San Francisco, CA: Chandler Publications for Health Sciences.
2. http://muttermuseum.org/.
3. http://www.mjt.org/.
4. http://elmodo.mx/.
5. http://www.santacruzmah.org/.
6. http://www.avam.org/.

7. http://www.movingimage.us/.
8. http://www.guggenheim.org/.
9. http://www.getty.edu/.
10. http://www.si.edu/.
11. http://www.moma.org/.
12. http://zoo.sandiegozoo.org/.
13. http://www.montereybayaquarium.org/.
14. http://www.amnh.org/.
15. http://www.childrensmuseum.org/.
16. http://www.diaart.org/.

Chapter Four

Starting a Museum

A museum begins with a founder. The founder is the one with a vision for a new museum. The founder gathers a group of supporters, at first an informal organization of people who might later become a board of directors.

In the beginning, the founder and the assembled group have specific objectives. These might be "share the work of local artists with the local community," "provide an archive for local history," or "provide an educational early childhood experience." These objectives will later become a part of a written mission statement.

Many informal organizations operate for years with only their objectives. Only later do some informal groups decide to incorporate and undertake the process of creating a formal mission statement (see sample mission statements in the Museum Toolbox). Often, "startup museums" never get beyond this informal group gathered to deliver an objective. Founders aren't always able to create a sustainable group that can incorporate and later form a board of directors. Many such groups later disband due to the lack of community support or funding.

It also happens sometimes that a museum founder creates an informal group that shares his or her vision, only to have the plans "stall." There are many reasons why new museum projects stall: lack of support for a shared vision, lack of funding, or sometimes "life just gets in the way" and people put off the founding until a later time in their lives. Many times, the process starts, stalls, and then is restarted years later with new support from a new group of enthusiasts.

Successful museums almost always begin with what we might call a "big hairy audacious goal" (BHAG). A museum founder has a vision and a BHAG, and is able to recruit friends and associates to support the vision and goals. This group often operates informally for a period of time before

applying for a form of incorporation. At the very early stages, museums are often nothing more than an informal group of people intent on making a difference. This group creates a constitution and a set of bylaws (see a sample constitution and bylaws in the Museum Toolbox).[1] At first, this might be a working document to test and put into practice a way of delivering the BHAG. Later, as the informal group gains more knowledge and experience, it may refine its objectives in its constitution and bylaws. It may then choose to become a formal board of directors.

Art museums are often founded by a collector. In these instances, the founder's collection may serve as the core of the as-yet-unformed museum. The collector-founder will typically have the resources to form a legal nonprofit organization and even to begin the process of raising funds for a museum building. In exceptional cases, the collector-founder may have the resources to have the museum designed and built: for example, philanthropist Eli Broad and his Eli and Edythe Broad Art Museum at Michigan State University.

In the case of artists such as Andy Warhol or Isamu Noguchi, a foundation operates a museum named after the artist. The foundation provides a steady funding for the museum.

Natural history museums, historic houses, and science museums are sometimes formed around the private collection of a wealthy individual. With such museums as these, however, this founding model was more common in the nineteenth and early twentieth centuries. But today the model remains viable: the founder builds support through an informal group until a nonprofit organization can be formed and funding secured.

Zoos, aquariums, and visitor centers are often municipal projects with one or more civic leaders as the founder. These institutions might be part of a city planning project and funded in large part by local, state, or even federal governments. The museum is formed as a nonprofit organization that can receive private donations and federal grants. Often, zoos, aquariums, and visitor centers are part of projects meant to vitalize or revitalize an area of a city or region. Zoos and aquariums are the most expensive type of museum to operate. They usually require municipal support to be viable.

Children's museums, science centers, art centers, nature centers, history museums, and botanic gardens are often started as "grassroots" efforts, gradually building community support as a "start-up" through local meetings and events. These might be events such as art exhibits, botanic displays, children's events, and displays of community history, used also to raise funds for the project. Museums that choose this approach often take the longest to open—five to ten years.

An informal association[2] can operate for years without any specific legal standing; some banks will recognize an informal association[3] and the group

can open a bank account. If the group gains enough members or supporters, it can decide to apply for nonprofit status.

Museums typically incorporate as nonprofits and thus receive tax-exempt status from the Internal Revenue Service (IRS) as a 501(c)(3) charitable organization that is legally allowed to accept charitable donations of money or objects, including art and artifacts. When the museum decides to apply for nonprofit status, a governmental organization (the IRS) will review the vision and goals of the institution and either grant or deny nonprofit status. To be granted this status, the museum must have as one of its goals to fulfill a civic need—that is, providing a service to the public. A tax-exempt nonprofit must have a constitution and be governed by a board of directors. The board is bound by the organization's bylaws and other legal and fiduciary responsibilities.

In my experience, I find that if a museum has a culture that is supported by a strong IMA, the major components—collections, exhibitions, education, marketing, governance, funding, and operations—are a natural output of that culture and are inherently aligned.

STEPS IN STARTING A MUSEUM

1. Select the name of your organization.
2. Form a board of directors.
3. Create a mission statement.
4. Hire an attorney.
5. File articles of incorporation with your state (see sample articles of incorporation in Museum Toolbox).
6. Apply for employer identification number.
7. Hire a certified public accountant.
8. With your certified public accountant, develop a reliable record-keeping system.
9. Download and read IRS Form 557 "Tax-Exempt Status for Your Organization" (see the link in Museum Toolbox).
10. Download and read IRS Form 4220 "Applying for 501(c)(3) Tax-Exempt Status."
11. Download the IRS Forms 1023 and Form 990, for reference.
12. Apply for tax-exempt status as a 501(c)(3) organization.
13. Apply for state tax-exempt status.
14. Draft constitution and bylaws.

NOTES

1. New York State Museum, "Chartering: Sample museum constitution." http://www.nysm.nysed.gov/services/charter/musconstitution.html; New York State Museum, "Chartering: Sample museum bylaws." http://www.nysm.nysed.gov/services/charter/musbylaws.html; New York State Museum, "Chartering: Museum definitions." http://www.nysm.nysed.gov/services/charter/musdefinitions.html.

2. State of Indiana, "Certificate of assumed business name." http://www.in.gov/icpr/files/CertificateofAssumedBusinessName.pdf.

3. Nicholson, Bob, "Starting an art guild of co-op." http://www.artchain.com/resources/starting.html.

Chapter Five

Museum Governance

Governance concerns how an organization's leadership is structured to deliver its stated mission. Museum governance includes the board of directors, paid museum staff at the director level, and volunteers. Most museum board members are volunteers and are not paid, although they often receive compensation in the form of museum memberships, invitations to special events, and acknowledgments.

In the United States, the majority of museums are private nonprofits.[1] In the rest of the world, most museums are supported by government funding. For the purposes of this book, I divide museums into three groups:

- Private, nonprofit organizations
- Government-run museums
- Nongovernmental organizations

The structure and operations of the three museum types are similar, with exception of their financial support and their financial accountability.

From a governance perspective, the museum is the responsibility of the board of directors. Selected members of the board (chairman, treasurer, secretary) and museum staff (executive director/chief executive officer (CEO), associate director, chief financial officer) are officers of the nonprofit corporation. They can sign contracts and enter into binding agreements. Most museums in the United States are nonprofit corporations that receive private and public funding to support the delivery of their mission.

I do not know of any museums that are not governed by a board of directors. A private museum[2] such as the Crystal Bridges Museum of American Art, located in Arkansas, is funded for the most part by the fortune of Alice Walton, Wal-Mart heiress. But it too has a board of directors[3] to oversee

operations. The Smithsonian Institution is a federally funded complex of museums with the majority of its funding coming from the U.S. government. The Museo Nacional de Antropología of Mexico City, Mexico, would be considered a nongovernmental museum, as the majority of their funding comes from governmental agencies, but the museum itself is not part of the government.

The Museum of Jurassic Technology[4] is a small museum located in Los Angeles, California,[5] that was founded in 1984[6] by David Hildebrand Wilson and Diana Drake Wilson. This small museum, with total annual expenses of $336,624 (2012)[7] including all staffing and programming costs, has an international reputation. Edward Rothstein of *The New York Times* describes it as a "museum about museums."[8] This museum is world class by any standard, yet it has only ten board members,[9] total staffing costs of $135,539, and total exhibit costs of $53,042 per year (as of 2012).

In essence, the Museum of Jurassic Technology is a museum governed and operated by two people, Mr. and Mrs. Wilson. They are board members and museum staff. The Museum of Jurassic Technology is a benchmark for museum governance. Often when people outside the museum field think of museum staffing, they think of fancy offices and complex organizational structures. But the majority of museums around the world are small museums with minimal staffing and revenue.

MUSEUM FOUNDER

Most often the museum's founder is voted the first chairperson of the board of directors.

Sharon Zaga, the founder of the Museo Memoria y Tolerancia of Mexico City, Mexico,[10] declared at the age of fifteen, during a career day at school, that she would build a museum dedicated to the Holocaust.[11] In 2010, Ms. Zaga opened a 75,300-square-foot museum. The museum's vision was also a personal vision: Ms. Zaga's "grandmother moved to Mexico from Czechoslovakia as World War II broke out, and [her] great-aunt survived Auschwitz."[12] The museum is an amazing testament to the power of a personal vision. "In 1999, a group founded a nonprofit organization, Memoria y Tolerancia (Memory and Tolerance), which began collecting donations and material for the museum, whose funding almost entirely comes from private individuals, many of them Jewish."[13]

Ms. Zaga had a vision of a cultural center[14] celebrating tolerance and honoring memory. This was certainly a big hairy audacious goal. She shared her goal and built a group of supporters. The idea of tolerance is viewed through a lens of activism: "Indifference is a form of intolerance."[15] From Ms. Zaga's

vision, the concept was born and the museum built. Ms. Zaga serves as the museum's director and still guides the museum's process.

BOARD OF DIRECTORS

The chairman of the board, appointed by a majority vote of board members, presides over board meetings. Typical board positions include chairman, vice president, treasurer, and secretary; each has appointed responsibilities (see the Museum Toolbox for a sample of a museum operations and policy manual, including descriptions of the role of the board of directors). The board of directors hires the director/CEO, approves museum budgets, and approves overall museum plans and fundraising initiatives. At some smaller museums, board members may also be involved in museum operations, even building exhibits, for example, or serving as docent-volunteers.

The board of directors oversees the subcommittees. Examples of these committees are exhibitions, fundraising, marketing, executive search, human resources, building, and gala committees. A "best practice" is to have a group of twelve to fifteen board members who direct the museum. There are also several board subcommittees that may be staffed by nonmembers of the board. With a structure of twelve to fifteen people on the board of directors and twelve to fifteen people on each subcommittee, there is an opportunity to have more people involved with the museum and have greater potential for donations.

Members of the board serve for a set period of time, then most often rotate off the board, allowing subcommittee members an opportunity to be voted onto the board.

Most museum boards adhere to the Robert's Rules of Order.[16] The roles and duties of a board of directors are determined by the museum's constitution and bylaws (see the Museum Toolbox for samples). Each board member agrees to the museum's constitution and bylaws by signing a board of directors agreement (see the Museum Toolbox for a sample).

From founder to board member to maintenance staff, everyone works at the museum for the same basic reason: to make the world a better place. This might sound trite, or an overly simple generalization, but the best museums talk about it and define how they make their communities better.

BOARD OF DIRECTOR, SUBCOMMITTEE

Most museums boards have subcommittees. These often have a role of advising or supporting the museum's operations in specific areas. Board subcommittees might include:

- Executive committee
- Finance committee
- Memberships committee
- Building committee
- Nominations committee
- Communications committee
- Fundraising committee
- Collections committee
- Retail and gift shop committee
- History committee
- Arts committee
- Education committee
- Volunteer committee
- Exhibition committee
- Special events committee

Each subcommittee has a chairperson who reports to the board of directors.

MUSEUM BOARD OF DIRECTORS AND ARTISTS

Some museums include working artists as members of their boards. But conflicts can arise. A recent example is the Museum of Contemporary Art, Los Angeles. The museum hired Jeffrey Deitch, an art gallery owner, as director. But concerns were voiced about the implicit conflict of interest in hiring a commercial art gallery owner as a museum director. If an artist represented by Deitch is shown in the museum, that artist—and Deitch—might benefit financially from an increase in the value of his art. The four artists on the Museum of Contemporary Art, Los Angeles, board of directors quit the board as a form of protest when Deitch fired curator Paul Schimmel. The artists felt that Deitch had a clear conflict of interest, as he was now directly influencing the art exhibited at the museum. Deitch has since resigned as director/CEO of the Museum of Contemporary Art, Los Angeles, and the four artists have rejoined the board of directors.[17]

MUSEUM COLLECTIONS

In all of the museums that I know of, the museum's collection is under the care and protection of the board of directors. The board hires a museum director/CEO who in turn either personally cares for the collection or hires

a collection manager to do so. The care and protection of the museum's collection in perpetuity is the board's most important responsibility; all other duties are subservient to the primary care of the collection. Other responsibilities include:

- Fiduciary responsibilities
- Support of mission
- Adhering to code of ethics
- Adhering to industry standards

Museum collections are held in public trust forever and are in the care of the museum's board. Museums often sell or "deaccession" pieces of a collection in the interest of building the overall collection. From the American Alliance of Museums' Code of Ethics:

> Disposal of collections through sale, trade or research activities is solely for the advancement of the museum's mission. Proceeds from the sale of nonliving collections are to be used in a manner consistent with the established standards of the museum's discipline, but in no event shall they be used for anything other than acquisition or direct care of collections.[18]

Recently, the Delaware Art Museum was sanctioned[19] by the Association of Art Museum Directors and lost its accreditation from the American Alliance of Museums.[20] The museum sold William Holman Hunt's 1868 painting *Isabella and the Pot of Basil* for $4.25 million to cover operating expenses. The museum felt it had to sell the art or close its doors. The issue was not whether the museum has the right to sell its art, but that it planned to use the proceeds to underwrite operating costs, directly in conflict with the American Alliance of Museums' Code of Ethics. If the proceeds had been used to acquire more art, or to care directly for the current collection, the sale would not have been in violation of the Code of Ethics.

STAFF

The board of directors hires a director/CEO to manage the museum. This is one of the board's most important functions. The museum director differs from other staff in that he or she has a dual role, serving as a member of the board and as a staff member, consequently earning two titles, director and CEO.

The term "staff" often refers to paid employees of the museum. At many successful museums, volunteers are essential to the smooth running of the museum. A paid employee may supervise an unpaid volunteer. It is impor-

tant that the volunteer feel valued, just as the paid staff are. Some museums operate as all-volunteer organizations, or with only one or two people as paid staff, plus the board of directors.

Volunteers perform many essential tasks at museums. These include helping in the following areas of operations:

Collections
Exhibits
Education
Development (fundraising)
Marketing
Operations
Finances

An interesting dynamic exists between the museum director and the board of directors. The board is the director's boss, so to speak: the director must answer to the board, and the board monitors the director's job performance.

Many directors are also museum donors. This is an important part of understanding philanthropy. From a philanthropic point of view, the director may be expected to donate to the museum, just as the board members are expected to do, demonstrating a strong belief in the museum's mission through a financial contribution to its success. Some museums extend the same philosophy to paid staff and volunteers, and include staff in fundraising efforts.

I have found that the most successful museums are very vocal about their mission and promote its financial support with both staff and community. Some museums require a yearly fee or dues to be a member of its board of directors. This can seem an odd concept for people outside the museum field: rather than board members being paid, they pay or contribute to the museum. In reality, most museums (more than 50 percent[21]) are small, community organizations run mostly by volunteers—and board members are volunteers, too.

As one example, take the rather unusual Toilet Museum of New Delhi, India. Dr. Bindeshwar Pathak is the museum's founder and one of the only staff. Dr. Pathak[22] realized that proper hygiene and sanitation is a major issue facing India and many developing countries, and he created a museum to address the issue.

When I visited, I was given a personal tour by Dr. Pathak. I arrived at the museum unannounced and not until after the tour did I tell Dr. Pathak that I worked in museums. Here is a man who has founded a museum, gives tours, and works on the exhibits himself. The reality of most museums is that they are small and history-based, operating with very little funding and

with only one or two staff. I can think of many museums whose director also serves as its curator. The Yuma Territorial Prison State Historic Park in Arizona is such an example. The director/CEO handles fundraising, marketing, operations, and finances, whereas the curator handles collections, exhibits, and education. Volunteers and a few hourly paid employees handle other duties. Both the director and curator have the use of credit cards from the museum's bank, each has a limit on the amount that can be approved for purchases, and each has the authority to hire hourly staff for short durations of time, usually one to two days. Each can sign contracts up to the spending limit after review by the museum's volunteer legal counsel. Each can propose ideas for new exhibits, educational programs, and museum marketing.

In some ways, it is easier to understand a small museum staffed by two people than it is to understand a large museum with hundreds of employees and volunteers. But it is only a matter of scale that differentiates a small museum from a large. The work that needs to be done is the same. In the Museum Toolkit, you will find samples of museum organizational structures, from a two-person staff to a large museum with hundreds of employees.

VOLUNTEERS

Many museums, especially small museums, are all-volunteer organizations. At many successful museums, volunteers go through the same interviewing and training as paid staff. It is considered an honor and an accomplishment to become a long-time docent (volunteer tour guide) at a major museum. Most docents work as volunteers. There are tens of thousands of unpaid docents working in museums throughout the world.

Museums are philanthropic organizations; they give to society and receive support from it. This give and take is at the core of philanthropy and museums. By volunteering at a museum, you are giving something to society. In return, you receive the pleasure of knowing that you are making your community a better place.

Why would anyone volunteer? At most museums, volunteers do receive special compensation, such as museum membership or invitations to special events, but most often that is not why people volunteer.

Where I grew up, volunteering was part of the culture. It is what we did as part of our schooling. I would volunteer by helping the blind with household chores or working with people with cognitive disabilities. I believe in Maslow's Hierarchy of Needs: a person's base needs must be met before the next level of needs can be attained. As communities mature, there is

more willingness to give back to the community. Where basic needs in a community or a nation are not met, that sense of "giving back" is still to be developed. I work in some still-developing countries (Mexico, Indonesia, and China), and I observe that only with time does a culture mature to a point of understanding and freely practicing philanthropy.

Sometimes museum board members assume that volunteers will provide much of the work of a museum. I have seen museum feasibility studies that were based on volunteer staff doing work such as building the exhibits. This arrangement is possible, but it is not the norm. It requires a very special organizational culture to support volunteers performing all the daily functions of a museum.

On a basic level, most volunteers want a sense of accomplishment: teaching kids about an artist, helping with an orientation of a group of senior citizens, or building part of an exhibit. Asking a volunteer only to clean bathrooms will most likely lead to a short-lived relationship. It would be an excellent practice to require all museum staff, including board members, to work the museum floor at least once a year. Interacting with the public at a museum is one of the most rewarding and difficult jobs, but it reinforces that idea that everyone at the museum shares the responsibility for implementing the mission. Direct contact with the public is a very useful reminder of that idea.

Everyone who works at a museum, paid or unpaid, is doing the work of building a better society. This is a key element of the integrated museum approach: everyone at the museum is making a conscious decision to contribute to civil society. It is important to create a museum-wide culture of equality. Whether cutting the lawn, teaching a class, or curating an exhibit, all jobs in the museum contribute to the mission. This is a message that should be shared from top down. I know of a story where a board member purposely left trash on the floor of a museum and watched to see who on the museum staff would pick it up. This is a great test of museum culture: Does the responsibility for picking up trash belong only to the maintenance staff? Or do museum staff and volunteers show their pride in the museum by doing the mundane tasks like picking up the trash?

VISITORS

The museum visitor is also a key part of the integrated museum approach. At one staff meeting I once attended, a museum worker quipped, "This job would be great if it wasn't for those pesky visitors." More often than you may think, museums develop just such a culture: an inward culture of protectionism. But museums are public spaces. Museum staff serve at the pleasure

of the board of directors, and the board is tasked with responsibility for the museum's mission. Museums communicate something of value; the visitor is required as a participant in the conversation. No museum would exist without the visitor. A museum with an integrated museum approach believes that the museum "belongs" to the visitor. In the Museum Toolbox, you will find my essay "Museums are Hospitality," sharing my view on how hospitality is one of the three core elements of a successful museum. These core elements are mission, collections, and hospitality.

IN CONCLUSION

A museum is governed by a board of directors and operated by museum staff and volunteers who serve at the discretion of the board. A well-functioning museum will always keep the museum's mission and its audience central to how the museum is governed. As most museums are nonprofit institutions or nongovernmental organizations, and thus a part of civil society, their governance and operations are different from other types of organizations.

I see five keys to successful museum governance:

1. An integrated museum approach
2. A "big hairy audacious goal" shared by all
3. A mission that solves a need
4. A visitor-centric approach
5. A collaborative internal culture

Successful museum governance will encourage these attributes to be shared, from founder to support staff. I am most impressed by museums whose board members attend staff events and make an effort to know the museum staff. It is easy for board members to separate themselves from museum staff. But in truth, all museum staff, board members, and volunteers share that larger goal of making the world a better place.

NOTES

1. http://photos.state.gov/libraries/amgov/133183/english/P_You_Asked_How_Are_Museums_Supported_Financially.pdf. Website accessed March 16, 2015.
2. Laster, Paul, (2011), "The 10 best private museums worldwide." http://flavor wire.com/196371/the-10-best-private-museums-worldwide. Website accessed March 16, 2015.
3. http://crystalbridges.org/. Website accessed March 16, 2015.

4. The Museum of Jurassic Technology 2012 Form 990. http://www.guidestar
.org/FinDocuments/2012/954/309/2012-954309388-09459e2b-9.pdf.

5. http://www.mjt.org/.

6. L.A. Record, (2010), "David Wilson: The Museum of Jurassic Technology."
http://larecord.com/interviews/2010/12/12/david-wilson-the-museum-of-jurassic
-technology.

7. The Museum of Jurassic Technology 2012 Form 990. http://www.guidestar
.org/FinDocuments/2012/954/309/2012-954309388-09459e2b-9.pdf.

8. Rothstein, Edward, (2012), "Where outlandish meets landish." http://www
.nytimes.com/2012/01/10/arts/design/museum-of-jurrasic-technology-shows-its-wild
-side-review.html.

9. The Museum of Jurassic Technology 2012 Form 990. http://www.guidestar
.org/FinDocuments/2012/954/309/2012-954309388-09459e2b-9.pdf.

10. http://www.myt.org.mx/.

11. SFGate, (2010), "Holocaust museum in Mexico promotes tolerance." http://
www.sfgate.com/news/article/Holocaust-museum-in-Mexico-promotes-tolerance
-3249553.php.

12. SFGate, (2010), "Holocaust museum in Mexico promotes tolerance." http://
www.sfgate.com/news/article/Holocaust-museum-in-Mexico-promotes-tolerance
-3249553.php.

13. SFGate, (2010), "Holocaust museum in Mexico promotes tolerance." http://
www.sfgate.com/news/article/Holocaust-museum-in-Mexico-promotes-tolerance
-3249553.php.

14. Museo Memoria y Tolerancia. http://www.myt.org.mx/MytIngles.pdf.

15. Museo Memoria y Tolerancia. http://www.myt.org.mx/MytIngles.pdf.

16. The Official Robert's Rules of Order Web Site. http://www.robertsrules.com/.

17. Rogers, John, (2014), "3 artists who quit LA museum's board are returning."
http://www.washingtontimes.com/news/2014/mar/18/3-artists-who-quit-la-museums
-board-are-returning/.

18. American Alliance of Museums, "Statement on the deaccessioning by the
Delaware Art Museum and the action taken by the AAM Accreditation Commission."
http://aam-us.org/about-us/media-room/2014/delaware-accreditation-status.

19. Association of Art Museum Directors, (2014), "Assocation of Art Museum
Directors sanctions Delaware Art Museum." https://aamd.org/for-the-media/press
-release/association-of-art-museum-directors-sanctions-delaware-art-museum.

20. American Alliance of Museums, "Statement on the deaccessioning by the
Delaware Art Museum and the action taken by the AAM Accreditation Commission."
http://aam-us.org/about-us/media-room/2014/delaware-accreditation-status.

21. Museum Universe Data File, fiscal year 2014 third quarter, Institute of Mu-
seum and Library Services.

22. http://www.sulabhtoiletmuseum.org/. Website accessed March 16, 2015.

Chapter Six

Museum Feasibility Studies

Feasible: "Capable of being done or carried out; 'a feasible plan'; capable of being used or dealt with successfully: suitable."[1]

A museum feasibility study proves or disproves the financial viability of a new or expanding museum. Museum viability is a balancing act of fulfilling mission (staffing and facility), attendance (revenue), and the ability to raise funds and generate revenue (covered in Part IV). A museum feasibility study is also a "reality check." Can a museum's mission, planned staff structure, and planned facility be economically sustainable?[2]

After the museum's nonprofit and tax-exempt status is secured, a museum feasibility study is often the next step. Much of the work of creating an integrated museum approach and establishing museum governance can be completed by an all-volunteer staff before a museum goes through the process of a feasibility study. Often a museum feasibility study is completed once the museum has received nonprofit status and has adopted a constitution and bylaws, but before the board of directors has hired a director/chief executive officer.

Some museums adopt a "build it and they will come" attitude, based on overly optimistic feasibility studies or feasibility studies that don't properly consider mission, potential business models, and the future of museums. I have seen many institutions get into long-term trouble due to a myopic feasibility study.

A museum feasibility study should include the following elements.

Area demographics: Research the area demographics and population trends. Is the local population growing or shrinking? What is the average education level of the local population? Who are the largest employers in the area? What is the city's/area's socioeconomic status?

33

Business model: Possible institutional business models include an admission-based model, a donor-/sponsor-based model, or reliance on rental income and other earned income.

Visitor demographics: Define visitor types (e.g., seniors, families, singles, etc.) and the potential percentage of overall visitation.

Area partners/competition: Include a list of major institutions in the surrounding area as potential partners and/or competitors, with information on each, such as location, website, admission prices, and annual visitation.

Area tourism: Major attractions and areas of interests for tourists, including historic sites, other museums, outdoor recreation, shopping, agriculture, etc.

Tourist trends: Look at the various age ranges, durations of stay, accommodations, areas visited, and reasons for visit (vacation, business, or tourism).

Benchmark case studies: Consider the business models of three to five comparable museums by researching their founding history, programs, organizational structure, admission prices, partners, and operating budget over several years.

Recommendations: Outline the strengths, weaknesses, opportunities, and threats facing the proposed museum, with consideration of mission/vision and the community profile.

Conclusion: Create a clear and concise summary of the findings, from evaluations to recommendations, and offer next steps.

Supplemental materials: Include all relevant visual aids or appendices.

Bibliography: List all sources used throughout the study, such as demographic data from the U.S. Census, organization websites, articles, etc.

THE BEST PRACTICES OF A FEASIBILITY STUDY

Draft schedule: A good rule of thumb for an aggressive museum schedule is one year for planning, one year for fundraising, and one year for construction. A museum feasibility plan should include a multiple-year plan, from museum formation to three years after opening.

Plan for the visitor: Visitors are not numbers. It seems simple, but a possible high attendance estimate without a supportive visitorship is of little value, often creating a second-year dip in projected revenue. Museum visitorship should grow in the second year, not shrink. If your visitorship is decreasing in the second year, you are not connecting with your visitor base.

Mission: It is not possible to create a realistic museum feasibility study without at least a draft of the mission statement. The mission can be very simple, but it should be at least a starting point for a board of directors to review.

Peer review: Politely ask the directors of the museums in your benchmark case studies if they would be willing to review your feasibility study and make comments. The data of your feasibility study may be of help with their own planning, and their feedback can be invaluable to the "startup museum."

Selective listening: Many times a founder or board member has a vision of the planned museum and only wants validation of his or her vision. This is fine if the data and visitor experience support the founder's or board member's vision. But if it doesn't, you are doing the museum a disservice to act on advice only to appease an important individual.

Partnerships: You want the information of the study to remain confidential, but you also want to understand potential partnerships and collaborations. Share parts of the feasibility study with potential funding partners and receive their feedback. Would they support the new museum financially?

Plan for your benchmarks: Once you have narrowed your potential business models, choose your benchmarks (visitor exit survey results, awards, comparable museums) and plan your study according to the benchmarks, no matter the location.

Be flexible to museum type: A client contacts you and requests a feasibility study for an "art museum." It is tempting to create a museum feasibility study based on an art museum similar to the one in the next county, but that may not be the best fit for the location.

Look beyond nonprofits: The museum's competition will be beyond other area museums. Try to understand the needs of the area and be realistic about the competition from for-profit destinations.

Plan for the building: Be very general. Try to understand how the proposed museum will use its building facilities, including approximate square footage, potential facility amenities, and a preliminary organizational chart (to provide approximate number of offices).

The best practice for feasibility studies is to remain "visitor-centric," always bringing the study back to the potential visitor and how each group of visitors will use the yet-to-be-created museum. A museum feasibility study template is included in the Museum Toolbox.

Museums are cornerstones of civil society, community-based, public institutions. It is important that museums remain affordable to the general public. In very general terms, museum admission should be roughly the same cost as a local movie ticket. A successful museum becomes a destination and can draw attendance from a larger area than the immediate region. In general terms, "local community" includes visitors within thirty to forty minutes of the museum.

For the past several years, I have worked with a sculptor who was part of the renovation work at the California Academy of Sciences. This sculptor told me he can't afford to take his family to visit the museum. He is a well-educated, working artist, yet can't afford the museum he helped create.

I love the work of architect Renzo Piano, but the California Academy of Sciences cost $488 million[3] to build. The museum costs fifty-eight million dollars a year to operate.[4] So if the attendance is eight hundred thousand visitors a year, the cost of each visitor is $67.50 (operating budget divided by attendance). Admission costs to the museum are currently $29.95 for adults, $19.95 for a child (ages four to eleven), while a family (two adults and two children) pays $99.80.[5] Almost half of the cost of every visitor, or $37.51 of every adult ticket sale, needs to be underwritten by grants and donations. I am guessing that the California Academy of Sciences is encouraging the purchase of memberships with their ticket pricing. A family membership is $199, or twice the cost of tickets for one day.[6] I believe the $29.95 ticket price sends an incorrect message that informal science education is expensive.

As part of conducting your feasibility study, include all destinations within your community.

Price of a movie yicket: The museum business model should be built around the price of family entertainment, such as a local movie or bowling. Work backwards. If you want your admission price to be the cost of a local movie, create your pro forma accordingly. Many times, museums are built on a what-if scenario, and the result is a $29.95 admission price.

Hierarchy of needs: Given a choice between feeding a family and going to a museum, a family will choose to eat. I believe in Maslow's Hierarchy of Needs. Creativity and problem solving are at the top of the pyramid. If the visitor's basic needs are not met, he or she cannot appreciate the joy of intellectual curiosity. Sometimes a family just wants a place where mom and dad can hold hands and watch the kids make a painting. Are you giving your community what they need?

Build local: If you were to use the same funds ($488 million) as the California Academy of Sciences, you could build at least thirty local community-based science centers. The effect of thirty local centers would likely have a greater impact on science literacy than one large center.

Humility: Museums serve their community.

Content is king: Overspending is often the cause of luxury finishes (granite floors, glass facades, expensive fixtures). Such amenities do not convey content. When comparing one science center to another, it is the building costs that are significantly different. In 2011, we completed work on a science center in Indonesia. Total costs for twenty-five thousand square feet

of science exhibits was $1.8 million, or $72 per square foot. All of the exhibits were built in the United States or Canada and shipped to Indonesia. Spending more money does not get you better content.

Tie-ins: Tie into trends that have momentum. The Hall of Science in Queens, New York, is working with Maker Faire—an event sponsored by *Maker* magazine catering to the arts, craft, engineering, and science-project crowd and the burgeoning do-it-yourself movement—to create a permanent exhibition space. The Maker Faire has gone viral, and ticket prices at the Hall of Science are eleven dollars for adults, ages eighteen and up, and eight dollars for children (ages two to seventeen), including access to the new Maker Space.[7]

For-profit is not the enemy: As long as the expectations and guidelines are set at the beginning, for profit/nonprofit partnerships can become a win-win relationship.

Respect your staff: I would recommend that it is better to save capital costs and pay a respectable, living wage to your staff.

Keep it going: Google has a 20 percent projects[8] policy (20 percent of staff time devoted to new projects), which is one way to feed the souls of their creative-minded staff—and also create fantastic new projects like Google Liquid Galaxy, among others. Most museums operate at 110 percent, creating burnout in staff and resulting in poor customer service. Most museums are so busy trying to pay back loans and bonds that there is not enough energy left for staff to give back to visitors.

Real estate developers: Real estate developers can be your friends. Every new museum project I have worked on has been part of either the vitalization or revitalization of a neighborhood. If the relationship is managed well, real estate developers can become partners in the development of a new museum.

I strongly believe that museum feasibility studies should be conducted by outside consultants. A museum's founder and board members want to believe that their museum is feasible and financially sustainable. An outside consultant can be more objective about the financial reality of creating a new museum or expanding an existing museum.

Even so, there are many museums that have hired a consulting firm to conduct a feasibility study only to find that estimated attendance numbers were inflated, leading the museum to lay off staff within the first year.[9] Before hiring a museum consulting firm, interview their previous clients and ask about the accuracy of their attendance estimates. For museums, the third year of operations is more important than the first year of operations. Often, museums will reach expected attendance estimates for the first year and then see

a dip in attendance in the second year. The third year is the best measure of expected museum attendance. As part of your museum feasibility study, ask other museum professionals to be part of the process. Most museum professionals will be happy to review and comment on a feasibility study. Often a peer review from museum staff at a similarly sized museum of the same type is as valuable as the study itself.

The goal of a successful museum feasibility study is to prove or disprove the sustainability of a new museum or the expansion of an existing museum. The important goal of the study is creating a museum business model that takes into account the needs of the museum's geographic community while also balancing the costs—staff, collections care, educational programming, operating the facility, and generally delivering the mission—with projected revenue from attendance, fundraising, and earned income.

NOTES

1. http://www.merriam-webster.com/dictionary/feasible. Website accessed March 16, 2015.

2. For the purpose of the book, a few words have multiple meanings. Sustainability refers to both the financial sustainability of an institution as well as ecological sustainability.

3. California Academy of Sciences, accessed May 13, 2014, https://www.calacademy.org/newsroom/releases/2008/rebuilding_project_facts.php.

4. "California Academy of Sciences report on audits of financial statements June 30, 2011 and 2010," accessed May 13, 2014, http://goo.gl/ywuhMd.

5. California Academy of Sciences, accessed May 13, 2014, https://www.calacademy.org/tickets/.

6. California Academy of Sciences, accessed May 13, 2014, http://www.calacademy.org/join/membership/.

7. New York Hall of Science, accessed May 13, 2014, http://nysci.org/visit-main/tickets/.

8. Tate, Ryan, (2013), "Google couldn't kill 20 percent time even if it wanted to," accessed May 13, 2014, http://www.wired.com/2013/08/20-percent-time-will-never-die/.

9. Nolte, Carl, and Kale Williams, (2013), "Exploratorium cuts 18% of staff as attendance lags," accessed May 12, 2014, http://www.sfgate.com/bayarea/article/Exploratorium-cuts-18-of-staff-as-attendance-lags-4737148.php.

Chapter Seven

Museum Planning Strategies

At the core of all strategic plans for museums is the method used to deliver the mission, typically through presenting the museum's collection to the public—whether that collection is art, science, animals, plants, or artifacts. A mission is the guiding principle of what the museum aims to accomplish and how. The strategic plan is the game plan for how a team of people plan to meet the museum's mission.

A strategic plan is a map of the route that the board of directors will take to reach their destination. It is their collective vision for how the museum will deliver its mission. Much of the strategic planning process is intended to understand and capture in words the style and the method for delivering the mission.

For a new museum, a strategic plan will include the financial plan, the fundraising plan, the staffing plan, and the marketing plan until the opening of the museum. Most important in the planning is the interdependencies between these efforts. For example, the fundraising effort has a goal of receiving a "lead gift," the first sizable donation. The receipt of the lead gift needs to be coordinated with marketing to maximize public awareness, so that the announcement of the lead gift has the largest impact.

The vision of the strategic planning happens at the level of the museum founder, board members, funders, and elected officials. Museum planning (facility planning and exhibition planning) happens at the level of the architect, the director/chief executive officer, and the director of exhibits. The two groups should be closely connected to one another. It is sometimes best to merge the two.

One of my favorite strategic planning exercises is the restaurant exercise. Ask all of the members of the strategic planning group to think of the museum as if it were a restaurant. What type of restaurant are they building?

Ask each member of the group to spend ten minutes describing the restaurant. How is the wait staff dressed? How is the space lit? What does the menu look like? Are there tablecloths or modern glass tabletops? When the members are finished writing up their descriptions, ask each to present their restaurant to the rest of the group. I have conducted this exercise many times and am always impressed with the outcome. It may be the first time each board member really shares his or her vision with the rest of the group. Have a person record the descriptions: the level of formality, budget, voice (how people communicate), temperament, and ambiance. These are all difficult concepts to put into words. In the Museum Toolbox, you will find a sample strategic planning workshop agenda.

Both The Oceanaire[1] and Bubba Gump[2] are franchise seafood restaurants owned by the same company. Both serve similar dishes but in very different styles. Some people will be offended by my comparison of franchise seafood restaurants to museums, but it is just for this reason that the exercise works so well. Often, strategic planning participants' egos and money are too vested in the process. It is helpful to step outside the museum world to examine how you will deliver mission.

The root of the word strategy comes from the ancient Greek word for "general"—the "*strategos*," or troop leader. For a start-up museum, the founder is the troop leader. For an existing museum, the troop leader is the director/ chief executive officer. I remember meeting a museum founder at a strategic planning meeting and within five minutes I had complete confidence that the museum would be built. The museum opened three years later. Leading the troops is certainly an art.

A strategic plan should be able to answer questions such as, "Can a museum founder lead the troops to the opening of the museum?" and "How will the troops (board of directors) meet the goal of opening (or changing an existing museum)?"

A strategic plan should include:

1. Mission, vision, core values, core strengths
2. A plan for using the collection to fully meet the mission
3. A description of the museum's lens: From what perspective does the museum view the world?
4. Framework for all educational content
5. A description of the museum's voice: The tone and method for communicating
6. An integrated museum approach: "Who" the museum is, with a description of the embodiment of the museum and its approach
7. A schedule (with milestones)

8. Strategic goals (measurable)
9. Organizational support

It all comes back to the collection and how it will be used to attract, educate, and inspire the public.

Recall our definition of a museum: "An organization in the service of society and its development, open to the public, which researches, communicates, and exhibits things and ideas, for the purposes of education, study, and enjoyment."

The strategic planning process is (in order):

1. Who do we think we are—board of directors, staff, and volunteers?
2. Who does the community think we are—elected officials, visitors, mothers, teachers, etc.?
3. How do the two perspectives compare?
4. Is who we think we are still who we want to be?
5. A description of who we are, including values, vision, and core strengths.
6. Mission.
7. Test mission: Is there a need to revamp the mission? Is there support?
8. Organizational structure (staffing) to implement mission.
9. Schedule to implement strategy.
10. Strategic goals (measurable).

To accomplish the above takes time. The strategic planning process can take three months to a year. It is a difficult process to undergo without an objective advisor. Many people compare the process to therapy, and there are many similarities. It is hard for people, either personally or professionally, to ask who they are. How does the museum identify? How do you want it to identify?

1. WHO DO WE THINK WE ARE?

I had the pleasure of working with Roy Shafer on the start-up of Discovery Science Center in Santa Ana, California. Prior to our first meeting, he asked all staff to take a Myers-Briggs personality test online (you can find a link to the exam in the Museum Toolbox). At our first meeting, the entire Discovery Science Center staff (approximately twenty people) had gathered in the boardroom, waiting for Roy's arrival. When he arrived, he asked us to look to our left and to our right and see whom we had seated ourselves next to. He then handed out the results of the personality profiles. We had unknowingly seated ourselves according to personality type: the introverts had seated

themselves with other introverts, and extroverts had seated themselves with other extroverts. I had seated myself next to my most similar personality type. It was an impressive experience; we are all attracted to similar types.

The same process is true for museum founders. They tend to draw similar personality types to them. This can result in a lopsided organization if, for example, a founder creates a board of directors that are all extroverts, who then hire an extroverted director/chief executive officer, who in turn builds an extroverted staff. This could result in an organizational structure that caters to only half of the general population, approximately 50 percent of the general public being extroverts and 50 percent introverts.

The Myers-Briggs has sixteen personality types, and a trained Myers-Briggs consultant can determine an institutional personality type. For a start-up, it is easier to diversify, as you can consciously hire to your weakness and have a blend of extroverts and introverts. If the organization's personality is made up of 80 percent extroverted individuals, it becomes important to hire introverts and pay greater attention to their input.

2. WHO DOES THE COMMUNITY THINK WE ARE?

Ask your community who you are. How do they view the existing museum? This can be conducted in the form of exit interviews. For a start-up, the question becomes, "What does the community need?" Create "town hall" meetings and ask your community to list their needs.

3. HOW DO THE TWO PERSPECTIVES COMPARE?

Now compare the two: Who you think you are and what the community needs and wants. Are they similar? This is a complex question, as one role of a museum is to elevate and enlighten, but the museum may not know what a community requires. When I moved to Orange County, California, before the science center was built, I would say that I worked at a science center (Discovery Science Center). People would not know what I was talking about. We built a preview facility and showcased informal science for the community.

4. IS WHO WE THINK WE ARE STILL WHO WE WANT TO BE?

Is your integrated museum approach aligned? "A high level of interactivity," "research-based," and "world-class" are easy phrases to say, much more diffi-

cult to deliver. Are the words you use to describe the museum actually the attributes of the museum? Are they the attributes you and the community want?

5. A DESCRIPTION OF WHO WE ARE, INCLUDING VALUES, VISION, AND CORE STRENGTHS

Having sat in several boardrooms crafting mission statements, I would say that honesty is the most important value in the process of strategic planning. Mission statements that are crafted around phrases such as "world-class" aren't going to prove useful. Leave the ego at the door and craft the "how"— how will the vision, the strategy, and the mission be delivered to your visitors to meet their needs? Then work to communicate messaging to your visitors across all media available to you (exhibit text, museum signage, logo, website, staff training, etc.).[3]

6. THE "HOW" OF THE MISSION

A good mission statement will answer the question, "How will the collection be used by the public for education and enjoyment?" Sample mission statements can be found in the Museum Toolbox.

7. TEST MISSION: IS THERE A NEED TO REVAMP THE MISSION? IS THERE SUPPORT?

Will people pay and donate money to support the proposed mission? Sit down with your potential donors and share your draft mission statement with them. Will they donate their money to support your mission as it is now structured?

8. ORGANIZATIONAL STRUCTURE (STAFFING)

Often, strategic plans get out of whack at this point. It would be great to have multiple outreach programs, but is there enough financial backing? I often find a better question is, "What are the minimal staff and volunteers we can have to support our mission?" Many museums are run with no paid staff and provide excellent educational programs. What are your minimum staffing requirements?

9. SCHEDULE TO IMPLEMENT STRATEGY
(WITH MILESTONES)

Scheduled milestones may include:

- Conducting a feasibility study: When will the museum conduct a feasibility study and decide if the project is financially viable?
- Hiring a director/chief executive officer
- Museum master planning
- Formalizing the board of directors; creating a constitution and bylaws
- Applying for nonprofit status
- Creation of a preview facility
- Locating a permanent home: Negotiating with city officials or with a landlord
- Fundraising: Create the strategy for a capital campaign
- Museum expansion: Defining the institutional impact
- Business planning: Dealing with economic realities
- Human resources: Setting or changing personnel requirements and guidelines

10. STRATEGIC GOALS (MEASURABLE)

Measurable strategic goals might include fundraising goals, community support measured in Facebook "likes," number of performed outreach programs, number of town hall meetings, and the number of board subcommittees.

A good strategic plan will answer this key question: Who is the visitor?

1. Who comes to the museum? Someone will need to make a decision to visit the museum. Why will a visitor do so?

 Museum visitors will travel to the museum by car, taxi, bus, subway, or foot to arrive at the museum's door. Why did they make the decision to visit? We each have our own internal decision-making drivers. What influences your visitors' decision to spend their time and money to visit your museum? It is often helpful to segment the types of visitors: parent, curious tourist, local mom, Sunday family, etc. Each type will have its own motivation for visiting the museum. Try to understand why each visitor makes the effort.
2. What are your areas? Every museum is divided into areas. The areas may be called galleries, zones, areas, or topics.
3. How does your museum facility support your strategy?
4. Does your present collection support your strategy? How do you need to change your collection to meet the strategic plan?

Conducting a strategic plan in isolation without a museum planning process is far less valuable than having both the museum planning and strategic planning process happen simultaneously. Museum planning is creating the "program" for the museum. A museum planning program will determine answers to questions such as, "How many parking spots do we need?" "How many bathrooms will we need?" and "What are the electrical requirements of the building?" Each of these questions requires description of the objectives, functions, and operation of the museum.

During a strategic planning meeting, many words are used. People can get caught up in words rather than the more important culture and experience of the museum. As previously mentioned, "world-class" is a description too frequently used during strategic planning. The issue is that one person's "world-class' may be the Mattress Factory[4] museum of contemporary art in Pittsburgh while another's is the Orange County Museum of Art.[5] There is not a right or wrong, because they are very different types of contemporary art museums.

I often suggest that a board of directors visit, as a group, at least ten museums of the type they are planning. It is very helpful to visit together and to have an outside advisor keeping record of thoughts and reactions. I have found that much more is learned from these group trips than can ever be learned from sitting in a room discussing words. *Stimulating, fun, educational, engaging, quality*—these are only words. It is the museum's staff and consultants who deliver on these words. Remember you are creating a culture, not a museum. The museum's staff are members of that culture. They create experiences for the public. These people and experiences are more important than the words used to describe them.

Strategic planning and museum planning need to be linked rather than performed at different levels. To have meaning, descriptive words such *stimulating, fun, educational, engaging,* and *quality* need to describe qualities that will be delivered to visitors.

I was hired to prepare a strategic plan for a science center. During our second day of the workshop discussing vision, it became apparent that there was a split within the board of directors. Half the board envisioned a marble, gothic science center in the style of the American Museum of Natural History. The other half envisioned an early Exploratorium with creative, low-tech exhibits built of plywood. During the meeting, the largest donor got up and left the workshop, threatening to cease donating to the science center. As uncomfortable as the meeting was, this was a turning point in the process. The resulting science center was built as a compromise, in the mold of Liberty Science Center in New Jersey or Columbus, Ohio's Center of Science and Industry. Neither side got their way, and the major donor

stayed on the board and continued to donate. The words in the strategic plan were far less valuable than the conversation at the strategic planning workshop. The truthfulness and honesty of the participants in the process will determine the success of the strategic planning process. In many ways, a strategic plan is an artifact of the many conversations that occur between board members, staff, and community.

NOTES

1. http://www.landrysinc.com/concepts/signatureGroup/oceanaire.asp.
2. http://www.landrysinc.com/concepts/restaurants/bubbagump.asp.
3. Parts of this chapter first appeared in a blog post: http://museumplanner.org/museum-strategic-planning/.
4. http://www.mattress.org/.
5. http://www.ocma.net/.

Part III

EXHIBITIONS

Chapter Eight

Collections

A museum is entrusted with the care and protection of its collection in perpetuity for the education and enjoyment of this generation and future generations of visitors. "Museum quality" is a layman's term for "best of the best," and museums are collections of collections. One goal is that every object in the collection should be the most significant of its kind. Different types of museums hold different types of collection. Let's do a brief, general summary.

Collecting museums:

Art museum: Art of one or many time periods or styles; the art of one artist or school of artists

History museum: Objects of historical significance of a specific time period, person, or event

Natural history museum: Objects of nature, including models of animals, plants, and human inhabitants of a geographic region or time period

Science museum: Objects related to scientific principles, historic and/or contemporary

Children's museum: Art objects and other objects, exhibits used for the education of children

Zoo: A living collection of animals

Botanic garden: A living collection of plants

Aquarium: A living collection fish and other aquatic creatures

Noncollecting museums:

Science center: Interactive educational science experiments (exhibits). Often science centers have small collections, but they are typically noncollecting institutions.

Art center: A nonprofit gallery for the display of the work of artists. Art centers often have small collections, but typically are not collecting institutions. The purpose of an art center is to serve as a venue for bringing art to a community. Art centers are typically not tasked with archiving art or objects.

Visitor center: An institution that educates the public about a specific geographic region, historic event, or person of note. Visitor centers often have small collections for the purpose of interpretation.

The institutional goals of collecting museums and noncollecting institutions are different. A collecting museum has a mission to collect, preserve, and display art and objects of aesthetic, historic, or scientific importance. A noncollecting institution has a mission to educate the public about a specific time period, artist or historical figure, or historic or scientific event.

For a noncollecting institution, the objects on display illuminate the educational content. For the purpose of this book, we will consider collecting and noncollecting institutions as museums.

The three core elements of a museum are mission, collections, and hospitality. These three elements work in unison to create the visitor experience.

A favorite museum of mine is The Noguchi Museum in Queens, New York. Here are the first two paragraphs of their mission statement:

> The Isamu Noguchi Foundation and Garden Museum is devoted to the preservation, documentation, presentation, and interpretation of the work of Isamu Noguchi. The Museum, the first in America established by a living artist of his own work, contains the world's richest holdings of Noguchi's art.
>
> The Museum seeks to honor and preserve the unique setting designed by Noguchi and to exhibit a core group of works for permanent viewing. Through changing exhibitions and educational programs, the Museum aims to illuminate the interrelation of his sculpture, works on paper, architecture, and designs for furniture, lighting, landscapes, and theater, as well as the intellectual environment in which the works were shaped.[1]

The Noguchi Museum's mission statement clearly describes how the museum will fulfill its mission. The mission statement describes the museum's responsibility for the collection: "preservation, documentation, presentation, and interpretation of the work of Isamu Noguchi." The statement clearly defines the purpose of the collection. The mission statement says the museums wishes to "honor and preserve the unique setting designed by Noguchi." The museum building itself is an important part of the museum, helping to interpret Mr. Noguchi's artistic process.

The Noguchi Museum is a prime example of the three core elements of a museum being put into practice in harmony. Mission: "the preservation, documentation, presentation, and interpretation." Collection: "preserve the unique setting designed by Noguchi . . . sculpture, works on paper, architecture, and designs for furniture, lighting, landscapes, and theater." And hospitality: "to honor . . . the intellectual environment in which the works were shaped."

What makes The Noguchi Museum so special is how visitors gain an understanding of the unique personality of Mr. Noguchi, and how they can imagine him as their personal host in his studio.

The Children's Museum of Manhattan put on a wonderful exhibition in 1998 called *Great Stuff*.[2] The exhibition was a series of kids' collections. Each exhibit included information about the collectors, their collections, and statements from the collectors explaining their reasons for assembling their collection. All of us maintain a collection of a sort: our clothing, our cooking utensils, or our furniture are examples among many. A vision and the intention of the collector elevate a collection above the pedestrian.

The Dorothy and Herbert Vogel Collection of the National Gallery of Art[3] is considered one of the world's finest collections of minimal and conceptual art. Mrs. and Mr. Vogel, who were state employees in New York—a librarian and a postal clerk—earned less than fifty thousand dollars per year,[4] yet the couple collected over four thousand works of art. They stored the art collection in their one-bedroom New York City apartment. Their determination, timing, and vision are mythic in the art world. They became friends with the artists they collected. They understood the importance of the art before prices went beyond their economic reach. The Dorothy and Herbert Vogel Collection of the National Gallery of Art also includes "Vogel 50 × 50," featuring 2,500 pieces from their collection, displayed at fifty museums in fifty states.[5]

When the collection was first gifted to the National Gallery of Art, several of the pieces were displayed in the 1994 exhibition *From Minimal to Conceptual Art: Works from the Dorothy and Herbert Vogel Collection*.[6] Individual pieces of the collection have been included in many other exhibitions since.

The Vogels had the vision to appreciate the cultural significance of minimal and conceptual art, and were able to assemble a representative collection of some of the most significant pieces. The Vogels' collection is greater than the sum of the individual pieces. The curators at the National Gallery of Art can now create exhibitions by selecting pieces from the Vogel collection along with pieces from other collections, thus creating new exhibitions. The individual pieces of the collection are also available for loan to qualifying museums.

Museums are collections of smaller collections that support the museum's mission. Curators, researchers, and exhibition developers create exhibitions from the museum's collection, often augmenting the museum's permanent collection with art and objects on loan from other museums and lenders.

Within a museum, there are many hierarchies of art and objects. An art piece, object, or artifact is an individual piece. A group of objects may be grouped together based on the artist, artistic period, or historic event. A collection is a grouping of the art or objects according to the vision of a collector, or in some cases, the vision of a museum curator. A museum's mission defines how the museum will collect a body of work and present the collection to the public.

During his artistic career, Alexander Calder went through many different artistic periods and used many different methods of creating art. Calder made jewelry, paintings, sculptures, and prints, among other artistic pursuits. A single piece of Calder's jewelry may be considered one of the best among his many styles of jewelry.[7] That piece of jewelry may be considered by curators and researchers to be one of specific stylistic or historic significance. A collector may own several pieces of the same type, loaning the objects to an exhibition, such as the Norton Museum of Art's excellent *Calder Jewelry* exhibition. The traveling exhibition contains 1,800 pieces of Calder jewelry borrowed from several museums and private collections. Being able to view many different pieces of one artist at one time allows visitors to appreciate the vision of the artist.

By viewing several of the pieces from the same time period and style, a viewer can often gain greater insight than by viewing only a single object, however significant. A collector or museum may own a collection of many pieces of jewelry of a larger time range and styles. The visitor may also gain greater understanding by viewing the progression of an artist's work and career.

What makes one object more significant than another? It might be aesthetic merit, historic significance, rareness, or scientific importance. Objects that are purchased, donated, or lent to the museum are displayed by artist or maker, time period, or type. The board of directors makes a strategic decision by defining the museum's areas of concentration. The museum staff pursues objects for the museum's collection by donations, purchase, or loan to fulfill that area of concentration and meet the museum's mission.

NOTES

1. Isamu Noguchi Foundation and Garden Museum, accessed May 15, 2014, http://www.noguchi.org/museum/mission.

2. Children's Museum of Manhattan, "Great Stuff" (1998), http://www.nytimes.com/1998/11/26/garden/children-who-collect-a-world-of-their-own.html.

3. National Gallery of Art, The Dorothy and Herbert Vogel Collection: Fifty Works for Fifty States, accessed May 15, 2014, http://www.nga.gov/content/ngaweb/press/2008/2008-vogel50x50.html.

4. "The Prom Queen of P.S. 1." (2013). http://www.newyorker.com/online/blogs/culture/2013/03/the-prom-queen-of-ps-1.html. Website accessed March 16, 2015.

5. "Vogel 50 × 50," accessed May 15, 2014, http://vogel5050.org/.

6. National Gallery of Art, Vogel 50 × 50, accessed May 15, 2014, http://www.nga.gov/content/ngaweb/press/2008/2008-vogel50x50.html.

7. "Calder's Precious Metals: Who Needs Diamonds?" http://www.nytimes.com/2008/12/12/arts/design/12cald.html. Website accessed March 16, 2015.

Chapter Nine

The Museum Building

A museum is not a building. A museum is an ideal without walls. A museum building only houses the museum's collection for the education and enjoyment of museum visitors. Often people confuse the museum building with the museum itself. The museum is found in its mission, culture, and purpose. Museum buildings are simply physical spaces where organizational mission is carried out.

The "how" and "what" of the museum's mission need to be clearly defined before you can design the systems of the museum building. This is often a push-pull process. It might be wonderful, for example, to incorporate an artist-in-residence program as part of a museum facility. The program may meet mission and may even energize the museum experience for the visitor. But in planning the museum building, it is necessary to ask whether an artist-in-residence program is essential to the museum. Such questions can be difficult.

For the purpose of this discussion, let's assume that the museum is a start-up and is beginning the museum planning process. At this stage, I recommend setting up a set of filters: must-have, nice-to-have, can-do-without, phase II, etc. These will help determine priorities in developing the museum building program. Before the development of a new museum building, the museum will need a mission statement, an established board of directors, a definition of the museum's integrated museum approach, a clear understanding of potential or current audience, and a potential budget for the museum facility. If the museum does not have all of those key criteria, the group is not ready for the museum planning process.

The museum mission statement becomes a guide to the museum planning process. The museum staff and volunteers will be tasked with how to implement the mission.

Here is the mission statement from Big Car of Indianapolis (a favorite art center of mine). Big Car describes itself as "an adaptive and flexible cultural organization" and "a creative community builder working to boost urban livability."

> Big Car brings art to people and people to art, sparking creativity in lives to transform communities.[1]

There are many ways this mission statement can be read. It is open-ended enough to allow for interpretation, but specific enough to guide the activities of the Big Car staff.

As part of the museum planning process, a board of directors might set up a full-day retreat with stakeholders (it's great to include a board member who is a building contractor), an artist, or a scientist. Part of the retreat should include time to create a list of all the functions the museum might contain. Don't turn down any ideas at this point; this is a blue sky (optimistic) list of every function the museum might perform. Try to capture all of the museum's possible functions. Examples might include the following:

- Outdoor sculpture garden
- Adjacent bus stop
- Area for picnics
- High-end café
- Artists-in-residence program
- Art continuing education
- Artist's retail sales
- Exhibit fabrication
- Art conservation
- Art research
- Science research
- Satellite locations

Try not to let budget restrict the thinking. As long as the suggestions are in keeping with mission, capture the ideas. The more typical functions of galleries, lobby, ticketing, art storage, offices, boardroom, meeting rooms, and programming space will also be added to the list. The list of possible museum functions can be valuable in creating the museum building program.

Set up a follow-up meeting and present all of the functions as a list. Use your list of filters to divide all of the activities into each category. Then start to review all of the items in the "must-have" category in terms of mission. For example, I don't believe an art conservation lab would be a "must-have" for an art center like Big Car.

I often find it better to exclude architects from these planning meetings that determine the "how" and "what" of the museum. The functions of the museum should not be limited by architecture. Continue these meetings, slowly letting the reality of budget enter the conversation, but continue to think of how to solve problems creatively.

In the planning of Discovery Science Center, we decided to move the ticketing outdoors. We realized that it was a better visitor experience to separate the purchase of the ticket from the experience of crossing of the science center's threshold. We reasoned that once visitors entered the science center, they should be able to leave the outside world behind. It was less expensive to build a small outdoor ticket booth, and it provided the "threshold experience" that the project team desired. During your meetings, capture exactly these types of comments and thinking.

Museums are about local communities. Recommend, whenever possible, local architects. Museums live and die by acceptance and use by local community. Only after the community accepts the museum can it expand its influence to become a destination. A local architect already understands the local community and is more vested in the success of the project. I am not a fan of "starchitects." Using a world-renowned architect is not a guarantee of success. Of the projects I have been involved with, the use of "world-class" architects often comes with problems of its own.

I love the Guggenheim Bilbao building by starchitect Frank Gehry. But I do not believe that the Guggenheim Bilbao is a great *museum* building. The museum is not aligned with its building. I traveled to Bilbao for the opening of the museum. I fervently took photos of the exterior, only to be disappointed when I entered. I remember standing in the first-floor gallery, viewing a Frank Stella painting so large that the gallery could barely contain it. No matter where I looked, the building got in the way of the art. The J. Paul Getty Museum is a breathtaking structure overlooking Los Angles, but I find the galleries somehow disconnected from the art inside them. Simple, flexible museum buildings often make the best containers for a museum.

I have mentioned the old Exploratorium. I loved the old open and flexible floor plan. The second floor offered a vista of an entire exhibition. At the new Exploratorium, visitors enter in the center of the building. I find it confusing. On my last visit, I walked left as I entered the building only to wonder as I was leaving if I had already seen the exhibits to the right of the entrance. The old Exploratorium was perfectly aligned with the Exploratorium's brand of letting visitors make science their own.

Such feelings are very important to the museum planning process. "Provide a vista to let visitors orient themselves" is an example of a museum

program goal. I have been part of many visitor interviews prior to museum construction and several comments are often repeated:

• "I like to be able to see the entire museum from the entrance lobby; it helps me to plan my visit."
• "I like to be able to see the entire gallery from the entrance." Parents often repeat this comment. Most parents like to be able to walk a gallery with their kids and not feel as though kids might get lost or wander out of sight.
• "I like that the exterior gave me an idea of what I will be doing inside the museum." The exterior of a museum is the "museum's face."

Often, the most complex part of a museum master plan is defining the activities of the museum before starting the building program (a building program is a document that outlines the requirements of the building). The Museum Toolbox contains a museum planning checklist and sample museum planning documents. I find it helpful to list the functions of the museum and the blue-sky thinking before trying to tightly define the museum's architectural program. Many questions must be answered before deciding upon the facility's details. These questions include the following:

• Will the museum be a collecting institution or a noncollecting institution?
• Will new exhibitions be curated in-house or will the museum use guest curators?
• Will new exhibitions be designed in-house or designed and built by outside contractors?
• How will the museum drive attendance?
• Is this the first phase of a multiphase building plan?
• Will the museum conduct significant research and conservation by museum staff?
• How will the museum accommodate specific audiences such as pregnant women, nonsighted visitors, seniors, school groups, and visitors with autism? Each of these groups has specific needs.

While some of these decisions will have been made during museum strategic planning and during the museum feasibility study phase, often the specifics of each decision need to be reviewed.

The group responsible for museum planning now has a list of functions for the museum that roughly meet a budget (good reason to have that building contractor board member included). The group should also have a rough description of how the museum functions will be performed. From this document, you will have a better idea of all the building needs based on function. Before interviewing architects, consider hiring a museum planner to review your plans

and turn your ideas into a building program. Museum planners think about activities; architects tend to think about architectural space. Both are needed.

Speak to other local museums. Speak to local libraries, local churches, and community centers to ask for recommendations of architects. Visit the architect's buildings and select four to six local architects to interview. Interview each of the architects onsite where the building will be built. I often like to step back and let the building contractor lead the conversations with the architect. Ask lots of questions of the architect:

- What do you think of the building site?
- How is this project similar to your other projects?
- Do you have experience with museum projects?
- Do you or your consultants have experience with museum climate control systems? Museum lighting systems?

Select three or four of the architectural firms to prepare a preliminary design. Offer a modest fee in exchange for their work. Their designs will be the property of the museum. Have the architects develop a preliminary floor plan using the work of the museum planner as the basis.

A board subcommittee should oversee planning, design, and construction of the museum building. Strategic planners, museum planners, and architects frequently make decisions that directly affect the museum's operations and culture. These decisions are handed down to staff who had no part in the creation of the museum. The consultants have moved on to other projects and the museum's staff is left with trying to create a culture within a structure that they did not help design.

A good practice is to have the board of directors establish the building subcommittee. Subcommittee members should work directly with museum staff to plan, design, and facilitate the museum building. Although the process of including board members and staff takes longer than handing over the responsibility to architects, this approach consistently saves money and always produces a better visitor experience.

Next we will cover museum exhibition design and fabrication. It is important that museum exhibition design happen simultaneously with the architectural design to assure that any specific requirements of the exhibitions can be incorporated into the museum's architecture.

NOTE

1. Big Car, Indianapolis, Indiana, accessed May 10, 2014, http://www.bigcar.org/aboutus/.

Chapter Ten

Museum Exhibition Development/Curation

Often, curators and exhibition developers work together using a museum's collection as the basis of research for the development of a new exhibition. The roles of curator, exhibition developer, and researcher are closely connected.

It might be easier to understand museum exhibition development within the larger context of museums. Museums can be categorized by discipline: art museums, history museums, natural history museums, children's museums, science museums, science centers, aquariums, botanic gardens, and zoos. For each of the disciplines, the museum collects objects, including art and artifacts. The museum's public space is comprised of an exhibition gallery or galleries. Many museums have only one gallery. For museums with more than one gallery, the museum's director/chief executive officer or its board of directors decides on the best approach to display the museum's collection by gallery. Museum galleries might be organized by topic, time period, artist, artistic movement, or region. Galleries can be changing galleries or permanent galleries. A permanent gallery might be organized and left exactly in the same design for the life of the museum. One example of this *very* permanent gallery, specified in the founder's will, would be the Isabella Stewart Gardner Museum in Boston, Massachusetts.[1]

Some changing galleries may have exhibitions installed for a period of two to five years; other galleries might be specified for traveling exhibitions to be rented from other museums on a more frequent basis. Still others may house exhibitions designed by the museum's staff or by exhibition contractors, and displayed for a period of three to six months. The permanence of the exhibition is a deciding factor in the process of exhibition development, design, and fabrication. For the purposes of this discussion, we will use the term "exhibit" to describe one freestanding display; an "exhibition" will refer to a grouping of exhibits.

HIERARCHY

A best practice of museums is to work with a "hierarchy of content." It is important to create a threshold to the museum experience and to each exhibition gallery. Many museums are organized in this way:

> Museum entrance
> Ticketing, café, restrooms, coat-check
> "Threshold"
> Orientation to the museum
> Orientation to the museum's galleries
> Individual galleries

It is considered a best practice to orient the visitor to the overall museum and the galleries. An example would be Museo Tolerancia y Memoria[2] in Mexico City, Mexico. Once visitors have bought their tickets, checked their coats, and had a chance to gather together, they take an elevator to the second floor. Here they meet a museum staff person at a sliding door. Visitors are allowed to enter the first gallery every six minutes. The staff person opens the sliding doors to a theater in the round. The theater-entry gallery orients visitors to the museum experience, the galleries they will visit next, and the main topic presented, the Holocaust. Museo Tolerancia y Memoria is a "linear experience," as there is only one way for visitors to travel through the museum.

Other museums such as the Children's Museum of Indianapolis, Indiana,[3] have a nonlinear approach. Visitors buy their tickets, check their belongings, and gather in the atrium. An advantage of a main atrium is that visitors can see all of the floors of the museum and can orient themselves before they start their visit. At the Children's Museum of Indianapolis, the galleries are organized by age of the visitor. From the atrium, families can plan their visit to the age-appropriate galleries.

Each gallery of a museum is designed as part of the overall visitor experience. Signage is the primary tool for most museums to communicate with visitors. I am a strong believer in creating a hierarchy of signage. Here is an example:

> On the exterior of the museum, "Museum Name"
> After lobby, orientation to the museum
> Orientation to museum galleries
> Gallery title
> Exhibition title
> Content area title
> Exhibit title
> Object label

A Disney Imagineer once told me that Walt Disney used to say, "Tell them what they are going to see, what they are seeing and what they have seen." Museum signage should follow the same philosophy. Let visitors decide what they will see, tell them what they are currently viewing, then help them understand how the previous experience fits within the overall museum experience.

Most often, how the museum galleries are organized is a decision made at the board-of-director level with input from museum staff. The museum's galleries are like "chapters" that together tell the story of the museum's collection and deliver the museum's mission.

WHAT COMES FIRST?

The idea for an exhibition can come from anywhere. The idea for the exhibition might be a single artwork as the "seed" of the exhibition or the exhibition might have specific educational objectives. I often recommend starting with "lens," "voice," and framework for the exhibition. Museums are objective venues, but selecting the "most important" art, historic event, or scientific theory is subjective. Before starting, decide upon the lens: From what "angle" does the visitor view the content? Then the "voice" of the content: Who is speaking to the visitor? And then the framework for the content: How is the content built to deliver the overall message (this is the top level of the content hierarchy)?

I had an interesting experience at the Vietnam Military History Museum in Hanoi, Vietnam. The museum tells the history of the Vietnam War from the Vietnamese perspective. It was very interesting to read the graphics and understand the history of the war from that perspective. Of course, the Vietnamese perspective—a triumphant, heroic victory against a powerful foreign invader—is different from the American perspective. I was very interested in understanding the Vietnamese museum's "lens."

This subjective perspective is your lens. Often, it is helpful to understand the different lenses before selecting one for an exhibition. It is not realistic to imagine there is a completely objective lens. It is better to understand the different possible views of content and then select the best approach to that content.

"Voice" is how you speak with the visitor. In developing an exhibition, are you communicating as a teacher? As an historian? As a participant? It is important to establish an effective voice of the exhibition.

Define the boundaries of the content. What content will be included in the exhibition and what content is outside the scope of this exhibition? Next, start

to create your framework. Often the content milestones are referred to as the scaffolding of your framework. It is a helpful metaphor. What is the specific content needed to build a strong framework for the exhibition?

Sometimes, an exhibit is completed by an exhibition developer who writes the exhibition script (an outline of the exhibition content), defines the educational objectives, and writes the text for the graphics. A curator is brought in to help with selection of specific art or artifacts. Sometimes the process is the opposite: a curator selects art to support a specific message of an exhibition. The curator writes the exhibition catalog and the graphics, and an educator is brought in to develop educational programs. Most often a curator (or historian or scientist) is a person with knowledge of the art (or history or science). An exhibition developer is a person more familiar with education and can apply educational methods to different topics.

As a general guideline, here are the steps of exhibition development:

1. Exhibition idea
2. Exhibition description: topic, description, content outline, possible art, artifacts or objects; schedule; educational objectives
3. Front-end evaluation
4. Exhibition development
5. Formative evaluation
6. Prototyping and testing of graphics and interactive exhibits
7. Exhibition design
8. Remedial
9. Summative evaluation

An interesting new development has been crowd curation, such as "Click! A Crowd-Curated Exhibition"[4] at the Brooklyn Museum in New York City. The results are mixed when viewing the "most discussed."[5] For me, the exhibition serves as a reminder of the importance of exhibition development and curation. Museum exhibitions are not popularity contests. Often, crowd curation results in a populist view instead of the museum leading the dialogue.

Exhibitions are a form of communication between the museum and the visitor. Exhibition development and curation are parts of the process of defining the scope of the exhibition content and crafting the messages of the exhibition to meet the museum's mission and the exhibition's objectives. Throughout the process, the visitor is central. An exhibition developer or curator can do a wonderful job writing text panels and installing artwork. But the objective of all exhibitions is to communicate something of importance to the visitor.

NOTES

1. http://www.gardnermuseum.org/about/history_and_architecture.

2. http://www.myt.org.mx/.

3. http://www.childrensmuseum.org/.

4. Johnson, Ken, (2008), "3,344 people may not know art but know what they like." http://www.nytimes.com/2008/07/04/arts/design/04clic.html.

5. http://www.brooklynmuseum.org/exhibitions/click/top_discussed.php.

Chapter Eleven

Exhibition Design and Fabrication

Museum exhibition design and fabrication happen as a collaborative process. A proposed exhibition needs to fit into the overall plans of supporting mission, museum finances, fundraising, operations, and marketing. Whether it is a new exhibition at an existing museum or a first exhibition at a new museum yet to be opened, the overall process is the same.

The museum exhibition design and fabrication process is a balancing act. Museums will often plan two or more years in advance to prepare for a new exhibition. There are several key decisions to be made at the outset. Is the purpose of the exhibition to drive attendance or support mission (these are not mutually exclusive)? Will the exhibition be produced internally or externally? Does the internal staff have the capacity to undertake the exhibition project?

Often, the executive team of the museum will set up a full-day retreat to review the exhibition schedule. A typical meeting at a mid-size or larger museum might include the executive director, director of exhibitions, the director of marketing, the director of education, a board member, and a curator. Sometimes the meeting will include a "visitor advocate"—a student, a junior museum staff member, or an appointed staff person. The most successful meetings begin with the discussion of a known budget for the year, a schedule of other activities happening in the museum, and a mandate for "vision" goals for the upcoming year.

This is how a hypothetical exhibition planning meeting might unfold: the director of exhibitions or the executive director puts large sheets of paper up on the wall and draws lines representing the museum's first floor, second floor, third floor, etc., and the names of each gallery. The director starts with scheduling. What are the other activities going on in the building at the same time? Based on that information, the group determines the best times for moving new exhibits or artifacts into the building. The group knows that a

specific type of exhibition will drive attendance. It also knows that in certain months attendance is slow. So the attendance driving exhibition is slotted for a weak attendance period. Next, the director of education speaks up and discusses a mission-driven exhibition. Sometimes mission-driven exhibits do not drive attendance, so the question becomes: How do we pay for this mission-driven exhibition? This question is left to the executive director, the board of directors, and the development department. They will begin to court potential donors and lenders.

In the best museums, this process of exhibition planning is repeated every month or two, as new plans for the museum are discussed and reviewed and schedules, budgets, and marketing plans are modified.

Once an overall schedule is set, an evaluator is tasked with surveying visitors about the exhibition topic. What is the general public's understanding of the topic? Are the museum's visitors interested in the topic? If there seems to be general interest in the exhibition topic, the process moves to the next step, an exhibition description.

The exhibition design process can be divided into ten steps:

1. Exhibition script. Usually a curator or education staff will be tasked with creating an exhibition script that answers several questions. What is the story of the exhibition? How do the artifacts/art tell the story? What object or exhibit is the highlight of the entire exhibition? If you were to imagine the artifacts/art objects as characters in a play, what role would each play? The writer of the exhibition script will describe each scene of the exhibition. "A gray, rainy day walking the Great Wall of China" goes a long way to describing the look and feel of an exhibition. The educational goals are also listed here, and it is determined how the goals of the exhibition will be met.
2. "Chunk it out." With the script in hand, the curator, exhibition designer, and educator will walk the gallery where the exhibition will be mounted. In very general terms, the group will "chunk out" the story—tell each part. Often the exhibit designer will start with a bubble diagram (see sample in the Museum Toolbox), creating circles representing each area of the exhibition and an approximate size. Then there is a bit of push-pull between the designer, curator, and educator. They discuss the relative size of each area of the exhibition. Often, the exhibition designer is speaking for the visual impact as a priority. The curator will speak for the research or specific content represented by an exhibit or art piece. And the educator is often representing the interests of the visitors and visitor groups, such as school children. Together, these three staff members will update the script once a "bubble diagram" is agreed upon. The newly revised script

will describe how each area of the exhibition will look and feel, and will identify potential exhibits and the objects to be shown.

3. Research. A research team will go on field trips to places similar to the areas of the exhibition. For example, in an exhibit titled "Take Me There: Egypt," our research team went to Egypt to visit the sites of the areas of the exhibition. We took video and photos and documented all of the sites, taking measurements and notes. A research team may also consider new technologies and techniques, and determine which might be incorporated into the exhibition.

4. Conceptual design. Now that the areas of the exhibition are defined, the components of each area are identified and chosen. The curator now starts to work with a registrar to review potential items in the museum's collection or potential pieces for loan. Together, the exhibition designer, curator, educator, and registrar will start a database of the art and artifacts to be included in the exhibition.

5. Schematic design. The goal of schematic design is to flesh out the scope and character of the project. This enables all parties involved to confirm themes and interpretation goals, and to review spatial arrangements, appearance, artifact use, materials, and cost. Up to this point, there has been a lot of "hand waving" to describe the exhibition as part of the general discussion. Now specific team members will become project managers. The role of the project manager is to keep to the stated budget and schedule. It sometimes happens that at this point an exhibition dies: the team realizes that the real exhibition costs are out of reach for the allotted budget.

By the end of the schematic design phase, the team will have visuals, a narrative, look-and-feel boards, and layouts to review the allocation of space, traffic flow, audiovisual components, interactive displays, lighting, and special effects. An overall graphic identity for the exhibit will be set.

In the Museum Toolbox, you will find checklists for the following:

- A plan for meeting requirements of the Americans with Disabilities Act
- A plan for creating a green exhibition
- A sample museum exhibition project charter
- A sample exhibition budget
- A sample exhibition schedule

6. Design development/media. During design development, section and elevation drawings of exhibits in the space are created. Content research is compiled into draft text along with descriptions of the exhibits and the interactives. The functions of audiovisuals and computer programs will be described in a storyboard. The family of graphic elements is compiled, and a schedule of all the graphics is created. Directional and identification

signage for interior and exterior spaces of the exhibit area now become part of the program.

7. Final design. By the conclusion of the final design phase, a complete package is created that illustrates the full exhibit design—how it will be built, where every component is located, and how each exhibit component works within the larger space. The final design package includes exhibition identification, exhibition descriptions, a database of exhibit components, measured computer-assisted design plans with content, floor plans, elevations, artifact lists, measured graphic design elements and samples, draft scripts with details for audiovisual components, interactive exhibits, final text, sound and lighting systems specifications, production schedules, and a fabrication cost estimate. By the end of final design, a list of arti facts/art is determined. Team members start to plan for mounts for objects, conservation needs for paper and fabric, light levels, and other conservation needs. The registrar and curator have located and made arrangements for any objects needed for loan, and the costs of the loans are included in the exhibition budget.

8. Partners. Potential fabricators and suppliers have been identified during the design development phase. Now the conversation becomes more serious and fabricators are invited to submit proposals. Often both internal teams and external teams will create a cost estimate for exhibition fabrication. Then the executive team can decide whether to fabricate the exhibition using internal staff or external contractors or a combination of the two. Either the fabrication partner will complete the construction documents or the construction documents will be completed by the design team.

9. Construction documents (also called contract documents). Construction documents are different from final design, as these drawings are usually drawn by the group that will build the components. Construction drawings will specify material suppliers, list the specifications of every exhibition component, and detail how the exhibits will be built. Often this part of the process is referred to as "detailing," as literally every nut, screw, and fastener is identified and specified. As parts of the exhibits become more fully specified, cost differences are often identified; this part of the process is called "value engineering." As more of an exhibition project is specified, cost differences are identified and the project manager, designer, and fabricator negotiate differences in materials, equipment, and techniques. For example, a specific laminate specified by the designer might be out of stock locally and the only option is to have the laminate shipped across country. Either the designer feels that only that laminate will work and the project manager will need to find cost savings elsewhere in the project, or the designer can specify a similar laminate as replacement. When the

construction documents are finalized, the client will be asked to sign an agreement to proceed with fabrication. The drawings now become contract documents. If there is a disagreement among the client, the fabricator, and the designer, the drawings serve as the deciding tool.

10. Prototyping/testing. The team can test and prototype interactive exhibits with the public during each phase of design. For example, during conceptual design, blue tape is placed on the floor to define approximate areas. During schematic design, cardboard mock-ups are made. During design development, PowerPoint presentations describe the media to be used. And during final design, functioning interactive exhibits can be tested for button layout and ergonomics.

In the Museum Toolbox, you will find the following:

• Samples of each phase of design
• A traveling exhibitions checklist
• Science center exhibition design checklist

The steps of the exhibition design process are similar for art museums, natural history museums, science centers, and children's museums. The differences are in the content development; the design process is the same.

Museums are public forums of communication and exhibitions are the method of communicating. Every exhibition is a collaborative effort of a team comprised of staff members of the museum. The exhibition is the means by which the museum speaks with its visitors.

Chapter Twelve

Museum Programming: Education

Exhibitions, museum programs, websites, outreach programs, museum theater productions, lectures, and museum-organized travel are all forms of communication that museums use. With each of these tools, museums communicate the content of their mission. Museum programs include gallery tours, organized activities, and demonstrations. Museum programming, curation, research, and exhibitions work together to create the educational experience for the visitor.

Creating visitor experiences is a process often divided between "back of house" (research, curation, design, and fabrication) and "front of house" (exhibitions, on-the-floor programming, lectures, demonstrations, and school trips). Museum staff spend hours researching, developing, and practicing delivery methods of content before it reaches the exhibition floor. Similar to a theatrical production, the backstage is kept separate from the visitor experience.

Museum programming is where the stage's backdrop is removed so the visitor can see behind the scenes and ask questions. In some museums, the education department is called the programming department. This department is tasked with developing and presenting educational programs. Museum education is similar in all museum types; the differences are related to content and presentation methods. The structure of museum education or programming departments is also similar between types of museums.

The typical roles in museum education include the following:

Director of education: Often someone with a Ph.D. in education, art, science, or history. The director of education is tasked with the oversight of educational content across all of the museum's communication channels, including exhibitions, programs, and online content. This person may or

may not be an expert in content; his or her role is to assure that content is accurate, factual, and current. This person also serves as a visitor advocate, assuring that various learning styles and the needs of different museum audiences are met. The director of education is tasked with determining how content is delivered. This position also works with local schools to assure that the museum's content is consistent with school curricula and standards (in the Museum Toolbox are links to the current science and educational standards of the United States).

Researcher: Often someone holding a Ph.D. in art, science, or history with a special area of concentration, such as being an expert on Abraham Lincoln, hissing cockroaches, or the art of Paul Klee. Although they have a special area of expertise, museum researchers often also have a breadth of knowledge in art, science, or history.

Curator: A museum curator has knowledge and experience writing on a specific artist, art period, history period, or area of science. Although they have a concentration in a specific area, they are selected as staff for their ability to clearly communicate content in written and oral form.

Exhibit developer: Most often, exhibit developers have a background in industrial design or education; they work in partnership with an exhibition designer, the curator, and researcher. The exhibit developer is tasked with creating educational content and deciding if the content will be delivered via interactive exhibit, static display, program, or online game. Exhibit developers work with exhibition and program evaluators to conduct evaluations.

Demonstrator: Most often hired by history museums, science centers, zoos, and aquariums, demonstrators present theatrical demonstrations of historical facts, science concepts, or animal or plant programs. Demonstrators often have a theatrical background and are able to attract visitors to programs and interact with an audience for up to an hour-long presentation.

Docent: Most often a trained volunteer who provides a guided tour of galleries, offering an in-depth lecture and discussion of art or artifacts.

Museum floor staff: At history museums, zoos, aquariums, science centers, and natural history museums, floor staff work in a gallery as interpreters. They interact with the public to answer questions and create discussions on the content of a gallery.

At larger museums, each of the above roles may be an individual staff member. At small or medium-size museums, the roles may be taken by a volunteer or contractor. Each role is equally important. At smaller museums, one person may fulfill almost all of the roles.

I am a fan of the work of the Yuma Territorial Prison State Historic Park in Arizona. It is one of three venues managed by a staff of only eight employees.[1] The executive director fundraises, writes marketing materials, and manages the development of new projects, whereas a single employee curates exhibitions, designs exhibitions, and trains staff. These two staff members manage all new projects at three museum venues. They stop at nothing to accomplish new projects, and they rely on a core team of volunteers and consultants. I have worked with them; they are a model of how much a small museum staff can accomplish with limited resources.

Although a museum staff may have an expertise in one area, generalists are able to handle tasks in a wide range of areas. I have watched as museum staff go from greeting board members to delivering programs, while other museum staff unload a truck and staff the wine bar at a fundraising event. These are the types of people museum founders and boards of directors look for: tireless workers who can easily and happily move from role to role. Often these people come from a theater background and understand that the show must go on despite the obstacles. All staff need to do whatever is necessary to provide an excellent visitor experience.

MUSEUM PROGRAM TYPES

Docent tour: Trained museum staff member or a volunteer provides guided tours of a museum's collection or an exhibition.

Education program: A group activity centered on the content of an exhibition.

Group interactive exhibit: An educational tool that requires a group of visitors to interact; can be didactic, with only one outcome or open-ended with multiple possible outcomes.

Online activity: Exercises that can be performed before or after a museum visit to help visitors engage with an exhibition's content.

Museum theater: Theatrical productions created as a narrative of the content to augment an exhibition.

Demonstration: Museum staff members perform an experiment that includes participation by the visitor.

In the interest of clarity, I believe it is important to make a distinction between title graphic, interpretation, narrative, theme, and technology. Let's use a painting as an example: The title graphic next to the painting will contain the artist's name, date of birth and death, the title of the painting as given by

the artist, a description ("oil on canvas"), and the owner of the painting. All of this information is considered fact. This is objective content and usually not subject to discussion. Of course there are examples in which, after additional research, the facts change, but the content of a name label is considered constant. Sample exhibit labels are contained in the Museum Toolbox.

The information below the label, or elsewhere in the exhibition, is an interpretation of the content, most often written by the curator, researcher, or exhibit developer. This information is the "why" of the painting: why it is significant and included in the museum and the exhibition. This information is more subjective and undergoes peer review. A researcher, curator, exhibit designer, and exhibit developer may collaborate on the interpretive content graphic.

At the entrance to the exhibition gallery, where the painting is hung, there might be an entry panel. This panel may be written as a narrative: the story of the painting, its ownership, or significance as part of the exhibition. Although presented as a narrative (story), the information is factual.

Much contemporary museum education is based on constructivist learning theory and the work of Jean Piaget. Piaget theorized that learners construct new knowledge from their experiences. Learners incorporate new knowledge into their already existing framework without changing that framework. When we don't know why the sky is blue, we each come up with our own theory of why the sky is blue until other knowledge challenges our theory. To change our knowledge of why the sky is blue, we first need to deconstruct our current theory and replace previous knowledge with new knowledge.

As museums are forms of informal education, they allow visitors a safe place to deconstruct their previous knowledge without fear of testing or review by a teacher. The goal of museum education is to transfer the ownership of content. Museums differ from schools or higher education. They serve as a spark for inquiry rather than centers of formal education. Once previous knowledge is deconstructed, it is owned by the visitor until that knowledge is replaced by new knowledge. The deconstruction of previous knowledge is a delicate dance between content provider and receiver of information. It is because of the delicacy of this deconstruction that museums are places for safe experimentation. Museums are an informal type of communication creating a relationship between museum and visitor, which is tantamount.

Today's archetype of a modern science center started at early science museums where staff wanted to engage visitors with the museum's dioramas and "manipulatives" by adding push buttons and cranks to operate exhibits. The simple addition of a push button changes the relationship between the museum and the visitor: the visitor becomes an active participant in the museum experience rather than a passive viewer.

It is useful to recall the work of renowned developmental psychologist Howard Gardner, who theorized the existence of multiple intelligences. He identified seven intelligences[2]:

1. Linguistic intelligence
2. Logical-mathematical intelligence
3. Musical intelligence
4. Bodily-kinesthetic intelligence
5. Spatial intelligence
6. Interpersonal intelligence
7. Intrapersonal intelligence

Museum educators work to meet the learning styles of all visitors and personality types.

The use of technology requires alignment with mission and educational objectives. Whenever technology is used, the museum must assure that it is useful to visitors. In the early 2000s, there was a movement toward themes in museums. At times, the emphasis on theme got in the way of the content. Technology should never be used for its own sake; it should always enhance the visitor experience and be in keeping with an exhibition narrative.

The Internet has dramatically changed the methods of museum education. Before the Internet, visitors were required to visit the museum in person to experience art, science, or history. Consequently, the role of the object/artifact is now changing, too. Visitors can review information about an exhibition, understand the history of an art movement, and gain a little insight into the life of an artist, all prior to visiting the brick-and-mortar location of the museum. All this was possible before easy access to the Internet, but now information can be presented on a museum's website. This change affects the relationship between the visitor and the artifact, the exhibition, and the entire museum visit.

In the early 1990s, Microsoft founder Bill Gates purchased the rights to numerous artworks to build a visual database.[3,4] At the time, it was a significant concern for museums, which worried that people would cease to visit galleries and museums if content was available online. Our concerns proved pointless. In fact, the opposite has become true: there is only one *Mona Lisa* and visitors will wait in line to see the art in person, no matter how many times they have seen the art online or reproduced in books. The same is true today with the relationship between the previsit, in-person visit, and postvisit experience. No digital experience can replace the in-person experience. Visitors now arrive at a museum with greater knowledge than previously. The

role of museum educators is now one of offering a greater level of detail, encouraging dialogue, and correcting misinformation.

The Smithsonian Institution is now in the process of creating three-dimensional scans[5] of parts of its collections. The long-term goal is to allow visitors to create three-dimensional printouts of objects, using three-dimensional printer technology. A family can print out an object at home and then study and discuss it prior to arriving at the museum to see the object in person. Museums are also using social media as a form of access to museum staff. New York's Metropolitan Museum offers its "Ask a Curator" program and the United States Holocaust Museum in Washington, DC, makes use of Reddit for their program, "Ask Me Anything."

The roles of curator, educator, researcher, and museum community are changing. The Rijksmuseum's Rijksstudio[6] in Amsterdam is an example: visitors can curate their own collection prior to visiting the museum. Some museums are going as far as encouraging a museum selfie, getting museum visitors to take photos with their favorite artwork. From a philosophical point of view, I don't believe there is a greater compliment to an artwork or artist; it shows that museum visitors want to own their relationship with the art. Another benchmark is Gallery One in the Cleveland Museum,[7] where visitors are encouraged to use in-gallery interactives to gain access to greater layers of detail about the art. In each of these examples, there is a democratization of the relationship between museum and visitor.

These new forms of communicating content have established a relationship between museum staff and museum visitor. In the words of noted museum scholar Stephen E. Weil, the museum needed to stop being only *about* something and instead become *for* someone. That someone is the visitor.

As education is typically a relationship between teacher and student, it is important to understand some of the background dialogue between museums and visitors. The relationship between museum and visitor has changed significantly since museums have evolved. Once institutions for use by scholars and later exclusive institutions by invitation only, museums today are inclusive public institutions. The process of communicating content has changed to a dialogue between the museum and members of the community.

NOTES

1. Yuma Heritage 2012 Report, accessed May 20, 2014, http://www.yumaheritage.com/pdf/Annual-Report-2012-2012.pdf.

2. Gardner, Howard, (2011), *Frames of Mind: The Theory of Multiple Intelligences*, third edition, New York: Basic Books.

3. Coor, O. Casey, (1991), "Gates Buys Electronic Rights to Artworks—Seattle Art Museum Images Will Be Shown at His $5 Million Home," accessed May 20, 2014, http://community.seattletimes.nwsource.com/archive/?date=19910509& slug=128215.asicBooks,n,(1991),sstudiofloorwhattheylike."1.

4. http://www.corbisimages.com/.

5. http://3d.si.edu/.

6. https://www.rijksmuseum.nl/en/rijksstudio.

7. http://www.clevelandart.org/gallery-one.

Part IV

BEHIND THE SCENES

Chapter Thirteen

Museum Finances

All businesses have revenue and expenses. The assets of a for-profit business are taxable at the time of sale as a "capital gain or capital loss." Museums with nonprofit status are different. The museum's collection is considered held in public trust. The museum's board of directors is the caretaker of the collection, but the public is considered the owner of the collection. The museum's board is held responsible for the protection and care of the collection, which is their public service role. This concept is central to museum governance and finances. The purchase or sale of pieces of the collection is exempt from taxation

One of the most difficult concepts for people unfamiliar with museums is the idea of the "public trust doctrine"—"that certain natural and cultural resources are preserved for public use, and that the government owns and must protect and maintain these resources for the public's use."[1] This doctrine has many consequences for museums, especially for museum finances. Museums are nonprofit businesses for the benefit of the public. One of the most significant differences between a nonprofit and a for-profit business is the advantage bestowed on a nonprofit because of its service to the public.

Public trust has existed for centuries, as far back as ancient Rome. The concept has been tested several times in the history of Western culture. During the Middle Ages, after the collapse of the Roman Empire until the Renaissance, the metaphorical intellectual light of culture was kept alive by religious organizations. The public trust idea was tested again during World War II, as the Nazis tried to eliminate entire collections of art thought to be degenerate. This idea is currently being tested in a different way in Detroit (2014).

The City of Detroit is in bankruptcy, with an estimated eighteen million dollars[2] in debt. The Detroit Institute of Art[3] is a municipally owned museum (a government museum, receiving the majority of its financial support from

the City of Detroit). The museum's collection includes approximately sixty thousand works,[4] considered one of the best encyclopedic collections in the United States. Depending on the source, the museum's collection is valued at between $1 billion and $2.5 billion.[5] But can any of it be used to pay off the museum's debt?

In the United States, there are two major governing associations for art museums: the American Alliance of Museums[6] and the Association of Art Museum Directors.[7] The codes of ethics of these two associations are perhaps the strictest in the world. Both associations have been very active in the discussion of the assets of the Detroit Institute of Art. Ford W. Bell, the president of the American Alliance of Museums, has stated, "the Federal Accounting Standards Board decided years ago that museum collections should not be viewed as assets on a balance sheet, precisely because these items are held in the public trust."[8] Because it is held in the public trust, the collection of the Detroit Institute of Art is not an asset of the museum, but of the public, and not to be sold to cover part of the eighteen million dollar debt of the city. Bill Nowling, a spokesman for Detroit Emergency Manager Kevyn Orr, said:

> We have no interest in selling art . . . I want to make that pretty clear. But it is an asset of the city to a certain degree. We've got a responsibility under the act to rationalize that asset, to make sure we understand what's it's worth.[9]

Museums in the United States with 501(c)(3) nonprofit status are not required to list their collections as assets nor are they required to capitalize the sale of their collections, as long as the proceeds of the sale of a piece from the collection are used to support the museum's mission and collection. This last issue can be a point of conflict for museums.

A museum's collection is not considered an asset; for accounting purposes, a museum's collection is considered outside the definition of an economic resource. This is a very important issue for museums, as the museum's collection is considered beyond value and not to be sold or traded for the economic advantage of the museum. Pieces of a museum's collection can be bought and sold, but only in the interest of the museum's mission. So if a museum has a collection of paintings by an artist and another painting by the same artist becomes available for purchase, the museum can decide to sell less significant pieces of the collection in the interest of purchasing a more significant painting. Deaccessioning (selling) a part of a collection to buy another piece for the collection is not an economic decision, but one based on mission. The guiding principle is whether the sale of certain pieces and the purchase of a new one strengthen the collection and support the museums mission.

The American Alliance of Museums' code of ethics does not allow collections to be considered an asset[10]; instead, museum collections are consid-

ered public trust responsibilities. In other words, the public is entrusting the protection and care of the collection to the museum, but the objects belong to the public. This is part of the give and take of philanthropy, as a museum builds a collection in the public's interest. Pieces of the collection may increase in value and the museum can then use the proceeds to continue to build the collection.

In the United States, Canada, and Europe, the idea of public trust is well accepted within museum communities, whereas in developing countries, the idea is not well established. The museum is responsible for the care of the collection, but does not "own" the collection. Pieces of the collection can only be sold for the care or "advancement" of the collection. As the code of ethics states, "Disposal of collections through sale, trade or research activities is solely for the advancement of the museum's mission. Proceeds from the sale of nonliving collections are to be used consistent with the established standards of the museum's discipline, but in no event shall they be used for anything other than acquisition or direct care of collections."[11]

This brings to mind a museum I visited in a developing country. The museums did not meet the minimum requirements as set out by this code of ethics. It was almost entirely funded by a single individual who purchased an entire collection with the help of a consultant, put it on public display, and began charging the public an admission fee to enter. The pieces of the collection are owned by a foundation funded entirely by the same individual. By the standards of the American Alliance of Museums and the Association of Art Museum Directors, this cannot become an accredited museum as presently conceived, as the collection has not passed from private ownership to public trust. The owner of this foundation and museum would have a difficult time surrendering ownership to the public after investing his own money to establish the museum.

Museums are judged by peer review, not by popularity (attendance). This is also a difficult concept for some joining the nonprofit world of museums. Peers give museum accreditation and awards. Many new board members often make suggestions for blockbuster exhibitions in order to drive attendance and revenue, but this is not the most important measure of a museum. Of course, museums need to keep their doors open and need to stay financially viable. But peers judge on quality.

I always suggest that museums charge admission. It is based on the proposition that visitors value what they pay for, no matter how small the amount. It can thus be important for visitors to pay admission. I believe it is part of philanthropy to give and to receive. This is a U.S.-centric belief, as many museums in Europe are free, a cultural difference between the United States and Europe. Museums are part of civil society and should be accessible to

everyone. I advise that museums price their admission at the same cost of a local movie. As many families all over the world will treat their families to a movie, this is a good price point for a museum. I also recommend at least one free day per month, underwritten by a corporate sponsorship. This way, every family has access to the museum at least one day per month. As an aside, I strongly disagree with the current trends of admission prices charged by some museums, including the California Academy of Science ($34.95 for an adult). This sends an incorrect message that museums are only for the rich.

I am a great believer in transparency in all matters of a museum, especially finances. One museum that has taken the issue of transparency to heart is the Indianapolis Museum of Art. They have created the Indianapolis Museum of Art Dashboard,[12] an online portal that tracks museum visitation, the museum's endowment, memberships, and their social media statistics. I encourage museums to emulate this type of transparency. In the United States, nonprofit organizations need to submit public tax documents (Internal Revenue Service [IRS] Form 990). Anyone can view these forms online using such websites as Guidestar.[13]

Nonprofit museums do not make money; by definition, they are public institutions. Museums do have revenue, however, including admissions, membership dues, fundraising events, grants, contributions, restaurants, consulting, and fabrication for other museums and rental fees. As nonprofits, museums will have parts of their business that are profitable, such as wedding rentals, retail stores, restaurants, and exhibition sales. But the profit from these ventures is used to offset the costs of operations and programs. For many museums, the cost of operations is approximately twice that of revenue. The difference is made up in the form of donations, grants, and revenue from endowments.

Museums also have expenses. Collection acquisitions are not considered an "expense," as they are not capitalized assets. The largest expense for most museums is salaries, although some museums operate utilizing an all-volunteer staff. Other museum expenses include the cost of providing grant services (programs), professional fundraising, and building expenses, including maintenance and utilities.

As part of museum accreditation, museums are required to have policies in place, including an institutional code of ethics that includes deaccessioning/disposal of collections, use of proceeds from the sale of deaccessioned items, and a policy regarding conflicts of interest issues.[14] When a museum displays an artwork, the economic value of the art usually increases, as the museum has deemed the art to be of value. This increases the value of other, similar pieces owned by collectors. This is one of the reasons so many people were upset by the implied ethics violation in hiring Jeffrey Deitch,[15] the owner of a for-profit gallery, to run a major nonprofit art museum.

Since the 1980s and "Reganomics," there has been a significant shift in the leadership of U.S. museums. Prior to the Regan era, directors and chief executive officers were often academics or curators who, in addition to managing the day-to-day operations of the museum, were experts in one or more museum disciplines. In the 1980s, a lack of financial support from government sources forced many museums to hire museum directors and chief executive officers who were experts in business management or fundraising and possibly had less expertise in academic studies or curation.

This has resulted in a change to the dynamic of many boards of directors. In the past, many board members were artists, historians, or scientists who not only governed the museum, but also advised on the academic integrity of the institution. Out of necessity, this has changed. Many board members are now told to "give or get"—either they give money to the museum or go out and get money from their friends and business networks.

As part of the IRS Form 990, some members of the museum (the board of directors and/or staff with officer status) are required to divulge any conflicts of interest. The IRS Form 990 also includes the "33⅓ Support Test"[16]—a way to test if a nonprofit is a publicly supported organization. A minimum of 33⅓ percent of the revenue is required to be from public support, such as gifts, grants, contributions, or certain membership fees.[17] Most for-profit businesses would not plan to spend more than they would earn, but by design, museums do exactly that. As public organizations, museums and nonprofits work to support their mission by receiving at least one-third of their revenue from public support.

Museums have capital expenses and operational expenses. Examples of capital expenses for museums include the design, fabrication, and installation of new exhibitions, the construction costs of a new museum building, and the purchase of equipment (computers, tools, furniture). Operating expenses include building maintenance, exhibition maintenance, supplies, insurance, legal fees, advertising, and non–project-based salaries. A person who works at the ticket booth is considered an operational expense. A person who is hired only to build a new exhibition on a per project basis is considered a capital expense.

In the past, museums had exhibit departments that built new exhibitions, maintained exhibition spaces, built crates, and prepared art for display. Before the 1980s, the everyday activities of a museum exhibition department were considered part of the operations of the museum, and most museums considered exhibition department staff as part of operational costs. With less public funding, museums have been forced to change how they categorize staff. Staff who maintain exhibitions are considered operational costs, but staff who only work on new exhibitions are considered capital costs. This was a very significant change. People holding most positions in a museum

once were able to work at that museum their entire careers. But with a change to project-based hiring practices, exhibition staff members are often contract employees with the goal of producing an exhibition. Once the exhibition project is completed, they move on to another museum for a different project.

Reduced government funding began the outsourcing of museum exhibitions and museum blockbusters. Museums can now handle the arrangements for an exhibition and outsource the production of the exhibition as a capital cost. In addition, the capital costs can be underwritten by corporate sponsorships. These two changes—the outsourcing of exhibition design and production and the corporate sponsorship of exhibitions—had a large impact on museum finances. Museums can now amortize (write off) the capital costs of exhibitions and building expansions. Corporate sponsorships help to cover these major costs.

As part of accreditation, museums are required to have financial policies in place. There are two governing bodies for museum best practices: the American Alliance of Museums and the International Council of Museums. The financial guidelines of both the American Alliance of Museums and the International Council of Museums can be found in the Museum Toolbox.

There are many types of accounting systems used by museums. Some are complex, all-encompassing systems that handle accounting, ticketing, donor databases, museum memberships, and museum scheduling. These systems can cost ten thousand dollars or more per year in software fees. Most small museums use far simpler systems, such as QuickBooks Premier Non-Profit at an annual cost of $419 per year.[18] As alluring as an all-encompassing system may sound, it is often easier and more efficient to use separate systems for accounting, ticketing, donor databases, museum memberships, and museum scheduling. One of the hidden costs of the all-encompassing software solution is the need for dedicated information technology staff. Systems such as QuickBooks can be set up and maintained by staff or volunteers without a dedicated information technology staff member. The most important thing is to speak with your museum's accountant and make sure that your system will allow for audited financial statements.

CONTRIBUTIONS

At a minimum, museums in the United States need to receive one-third of their revenue from the public. Contributions to a museum can be considered charitable contributions if they meet the IRS guidelines.[19] Contributions must be categorized as unrestricted, temporarily restricted, or permanently restricted. For example, a private donor may make a donation that can only be used to fund the purchase of a specific artist. The museum can either accept the donation or not.

The most significant contribution to museums is in the form of endowments. An endowment is a permanent fund for the benefit of the museum for a specific purpose. The principal amount is kept intact, while the proceeds of the endowment's investments can be used for a specific purpose of the museum. Often an individual will make a large donation as a form of endowment for a museum; other donors can then add to the endowment in unrestricted support of museum operations. With endowments, as the monies grow from investment, the museum then uses the income from the principal to support operational costs. Included in the one-third of revenue from the public is income from endowments and gross investment income.[20] Donations to museums may also be tax deductible, whether given by an individual or a corporation. Nonprofits also donate money to other nonprofit organizations.

It is instructive to look at the revenue of two of the largest museums in the United States: New York's Metropolitan Museum of Art and the Museum of Modern Art. Each only receives between 9 and 10 percent (July 2010 to June 2011) of their revenue from museum admissions,[21] yet they prosper because most large museums get by through the patronage of wealthy donors. It is interesting to read Eli Broad's view of the Los Angles Museum of Contemporary Art in the *Los Angeles Times* (July 8, 2012).[22] Mr. Broad was the founding chairman of the board of the Museum of Contemporary Art (Los Angeles). He believes the museum's expenses spiraled out of control and the museum used the principal of the endowment to cover costs. Most of this is a moot point for a small or medium-size museum (most small museums do not have funds at this level), except when considering the following.

1. Popularity is not a measure of success or a path to financial health. The museum will need to court and retain wealthy donors.
2. Museums, no matter the size, should never use the principal of their endowment to cover costs.
3. Museums need to be financially conservative.

In addition to monetary contributions, museums may accept "in-kind" donations: a computer manufacturer, for example, can donate computers to be used by the museum.

MUSEUM MEMBERSHIP

Museum membership is recorded as part of the IRS Form 990. Depending on the benefits the member receives, the membership may or may not be considered tax deductible by the IRS. If the member receives goods or services as part of the membership, only part of the membership cost would be consid-

ered deductible. Your accountant can explain what part, if any, of a membership is deductible or not. Many granting foundations (nonprofit donors) are interested in the number of members as an indicator of public support.

EXHIBITION COSTS

I am a strong believer in "napkin budgets"—simple rules of thumb that can be applied to museum costs. With my background in exhibitions, I use the following formulas:

- Approximately 50 percent of a museum is front-of-house: public space that includes exhibitions, lobby, public bathrooms, restaurants, and retail.
- Approximately 50 percent of a museum is back-of-house: nonpublic space, including offices, art storage, food preparation, storage, loading docks, and boardrooms.
- Exhibition space costs significantly more than back-of-house space. Depending on the type of museum, the costs per square foot can vary from seventy-five dollars to five hundred dollars.[23]
- Construction costs, not including land, can vary greatly, from one hundred dollars to three hundred dollars per square foot.[24]

For a napkin budget, let's say we are interested in creating a ten-thousand-square-foot science center with about five thousand square feet of exhibits and five thousand square feet of back-of-house.

- Building costs for ten thousand square feet = $1.75 million ($175 per sq. ft.)
- Science center exhibition costs for five thousand square feet = $850,000 ($175 per sq. ft.)

The total is $2.6 million, plus staffing; furniture, fixtures, and equipment; land costs; fundraising costs; and costs until opening. This exercise is helpful as a rule of thumb. Of course, science centers have been opened for less and for more money; this is only an example.

The costs of opening a museum can be daunting, given the amount of time required. Suppose you are planning on opening a small, ten-thousand-square-foot children's museum.

Founder's idea, starting point
Build board of directors, one to two years
Build community support, one to two years

Raise funds, one to two years
Design and construction, one to two years

Such a project can take four to eight years. During the process, there are ongoing expenses, even for an all-volunteer organization.

In conclusion, the finances of museums make a fascinating study. I am often amazed that these extraordinary institutions exist at all. In the process of writing this chapter, I closely reviewed the IRS Form 990 of the Museum of Jurassic Technology. Besides their amazing exhibits, how does this museum manage to exist, financially? The answer is, through the talent and passion of David Hildebrand Wilson and Diana Drake Wilson, the museum's founders and staff. The Museum of Jurassic Technology is a benchmark for what can be accomplished. Their total revenue in 2012 was $376,108 and their expenses for the same year were $336,624. In 2011, their attendance was twenty-three thousand visitors,[25] with a cost of $14.63 per visitor (adult admission $8). This is an amazingly efficient museum! The Museum of Jurassic Technology is a throwback to an era of private museums. I am a proponent of community-based museums that become destinations. The Museum of Jurassic Technology runs on a minimal budget, yet has an international following.

NOTES

1. Hill, Gerald and Kathleen Hill, *Nolo's Plain-English Law Dictionary*, Nolo. com, 2009.
2. Halcom, Chad, "Police and fire system joins others in endorsing Detroit bankruptcy plan," http://www.crainsdetroit.com/article/20140619/NEWS/140619804/police-and-fire-system-joins-others-in-endorsing-detroit-bankruptcy#.
3. http://www.dia.org/.
4. http://www.dia.org/art/.
5. Stryker, Mark, and John Gallagher, "DIA's art collection could face sell-off to satisfy Detroit's creditors," http://www.freep.com/article/20130523/NEWS01/305230154/DIA-Kevyn-Orr-Detroit-bankruptcy-art.
6. American Alliance of Museums, (2000), "Code of ethics for museums," http://www.aam-us.org/resources/ethics-standards-and-best-practices/code-of-ethics.
7. Association of Art Museum Directors, (2011), "Code of ethics," https://aamd .org/about/code-of-ethics.
8. Bell, Ford W., "Why the Detroit Institute of Arts is one asset that Kevyn Orr shouldn't touch," http://www.freep.com/article/20131010/OPINION05/310100045/detroit-bankruptcy-kevyn-orr-institute-of-arts-DIA-collection.

9. Stryker, Mark, and John Gallagher, "DIA's art collection could face sell-off to satisfy Detroit's creditors," http://www.freep.com/article/20130523/ NEWS01/305230154/DIA-Kevyn-Orr-Detroit-bankruptcy-art.

10. American Alliance of Museums, (2000), "Code of ethics for museums," http:// www.aam-us.org/resources/ethics-standards-and-best-practices/code-of-ethics.

11. American Alliance of Museums, (2000), "Code of ethics for museums," http:// www.aam-us.org/resources/ethics-standards-and-best-practices/code-of-ethics.

12. http://dashboard.imamuseum.org/.

13. http://www.guidestar.org/.

14. American Alliance of Museums, "Core documents," http://www.aam-us.org/ resources/assessment-programs/core-documents/documents.

15. Kennedy, Randy, (2013), "In Los Angeles Art Museum arrival, a foreshadowing of a departure," http://www.nytimes.com/2013/07/26/arts/design/in-los-angeles -art-museum-arrival-a-foreshadowing-of-a-departure.html.

16. http://www.irs.gov/pub/irs-tege/eotopicm80.pdf.

17. http://www.irs.gov/pub/irs-tege/eotopicm80.pdf.

18. http://quickbooks.intuit.com/premier.

19. Internal Revenue Service, (2015), "Topic 506 – charitable contributions," http://www.irs.gov/taxtopics/tc506.html.

20. http://www.irs.gov/pub/irs-tege/eotopicm80.pdf.

21. Ferro, Shane, (2012), "As MOCA's money woes simmer, a look at how major museums' finances work," http://www.blouinartinfo.com/news/story/815198/as -mocas-money-woes-simmer-a-look-at-how-major-museums.

22. Broad, Eli, (2012), "MOCA's past and future," http://articles.latimes. com/2012/jul/08/opinion/la-oe-broad-schimmel-moca-20120708.

23. Museum Planner, (2011), "2011 museum exhibition cost survey results," http://museumplanner.org/2011-museum-exhibition-costs/.

24. CMD Group, (2015), "What's to like or not like in today's economy?" http:// www.reedconstructiondata.com/Market-Intelligence/Articles/2013/8/RSMeans-dol lar-per-square-foot-construction-costs-for-four-small-commercial-types-of-structure -RCD012973W/.

25. http://www.smithsonianmag.com/arts-culture/the-museum-of-jurassic-tech nology-160774366/.

Chapter Fourteen

Museum Fundraising

Museum fundraising is a "complex sale." It is part personal relationship, part trust, and part hope. Recently I watched an episode of "World of Business Ideas" on cable featuring Jeff Thull, author of *Mastering the Complex Sale* (highly recommended). During the one-hour episode, Thull divided sales into four generations[1]:

Sales 1.0: The presentation
Sales 2.0: Solving issues
Sales 3.0: Looking at the business and becoming a partner, solving problems
Sales 4.0: No salespeople, the educated consumer

Thull's description resonated with me. He reasons that medical doctors don't have salespeople; a patient does his or her research and either likes or doesn't like the doctor. The potential client views the services offered by the doctor and decides if the doctor is right for him or her. Thull theorized that we are heading to a future without salespersons.

Although museum fundraising is still a very personal relationship, before a potential donor ever speaks to the museum, he or she will have viewed the museum website, Twitter and Facebook accounts, and looked at related LinkedIn profiles. A potential donor will also perform a Google search on the museum, the founder, and the director. The entire research process takes less than an hour. The potential donor will have established an opinion of the museum before speaking with someone on the phone. All of the online information will have established your brand in the donor's mind before you even speak with him or her.

Recently I have been very interested in two start-up projects: the Tesla Museum and the fundraising work of the comics website known as The Oatmeal,[2] and the Museum of Food and Drink.[3]

I have no association with either project. Both are yet-to-be-built museums looking for funding. I have purposely not contacted either institution and have only viewed their online presence. Both have done a great job of establishing brand and trust. Their campaigns are fun, inventive, and aligned with their missions.

I believe a potential donor, whether small or large, would have positive reactions to either of the brands. I believe this is part of future that Thull is describing. I have formed an opinion of each start-up, without having spoken to anyone or watched any presentation. I already understand their mission.

There are many similarities between salespeople and museum development people (fundraisers). A good museum fundraiser is:

1. Not disappointed by "no"
2. Able to build relationships with many types of people
3. Able to "ask" for the money and close the donation
4. Able to maintain the relationship

People give large sums of money to nonprofits for very personal reasons, and I don't believe that a website or digital medium will ever replace the personal relationship between donor and development officer.

For a start-up, the founder will fill the role of development officer and will (with the assistance of the board of directors) work to create relationships that may result in large donations to the museum. The following general flow chart outlines the steps for securing large donations.

Donor Process
Founder
Board of directors and director/chief executive officer
Primary objectives
Board of directors (trustees)—high-value donors—database/friends
Board of directors (trustees)—high-value donors—members
Event
Additional high-value donors/introductions
Mailing, emails, letters
Thank you letters
Database
Relationship building
Customer relationship management database
Closer meetings

Segment list
High value
Medium value
Low value
The "ask"
Board of directors
Director/chief executive officer
Friends
Repeat gifts
Legacy prospects
One-off gifts

The board of directors sets the objectives and/or mission, vision, and core values of the museum. If the museum is at the outset, it may be only objectives. If the museum has achieved nonprofit status, it will be mission, vision, and core values. As a team they identify high-value potential donors and hold an event to gather potential donors to share the vision and make introductions.

Follow-up after the event is key. Who spoke with whom? What did they think? What are the next steps? Many museums use a customer relationship management system such as Salesforce[4] to manage these relationships and next steps. I have used Salesforce and Zoho CRM[5] for this type of database, and depending on the number of donor leads, I have occasionally used a shared spreadsheet such as Google Docs. The most important thing is to be able to capture the information about the donor lead, segment the lead (high value, medium value, or low value), and segment the list by the likelihood of a donation. Similar to a sales funnel, these are the steps to securing the donation. Each high-value, high-likelihood lead should be assigned a board member for follow-up. The board member needs to write a thank you note and make a follow-up phone call asking about the event and, if appropriate, to make plans for a lunch. The process from an event to donation can be months or years.

A wealthy museum founder is more likely to be successful with fundraising. By wealthy, I am implying a net worth in the tens of millions of dollars. If you are wealthy, there is a higher likelihood that your friends and associates are also wealthy. This is how philanthropy works. A wealthy museum founder works with their friends to build a public resource, the museum.

Philanthropy is highly personal. In my experience, there are three types of significant fundraising:

1. Gifts from wealthy donors
2. Partnerships with real estate developers
3. Partnerships with elected officials

Of course there are other forms of donations. A recent crowd-funding campaign on Indiegogo raised $1.3 million toward the creation of a Tesla Museum.[6] The sum is the largest amount that I know of for museum crowd-funding. As significant as $1.3 million is, it is a far cry from the additional $8 million needed to open the museum.[7] For the rest of the money, Matthew Inman,[8] The Oatmeal's founder and brainchild behind the museum idea, has reached out to Elon Musk, owner of Tesla Motors. According to the Forbes list of billionaires, Elon Musk is number 137 (as of June 2014) with an estimated net worth of $9.6 billion.[9] Telsa Museum working with Telsa Motors sounds like a possible partnership. Yes, you can raise significant money from crowd-funding, and it is a wonderful form of building community and support. But it is very difficult to bring in really large chunks of money.

A short list of crowd-funding platforms:

Rockethub, http://www.rockethub.com/
Kickstarter, https://www.kickstarter.com/
Indiegogo, http://www.indiegogo.com/
Razoo, http://www.razoo.com/

I would like to get a couple of common misconceptions out of the way. First the "Let's sell bricks and we can put the donor's name on the brick" idea, and second, the "Let's contact Bill Gates; if he only gives us 0.001 percent of his net worth, we could build our museum." Even if you can sell each brick for one thousand dollars and you sell one thousand bricks, that is only one million dollars. A million dollars is a significant amount of money, but the effort and time to sell those thousand bricks would be better spent on building personal relationships.

According to the Forbes list of billionaires, Bill Gates now ranks as number 1 (June 2014) with an estimated net worth of $78.9 billion. Yes, Bill Gates has the financial resources to help you build your museum. But why would he? Are you planning a museum that closely aligns with Mr. Gates' philanthropic interest of eliminating polio?[10] Is your planned museum in the Seattle area? If your answers are no, then you are most likely wasting time trying to contact Mr. Gates.

Fundraising is a numbers game. The more targets you can reach, the better. Concentrate on establishing relationships close to the location of your museum. In very simple terms, you need both community support and wealthy donor support. These are not mutually exclusive.

If you are rich, talk to your friends about your museum's vision. Even if you are rich enough to underwrite the entire museum without support, you

will still need support. You are creating a museum and engaging the public in a form of public trust. The collection of the museum will become the property of the public. If you can't get your friends interested in becoming board members, maybe you need to revisit your vision and objectives.

If, like most of us, you aren't rich, how connected are you in your community? Are you in a position to call the mayor and set up a meeting? Do you know the largest real estate developer in your area? If not, do you have a friend who is close to the mayor, real estate developers, and other wealthy community members? If not, creating your museum is going to be difficult. There are lots of children's museums that have been created by community moms working as volunteers and creating grassroots organizations. There are lots of art centers that started over drinks shared by a group of artists. These organizations operate for years as grassroots organizations. Big Car,[11] the Children's Museum of Northern Nevada,[12] and historic houses often fall into this category of by-the-boot-straps approach. If I sound like I am trying to talk you out of starting a new museum unless you are rich or have rich friends or are very well connected, I am. Many of these small museums struggle for years and only make it month to month.

When you approach the mayor or other potential key stakeholders, play your cards close to your chest. Say, "I am thinking of creating an art center." This is a good starting point. These meetings are best conducted in small groups of two to four people. Be very general, do not give away any specifics of your project. You are only looking for possible interest. Is your vision for a new museum in line with a new mayor's agenda? Does your vision work with a real estate developer's vision for the revitalization of an area? If yes, there might be the possibility of a partnership. Be ready for many meetings over a long period of time, starting with very general concepts. Only after you build a level of trust do you share the details of your project. Until then, your project is in the "quiet phase," and you are only having polite conversations and trying to gauge interest.

Who are the wealthiest people in your community, and what are their interests? Do you know any of them personally? Do you know anyone that could set up a lunch meeting? Getting to know your potential donors is the best form of fundraising. Understand that you are creating a personal relationship between an organization and wealthy donor. You should find out about their personal interests.

There are wealthy couples who never had children but who would like to create a resource for kids. There are wives who love art and would like to share their passion with the community. There are wealthy unmarried people who would like to create nature centers. I was personally involved in relationships with these very donors. I grew to understand and respect their interests

and each gave millions of dollars. However, they only agreed to donate when they were given something in exchange. Each donor was interested in naming the building. Their names appear on donor walls, and they were included in the opening ceremony—but nothing more. The donors grew to understand the mission of the museum and wanted to support it.

Whenever possible, keep conversations restricted to mission and vision. If the conversation starts to go in the direction of specific exhibits or exhibitions, the donor may not be a good match for the institution.

Most museums have a donor policy. I recommend including specifics, such as recognition and inclusion. "The donor will be recognized on the Donor Wall" and "The donor's name will appear on the exterior of the building in the form of a plaque" are examples to consider when creating this document. You will find sample donor policies in the Museum Toolbox.

I am not a fan of professional fundraising or the use of lobbyists. Both approaches can work but they can also become tricky and complex. It is too easy to be unsure of what the professional fundraiser or lobbyist is selling because the board of directors is not typically involved in these meetings. Also these activities need to be reported to the Internal Revenue Service as part of your museum's Form 990.

The issue of corruption will most often arise at the fundraising level. The Association of Fundraising Professionals[13] is a great place to start. Maybe the most important of the Association of Fundraising Professionals' code of ethics is: "Members shall not accept compensation or enter into a contract that is based on a percentage of contributions; nor shall members accept finder's fees or contingent fees." This is where issues and conflicts of interest between fundraiser and a corporate partner can occur.

SMALL MUSEUMS

At museums101.com you will find a chart from the Institute of Museum Library Services report, *Supporting Museums-Serving Communities: An Evaluation of the Museums for America Program* (2011).[14] Small museums, historic houses, historical societies, and small history museums can find fundraising particularly difficult. The issues originate from the museum's objectives. This is not a criticism, it is factual: a community of two hundred thousand trying to create a sustainable museum has a difficult task. It is often easy to adjust initial objectives, but is there critical mass to support the museum? At museums101 .com you will find the Institute of Museum Library Services definitions of small, medium, and large museums by type. The Small Museum Association[15] is a great resource. Museums outside your community can be resources for ad-

vice. Contact museums of a similar type and find out what works and doesn't work for them—events, capital campaigns, and memberships.

WHY WOULD ANYONE GIVE TO A CHARITY?

Yes, a nonprofit museum is a charity, according to the Internal Revenue Service definition. Philanthropy is an ancient practice. It is an expression of love for humanity, and it is meant to nourish and develop what it is to be human. Philanthropy is a form of feeding one's soul by giving to others. In doing so, we also help ourselves. All museums raise funds, but there are a few exceptions. The International Spy Museum,[16] the Sports Museum of America,[17] and the Museum of Sex[18] are, or were, for-profit museums. (Note: Ripley's Believe It or Not is not a museum.[19]) There are many nonprofit museums associated with for-profit corporations, such as casino museums and private museums (museums supported by individuals). Raising funds for a museum is a form of philanthropy.

A gift to a museum either in the form of cash, stocks, bonds, or real estate is considered a donation. The reasoning is this:

Museums are part of a civil society.
Philanthropy is the support of civil society.
Fundraising is the effort to encourage giving to museums, and thus to society.

The term civil society dates to Aristotle's reference to a community with a shared set of norms and ethos in which free citizens are on equal footing, living under the rule of law.[20] In the United States, museums are charitable organizations, categorized by the Internal Revenue Service as 501(c)(3) organizations.[21] Outside the United States, Canada, and Europe, many museums are nongovernmental organizations (also called civil society organizations) and belong to the International Council of Museums and/or the United Nations Educational, Scientific and Cultural Organization.[22]

If you are starting a museum, expanding a museum, or opening a new exhibition, you will need to fundraise. Museums may bring in enough earned income to cover 30 to 50 percent of their total annual operating budget; sometimes it is far less. The remaining amount comes from government funding (10 to 25 percent), investments (5 to 10 percent), and private donations (30 to 50 percent).

Whatever you project, make sure your board of directors has bought into it— literally. Are they willing to give personally to the project? Are they willing to make introductions? Often boards go along with an agenda item, not wanting to kill a project. But board members need to be personally vested in fundraising.

A new museum needs to create a fundraising committee and assign a leader or chair. The chair of the fundraising committee needs to be a well-connected, outgoing person who can make "the ask." I have been at the table with many fundraisers over the years who were unable to personally request the money needed. If you can't ask, you aren't going to get anything.

You should already have organized the initial data from your community (including elected officials and key stakeholders) and from your research on the twenty museums you visited before setting out. Now you should collect endorsements and build a database of potential donors.

To create a database of potential funders, government agencies, individuals, and real estate developers, consider turning to the American Alliance of Museums, the Association of Children's Museums, or the Association of Science and Technology Centers. Each organization has data regarding the impact of museums on communities. Assemble the data into a simple document (maybe ten to fifteen pages). So far, there is no need to spend any money on raising money. You are doing your due diligence by proving that your community needs a museum.

You will need to decide whether to retain a lobbyist, a grant writer, and/or a capital campaign consultant. For new museums, elected officials, real estate developers, wealthy individuals, and corporations are your best options. Create a game plan covering how to approach different potential donors and who is best for the job.

A capital campaign is for capital expenditures versus operating expenditures. It is much easier raising funds for a capital project than for museum operating costs, so build operating funds into the capital campaign. If the new museum costs $1.8 million to build and will cost $360,000 per year to operate and maintain the exhibitions, collections, etc., and you're planning ahead three years, your capital campaign should be $2.9 million.

Once your committee and chair have been selected and your campaign goals set, you are in the "quiet phase" of fundraising. Use your board of directors to raise funds to show a proof of concept, create a preview facility of your new museum, and create renderings of the exhibition spaces. These tools are the sizzle that you will use to promote your project to potential donors. Secure a lead gift from a credible source, such as a major corporation or an influential individual who is willing to help promote the project to other potential donors. Using the lead gift and the collateral materials, go out and speak to potential donors. It will get easier to raise funds as the campaign moves forward, so start off with the easier leads (small donations) that can be secured, then build up to larger donations and bigger asks. Finally, foster credibility for the project by securing corporate support.

A sample museum donation form and museum donation policy is included in the Museum Toolbox.

Corporate donors are a double-edged sword: you want their support and funds, but it's important to be upfront about what you will and will not do for the funds. Often, it's best to have guidelines at the start of the project (i.e., no corporate sponsors' names will be on any exhibits; corporate sponsors will be recognized only at the entrance of the exhibit; bronze level donors will be recognized in twenty-four-point font on the donor wall, etc.). Once you have reached 50 percent of the capital campaign, go public. As the fundraising gains momentum and is moving forward, create donor events. Make sure the donor events raise money, because many donor events present the possibility of losing money: a golf tournament that costs fifteen thousand dollars and raises ten thousand dollars is a waste of time. Often simple donor events are the best, such as "Dads, Daughters, and Doughnuts" or "Meet the Scientist." A private dinner at a board member's home is often the most successful. Once 50 percent of the funds have been raised, gala events can be a great way to announce the lead gift and the launch of the capital campaign.

Establish tiers of giving and have a "Donate Now" button on your website, with levels starting at ten dollars. When you apply for grants, granting organizations will be interested in your member participation and the number of donors to the museum.

Have a donation box at the entrance of the preview facility. You might not raise much money, but it sends a message that the institution requires donor money to operate. I have personally been involved with more projects that have raised funds from lobbyists, individual donors, or corporations. The grants that I have been involved with are often so restrictive that the grant ends up driving the project. And don't forget about in-kind donations: airplane tickets, computers, LCD flat screens, construction materials, and building construction are all great in-kind donations that can be used in the development of the museum or exhibition, or could be raffled off or used at auctions during gala events.

CONCLUSION

I am not trying to talk anyone out of starting a museum, but if you can't raise the money, you won't be able to open the museum. Be honest with yourself. Are you ready to spend years happily having people say "no" to you? It is a very special person who can persevere for years to raise the money and open a museum. If you don't have the personality, does one of your board members or

director/chief executive officer have the personality to build the relationships that will result in large donations? No matter how wonderful your vision, without the ability to raise money, the museum will never be sustainable.

NOTES

1. http://www.wobi.com/wobilive/library/124373.
2. http://theoatmeal.com/blog/tesla_museum.
3. http://www.mofad.org/.
4. http://www.salesforce.com/.
5. http://www.zoho.com/crm/.
6. https://www.indiegogo.com/projects/let-s-build-a-goddamn-tesla-museum--5.
7. Landau, Elizabeth, (2014), "Will Elon Musk fund a Nikola Tesla museum?" http://www.cnn.com/2014/05/14/tech/social-media/elon-musk-tesla-oatmeal/.
8. http://theoatmeal.com/blog/tesla_museum.
9. http://www.forbes.com/profile/elon-musk/.
10. Bill & Melinda Gates Foundation, "What We Do: Polio," http://www.gates foundation.org/What-We-Do/Global-Development/Polio.
11. http://www.bigcar.org/.
12. http://cmnn.org/.
13. http://www.afpnet.org/.
14. Apley, Alice, Susan Frankel, Elizabeth Goldman, and Kim Streitburger, (2011), *Supporting museums-serving communities: An evaluation of the Museums for America Program*, (IMLS-2009-RFP-09-002), Washington, DC: Institute of Museum and Library Services, http://www.imls.gov/assets/1/AssetManager/MFAEval_Report.pdf.
15. http://www.smallmuseum.org/.
16. http://www.spymuseum.org/about/faqs/#q2.
17. Sandomir, Richard, (2009), "Financial problems close sports museum," *New York Times*, accessed May 13, 2014, http://www.nytimes.com/2009/02/21/sports/21museum.html.
18. McCambridge, Ruth, (2012), "With nonprofit status denied, Museum of Sex goes for-profit," *Nonprofit Quarterly*, https://nonprofitquarterly.org/management/20526 -with-nonprofit-status-denied-museum-of-sex-goes-for-profit.html.
19. The goal of The Jim Pattison Group is profit: Accessed May 13, 2014, http://www.jimpattison.com/entertainment/default.aspx.
20. Pérez-Díaz, Víctor, (2011), "Civil society: A multi-layered concept," accessed March 16, 2015, http://asp-research.com/pdf/CivilSocietyREV.pdf.
21. The Internal Revenue Service, (20140), "Exempt purposes—Internal Revenue code section 501(c)(3)," accessed May 13, 2014, http://www.irs.gov/Charities-& -Non-Profits/Charitable-Organizations/Exempt-Purposes-Internal-Revenue-Code -Section-501(c)(3).
22. United Nations Educational, Scientific and Cultural Organization, "International Council of Museums," http://ngo-db.unesco.org/r/or/en/1100048611.

Chapter Fifteen

Museum Marketing

Museum marketing is the public communication of the integrated museum approach (IMA). Marketing is a form of sales. Visitors require a "need" to visit your museum. A museum may have the world's best collection or a world-class facility, and it may still not attract many visitors. That is not to say that museum attendance is the only measure of success, but for many museums, attracting visitors is the primary way that the institution sustains itself financially. I am firm believer in the power of "wow", creating a spectacle, a need, and a sense of urgency for people to visit a museum. For this reason, I believe in both traditional marketing (radio, television, print, and online advertising) and word-of-mouth for sharing your "wow."

In a city of three hundred thousand people, it might be a reasonable target to attract sixty thousand visitors per year. But to consistently reach an annual goal of sixty thousand visitors, you will need to attract an audience from a greater area than just the immediate population. This is the power of word-of-mouth marketing.[1,2] If every visitor to your museum has a positive experience and tells his or her friends, the potential for growth is exponential. I often tell clients that smiling and helpful floor staff are your best marketing tools. Online social media is another form of word-of-mouth marketing and is vital to the success of a marketing campaign.

The key components of museum marketing are consistent messaging of your museum's IMA approach and having a strong vernacular, or "museum voice," for the museum. At the best museums, the museum's approach is consistent from every angle: the collection, the customer service, the exhibitions, and the marketing are all in unison. When all these elements are aligned, the staff and audience know what to expect from the museum. I am a fan of El Museo Universitario Arte Contemporáneo (MUAC) in Mexico City. MUAC is part of Universidad Nacional Autónoma de México, a public university in

Mexico City. It is the largest university in Latin America.[3] From the playful colors, fun photos of their website, and print marketing, the museum has a fun, youthful attitude. MUAC's text panels are written in a scholarly fashion that is still friendly and easy to read, with an approachable and welcoming contemporary art attitude. "Become a Friend of MUAC!" is their marketing slogan for donations and membership—casual yet enthusiastic.

Most museum marketing budgets are small. Every dollar needs to make the largest impact. I love the City Museum of St. Louis, Missouri.[4] It has a strong IMA. The museum communicates its IMA in a consistent manner and builds enthusiasts. The City Museum's tagline encapsulates a six hundred thousand-square-foot museum in two words: "Always building."

Opened in 1997, the City Museum was founded by artist Bob Cassilly and his wife Gail Cassilly. From the outset, the museum was created with the intention of never being complete. "Always building": the museum, its IMA, and the marketing are aligned. Anyone who has ever visited the museum can sense the dynamism and energy. Just saying the words "City Museum" to people who have visited will evoke a strong feeling and recall images of the museum. The museum effectively connects visitors on an emotional level. City Museum serves as an example effective marketing by word of mouth. It is ranked the number seven destination in Saint Louis, ahead of the Saint Louis Art Museum (currently ranked eleventh).[5] The City Museum has become a destination that people travel to from all over the world.

Creating a destination is an important element of a museum's success: there must be a need for people to visit, an emotional connection. I often think in terms of spectrums. Museums exist on several spectrums: level of formality, level of interactivity, level of visitor participation, and level of depth of scholarship, to name a few museum spectrums.

I often talk about the St. Francis Hotel in San Francisco, California, as an example of formality. When you enter this elegant hotel, modeled on the Old World charm of early twentieth-century hotels in Europe, you stand a little taller, you check your clothes, you lower your voice. The grandeur encourages a reaction: you want to meet the expectations of the hotel. At the St. Francis, guests expect the best from the hotel, and in return the hotel encourages the best from its guests. This is formality—raising the expectation of the guest.

The City Museum is at the other end of the spectrum: very informal and relaxed. At the formal end of the spectrum is the Benesse Art Site Naoshima, a small island off the coast of Japan accessed from the city of Takamatsu. The museum is financed primarily by Tetsuhiko Fukutake, the founder of Fukutake Publishing Co., Ltd., now the Benesse Corporation.[6] With multiple museums and art installations, the island is now a world-class

art destination. The collection includes works by James Turrell, Walter De Maria, and Claude Monet. Tadao Ando designed the buildings. Both the City Museum and the Benesse Art Site Naoshima are destinations; each museum has created a strong desire for locals and tourists to visit. There is no better form of marketing than creating an emotional connection with visitors. This connection is what motivates them to spread their excitement by word of mouth.

On a much smaller scale is the Eli Whitney Museum and Workshop[7] in Hamden, Connecticut. This museum is the factory site and workshop of Eli Whitney, opened in 1798. The Eli Whitney Museum contains a collection of artifacts and inventions. The museum has chosen to expand beyond a display of artifacts connected to Mr. Whitney. It now hosts events such as the Whitney Workshop and the Leonardo Challenge.[8] These educational programs encourage invention and are geared toward children. The Eli Whitney Museum and Workshop, although a typical museum housing the collection of the inventor of the cotton gin, has expanded the museum's mission to encourage a sense of invention in its visitors. This small museum has now become a destination with worldwide participation in its programs.

In each of the previous examples, the museum itself becomes a marketing tool by becoming a destination.

The goal of museum marketing is twofold: to create attendance and to create donations. Museum marketing is a process that can be divided into five segments:

1. Museum awareness and stating the "need" for a visit (online, print, radio, television, word of mouth). Clearly state why visitors need to visit: "Come to the museum before July 12 and see the only showing of Paul Strand's photographs in Texas." The marketing states a date and the only time that the event will be happening nearby. A need has been clearly stated.
2. Online museum experience. Once a potential visitor has become aware of the need, he or she will visit your website. The need for the visit should be restated on the website. The website will start to create the IMA.
3. In-person museum visit. I am a strong believer in the event-driven museum. You have already set up a need. At the entry of the museum, give notice of the next event. Before a visitor has entered the museum, you are already setting up the need for the next visit.
4. Joining community. Define who the museum audience is and is not. Is the museum great for weekly visits for families for young kids? Is the museum great for young professionals for social events or for retired couples to have a Sunday brunch? At the entrance, have photos of your targeted audience enjoying the museum as part of their community.

5. Museum membership. Price membership at less than two visits for a family of four (two adults and two children) and sell membership at the time of ticket sales and at the museum exit.

The first steps of museum marketing also correspond to the tiers of museum philanthropy: online museum experience, in-person visit, joining community, membership, becoming a donor, and volunteering.

HOW TO CREATE A MUSEUM MARKETING CAMPAIGN

1. The museum's IMA: Ask museum staff to tour the museum and describe it as a personality. The more specific they can be, the better. Then interview your current visitorship and ask them to do the same. If the museum's staff and visitors both see the museum's personality in the same way, your IMA is fairly strong.
2. Define your primary audience: You can have multiple segments: your primary, secondary, and tertiary audiences. I always suggest that tourists should not be part of your targeted audience. Target local first, then tourists. Many museums incorrectly target tourists and end up alienating their local audience. No museum can exist without support from its local community. Target audiences by age, zip code, reason for visit, and socioeconomic profile.
3. The need: Create a written description of why visitors need to visit the museum. Examples: "the world's largest . . .," "the world's best . . .," or "only at our museum . . ."
4. Look and feel: Describe the visual aspects of the museum and how it corresponds to the IMA. This will become the "look and feel" of the marketing campaign. As an example, if you are targeting young families as your primary audience, have photos of families enjoying the museum.
5. Samples: Create sample marketing text, logos, and graphics.
6. Audience testing: Test your marketing with your targeted primary, secondary, and tertiary markets for their response. Umbrella concept with your current audience, and test your IMA with your desired audience.
7. Revisions: Revise the marketing until it is aligned with the likes of your desired audience (potentially a mix of your current audience and a new audience).
8. All channels: Launch your marketing campaign across all media channels: social media, print, radio, and television.
9. Feedback: Survey your desired audience for their reactions to your marketing. Include museum members in focus groups for their feedback.

Target museum members who match your targeted primary, secondary, and tertiary audiences.

The marketing campaign needs to have many entry levels in order to reach the widest audience. Work through iterations of the marketing that can run in media channels for two or more years, starting with the umbrella concept. I loved the recent marketing campaign of MUAC[9] of Mexico City. The tag line of the campaign was "*nadie sale como entró*" ("no one leaves as they entered"). Throughout Mexico City are large billboards of typical working people with one eye more open than the other. Each billboard is different but there is no text on any of them, only quizzical looking faces. MUAC is also running print ads on buses and at bus shelters throughout Mexico City. The museum is directly addressing an issue facing many contemporary art museums: visitors don't know what the art means. Instead of taking a highbrow approach, MUAC is facing the issue head-on and reaching working class people of Mexico City on public transportation. They are poking fun, saying, "It's okay not to understand contemporary art, come to MUAC and we will explain." "No one leaves as they entered" means that after a visit to MUAC, they will understand. The marketing campaign is addressed to a target audience on all channels—billboards, print, and radio. This family of marketing ideas and concepts can easily run for two to three years and stay fresh.

A well-formed IMA will naturally create enthusiasts for the museum. Marketing becomes a communication of the IMA to a targeted audience: the marketing design and implementation are a communication of the museum's approach to the targeted audience.

NOTES

1. Lindgreen, Adam, Angela Dobele, and Joelle Vanhamme, (2013), "Word-of-mouth and viral marketing referrals: what do we know? And what should we know?" *European Journal of Marketing*, Vol. 47, No. 7, pp. 1028–33.
2. Bughin, Jacques, Jonathan Doogan, and Ole Jørgen Vetvik, (2010), "A new way to measure word-of-mouth marketing," accessed May 9, 2014, http://www.mckinsey.com/insights/marketing_sales/a_new_way_to_measure_word-of-mouth_marketing.
3. http://www.unam.mx/.
4. http://www.citymuseum.org/.
5. Ranked number four attraction in St. Louis, Missouri http://www.tripadvisor.com/Attractions-g44881-Activities-Saint_Louis_Missouri.html. Accessed March 16, 2015.
6. http://www.benesse-artsite.jp/en/.
7. http://www.eliwhitney.org/.
8. http://www.eliwhitney.org/museum/leonardo-challenge.
9. https://www.facebook.com/MUAC.UNAM/app_439312172878966.

Chapter Sixteen

Museum Project Management

Museum projects are inherently different from other businesses. Because the museum's goal is to meet mission rather than make a profit, the museum requires a unique project management system. "Meeting mission" is a much more difficult criterion to define than profitability. The more clearly a project manager and project management team can define project objectives at the outset, the higher the likelihood of a successful project management approach—and a successful project.

In 2008, I completed the Project Management Institute's (PMI) Project Management Professional certification. I tried unsuccessfully to apply the PMI methodology on three separate museum projects, only to abandon the process midway. Although I gained a great deal from the Project Management Professional training, in the end I found the methodology difficult to apply to museum projects. What I did take away from PMI was an understanding of how to set up a project. Central to my understanding of the PMI approach is the use of "Project Charter" as a tool for all museum projects (a sample Project Charter is included in the Museum Toolbox). Often, the intangibles are the most difficult part of museum project management: Does a painting look better against a blue wall or red wall? Should an exhibition be laid out in chronological order or in order of importance? Is the goal of an exhibition an overview of a topic or creating excitement about a topic?

DEFINE THE PROJECT

What is a project? To use the PMI definition:

A temporary group activity designed to produce a unique product, service or result. A project is **temporary** in that it has a defined beginning and end in time, and therefore defined scope and resources.

104

And a project is **unique** in that it is not a routine operation, but a specific set of operations designed to accomplish a singular goal. So a project team often includes people who don't usually work together—sometimes from different organizations and across multiple geographies.[1]

Often, it is best to start by confirming that the task outlined is a project rather than an ongoing routine operation. A new exhibition is a project; exhibition maintenance is an ongoing operation. Typical museum projects include museum expansion, new exhibitions, reorganization, opening a new museum, building upgrades, and infrastructure changes.

DEFINE THE CLIENT

With many museum projects, the client is the visitor. The project will provide a new exhibition or improvement to the museum for the visitor's benefit. For other projects, such as installing a new art storage climate control system, the museum's staff is the client. At the outset, describe and outline the required benefits to the client.

On many projects, the museum's executive director is the project sponsor, to use PMI terminology. The project sponsor is the person who appoints the project team, but also defines the destination of the project. It is left to the project team to determine how they will complete the project.

When creating a new exhibition, the museum's staff will create a schedule for upcoming exhibits, while the museum director will review the exhibition description and schedule with the board of directors and the board will approve the schedule. Most often, while the board of directors will approve a high-level exhibition description and schedule, they will leave the exhibition schedule largely to the director and the museum staff. It is then at the discretion of the director to keep the exhibition development in line with the museum's mission, vision, and voice. In a smaller museum, the director and board may also design and build the exhibition; in that case, it is even more important to appoint the project sponsor, the person who defines the goals of the project. Defining the goal of the project can prove to be difficult. I have found that spending more time on defining the goals of the project at the outset yields best results.

DEFINE THE DESTINATION

The board of directors will often ask the director to define the precise goals and aims of the project. The project team is given the resources and informa-

tion to be self-sustaining while they are determining the best course of action for reaching these goals. Often, concrete examples are best for this type of upfront work. The project sponsor should define the goals of the exhibition project as clearly as possible, take photos, create a project team website of the photos, and describe the desired outcomes of the exhibition.

DEFINE THE PROJECT'S ROLES

Once the ultimate goal is established, it is best to start defining roles. These might include a project manager, an exhibition developer, an exhibition designer, a curator (sometimes also the exhibition developer), fabricator(s), installers, educators, etc.

Even when working with a small staff, it is important to define the roles in a project. In a small museum, each person may need to fulfill several roles. Create a list defining the responsibilities of each role. By clearly defining each role, you will get a better sense of timelines and expectations.

ASSIGN PROJECT TEAM

Once you have defined the required roles, start to find the right people to take them on. In a small museum, board members may serve as active project participants. When a board member becomes an active participant on a project team, he or she is no longer serving as a board member, but instead has an appointed role on the project team. At a larger museum, the same can be said for a director of education working as an exhibition developer. It is important for everyone to realize this slight role change in order to be most efficient. Often, it is helpful to quickly define the roles and responsibilities of each role for the specific project and how the role relates to the other project roles (see detail of Project Charter in the Museum Toolbox). As an example, the exhibition designer is responsible for the design of the exhibition, but the design needs to meet the requirements of the exhibition developer, curator, and educator.

CHUNK IT OUT

Typically, the project manager is responsible for the project's budget and schedule, while the rest of the team is responsible solely for their respective roles. Sometimes the project manager may also serve as "producer." The distinction is that the manager keeps the project on track, both in terms of

schedule and budget, while the producer has a role of defining the approach each project team member will take for his or her job. It is very helpful to define the role distinction between project manager and producer with the whole team.

The project manager will assign approximate budget amounts to each area of the exhibition (a sample exhibition budget is included in the Museum Toolbox). The estimates for each area of the project will be updated as the project proceeds. The project manager will do the same for the exhibition schedule (a sample exhibition schedule is included in the Museum Toolbox), by assigning approximate time durations to each part of the project. It is very helpful to have all of the project's information on a shared platform (intranet, website, or other).

A list of resources for project management tools is included in the Museum Toolbox.

BEFORE BEGINNING

The goals have been set, the roles have been determined, a person has been assigned to each role, and you are now ready to begin. Before the project is officially launched, a few actions need to be addressed. As a team, decide how disagreements or unexpected challenges will be handled. Some projects take only a few weeks; some take several years. On projects that extend over a long period of time, team members may change. It is very helpful to be able to show new team members how the project team makes decisions in difficult situations.

DEALING WITH CHALLENGES

If the project team has done a good job, they have the blessing of the project's sponsor to spend money, allocate resources, and decide how to move forward with the project. The project's sponsor should check in regularly. The project sponsor can review the work to date and confirm that the project team is indeed on course. Sometimes, the sponsor will review the project team's work and decide that the team needs to alter the project goals. This is the sponsor's prerogative, as the board of directors has given the sponsor the responsibility of meeting mission.

It is meeting mission that is the most difficult in managing museum projects. Museums exist to fulfill mission, and the role of the director is to assure that the activities of the museum are meeting the mission. This is one way in

which museum projects are different from for-profit projects. Profit is quantitative; meeting mission is qualitative and subjective. The board of directors employs every staff member at a museum and entrusts the executive director with running the museum. A great director can interpret and expand on how to meet the mission while adhering to the mission.

If the project sponsor changes the goals of the project while the project is underway, it is then the project team's responsibility to report the impacts of a change in goals to the project sponsor. What are the cost implications? What are the schedule implications? What are the implications to the resources assigned to the project? It is important that the project sponsor and the project manager are two different people and that these roles remain separate.

ACHIEVING THE GOALS

Throughout the project, you have been ensuring that the project will meet the client's needs. Now is the time to ask the client (often the visitor) for reactions to the project. Often members of the project team will work on multiple projects. A director of exhibitions may be the project manager on one project and exhibition designer on another simultaneous project. As the project winds down, project team members will become less available. Often it is a good idea to set up a formal meeting with the project sponsor to share thoughts on what was successful and suggest areas for improvement with the entire project team.

It is a great idea to plan a project team dinner to mark the successful completion of a project. A dinner or a group outing offers a sense of closure of one project and allows project team members to move on to their next project.

RETURNING HOME

You have met your goals, and your client is pleased. You have heard the sponsor's thoughts on the project. Now is the time for reflection and project closeout. Did the project actually cost what you projected? Are you receiving as many visitors as anticipated? Now you should archive project documents and make them accessible to future project teams. How you reached your destination is very valuable information to others. Consider presenting your project at a museum conference, or publish project findings as part of your project closeout.

After being part of more than fifty museum project teams and being project manager in more than thirty museum projects, I have found that creating clear systems from the outset is what allows for success.

NOTE

1. Project Management Institute, "What is project management?" accessed May 7, 2014, http://www.pmi.org/About-Us/About-Us-What-is-Project-Management.aspx.

Chapter Seventeen

Museum Evaluation

Museum evaluation is a method to analyze how effectively the museum communicates the museum experience. This includes the overall visitor experience, the online experience, the experience of exhibitions, and museum programs.

In the past, museums referred to their communication with visitors—the transfer of a message—as didactic. The museum would provide "didactic panels" next to a work of art, for example. Today the word didactic (from the Ancient Greek *didaskein*, to teach) is considered antiquated. The implication was that the museum must be in the role of instructor and the visitor in the role of student. Today's museum assumes a bidirectional dialogue. The museum conveys content and the visitor receives the content, processes it, and gives back to the museum in the form of conversations with museum staff, through social media, crowdsourcing, and even crowd-curating. Many museums once "spoke down" to visitors, as if the museum possessed all the knowledge and the visitor was privileged to have access to that knowledge. Some of this is historic: private museums once literally required the invitation of the patron for access, and the role of the visitor was that of invited guest. Some of that history is still alive in museums today.

A best practice is to develop a clear "museum voice" in which the museum is more akin to a mentor and the visitor is treated as a peer. The relationship becomes one of peer-to-peer guidance. The museum voice should be bidirectional—asking questions and encouraging responses.

Museum evaluation is the measure of how the visitor has received and processed the content inherent in this bidirectional communication. Has the visitor taken the content—the "message" inherent in the questions asked—and made it her own?

For the purpose of this discussion, let's assume there are three principal types of communication in the museum:

Verbal communication: Docent tours, programs, orientation, lectures and audio tours, guest services

Nonverbal communication: Architecture, interior design, industrial design, graphics, body language, and "paralanguage" (how the verbal communication is delivered)

Written communication: Wayfinding, exhibition graphics, building signage, and pictograms

With these three basic forms, museums communicate with visitors.

Museum exhibition evaluation is a balancing act.[1] On one side, you have the museum's intended message. On the other side, you have the content received by the visitor. Museum evaluation is the process that will answer the question, "What is the visitor receiving from the museum experience?"

Here we refer to the entire museum experience:

Previsit: Website, social media, advertising, podcasts, online courses, and smart phone apps

In-person visit: Architecture, interior design, programs, visitor experience (customer service)

Postvisit: Ability to access additional content online, via membership, newsletters, advertising, and additional resources

I see the entire museum as a form of communication. Museum evaluation will analyze that communication.

There are several ways that a message from the museum can be lost, confused, or not heard.

BARRIERS TO MUSEUM COMMUNICATION

Physical: The environment, time, comfort, ambient noise, staff shortages, lighting, temperature, and nonoperational equipment

System design: Poor design, design miscommunication, design miscues

Attitudinal barriers: Poor morale of staff, lack of training, inappropriate staff, organizational missteps

Language: Misuse or confusing use of language

Physiological barriers: Impaired hearing, limited eyesight or mental capabilities

Perceptual: An experience that is different from expectations

Cultural: Ethnic, religious, or social differences

Gender: Gender bias or lack of gender sensitivity

There are many other barriers to communication, of course; above are a few common to museums.

Many times, evaluation is required as part of a grant. Granting organizations such as the National Science Foundation,[2] Institute of Museums and Library Services,[3] and the National Endowment for the Arts[4] require a third-party evaluation.

Exhibition evaluation can be divided into four phases: front-end, formative, remedial, and summative evaluation.

Front-end evaluation: Provides background about the visitors' prior knowledge and experience and gathers their expectations regarding a proposed exhibition. The primary goal of front-end evaluation is to learn about the audience before an exhibition has been designed to better understand how visitors will respond. This can help assure that the final product will meet visitor needs and project goals.

The aims are to:

- Define the exhibition objectives for use in the Project Charter
- Gain an understanding of the visitor's prior knowledge and interests related to the exhibition concept
- Test theories about visitor behavior and learning
- Identify visitor needs and how these can be met
- Collect relevant information about audiences and any proposed ideas to help decision making

The methods used include:

- Focus groups
- Interviews and surveys, face-to-face, phone, mail, partial self-administered
- Large- and small-scale sample surveys/questionnaires
- Unstructured and semistructured interviews
- Informal conversations and feedback
- Computer surveys, online surveys
- Community days/workshops
- Review of similar exhibition evaluations
- Review of market research

Formative evaluation: Provides information about how well a proposed exhibition communicates its intended messages. Formative evaluation occurs while a project is under development. The evaluator measures visitor re-

sponse to models, plans, or prototypes of the program or exhibit. A prototype is a working version of an interactive exhibit; it should closely resemble the final product, although it may be more roughly constructed. The more developed the model or prototype, the more likely visitor reaction in the formative stage will anticipate reaction to the final product.

The aims are to:

• Seek feedback related to how well the proposed exhibition communicates the messages
• Produce the optimum exhibition program within the limits of what is possible
• Provide insight into learning and the communication processes

The methods used include:

• Prototypes
• Semistructured interviews
• Cued and noncued observations
• Workshopping with staff and/or special interest groups
• Mapping the visitor experience
• Consultants and peer feedback

The formative evaluation process is repeated until the exhibition developers are satisfied with the items being tested. Information from formative evaluation is used to make changes to improve the design of a program or exhibit before it is implemented.

Remedial evaluation: Takes place once an exhibition is open to the public. It is useful in troubleshooting problems and informs museum staff and designers about improvements that can be made to maximize the visitor experience. Remedial evaluation is useful for addressing problems that could not be foreseen during the development of a program or exhibit, such as lighting, crowd flow, and signage issues.

The aims are to:

• Check that the program works in a practical sense
• Determine what maintenance/resources are needed
• Improve the short- or long-term effectiveness of the program for visitors
• Provide some early insights into how visitors use the program

The methods used include:

• Observations
• Informal feedback from visitors
• Feedback sheets
• Surveys and interviews
• Comments books
• Staff feedback, especially "front-of-house" and floor staff
• Mapping the visitor experience

Summative evaluation: Tells about the impact of a project after it completed. It is conducted after the exhibit has opened to the public or after a program has been presented. Summative evaluation can be as simple as documenting who visits an exhibit or participates in a program, or it can be as complex as a study of what visitors learned. Generally, the results of summative evaluation will be used to improve future activities through an understanding of existing programs. Summative evaluation uses a variety of methods at the conclusion of an exhibition or program to check whether it delivered the messages that were intended and what learning occurred, how satisfied people were with the program, and how well the marketing strategy performed. It is conducted on the finished exhibit or program and its components, using a combination of internal sources (project team, other staff) and external feedback (visitors, special interest groups, others).

The aims are to:

• Give feedback about achievement of objectives
• Provide information on how a program is working overall, how people use it, what they learn from it, or how they are changed
• Provide reports, plan for future projects, suggest research, identify problems with visitor usage, interest, and learning, identify successful strategies, layouts, etc.
• Identify the relationship between the program costs and outcomes through a cost/benefit analysis

Museum evaluation is part science, part art. A good evaluator uses scientific method through interviews, observation, and testing; creates a hypothesis; and then tests the hypothesis. There is a necessary level of trust with an evaluator. I have worked with several talented evaluators. They can "see" from the visitor perspective and can hypothesize solutions to test.

In the Museum Toolbox, you will find samples of completed evaluations, sample questionnaires, and mapping of the visitor. Each evaluation study is

designed to meet the specific needs of the institution, exhibit, or program. Exhibition evaluation is a process that starts before exhibition design and continues throughout the life of an exhibition.

What if your evaluation report comes back with glowing feedback and the exhibition is perfectly meeting its objectives, but the museum is empty?

I often think of exhibition development as a funnel. You feed lots of exhibition ideas into the top of the funnel and see what comes out the bottom. Museums need to review potential exhibitions for:

Mission: Does the exhibition meet the museum's mission and advance the field of museums and the exhibition topic?
Revenue: Will the exhibition be a draw for visitors? Will the exhibition increase museum attendance?
Visitor needs: Does the exhibition fulfill a community need? Is the museum's audience interested in the proposed content?

I often propose a matrix approach. Create a matrix of the museum schedule, identifying each gallery over a period of three years. Then look at the proposed exhibitions at any period of time and see how each exhibition meets the museum's mission, revenue, and visitor needs. Then you can start feeding the top of the funnel with new exhibition ideas and have the exhibition evaluator, director of finance, community advocate, and visitor advocate weigh in. Often, it is good to assign a small amount of money to exhibition development for each new exhibition idea, and then make decisions once the evaluation team has gathered enough data.

I have been watching with great interest the recent changes at The Museum of Contemporary Art (MOCA), Los Angeles.[5] Museums need to balance the academic with the popular. It is clear that MOCA swung too far to the "self-interested," popular side of the spectrum. I am sure that the proposed controversial exhibition on Disco ("Fire in the Disco") would have been popular, and I am confident that such an exhibition could have had a positive exhibition evaluation. But would the exhibition have met MOCA's mission? I would say no. It seems the board of directors agreed.

CONCLUSION

I realize that I have extended the definition of evaluation beyond the typical definition of exhibition evaluation only. In my experience, many of the issues of a museum's operations are outside of what can be captured in a typical museum evaluation. If the museum parking lot has insufficient parking, the air

conditioning is not working, and the staff just went through a layoff, a typical exhibition evaluation is of little value. I believe the same process of evaluation can be applied to the entire visitor experience, including the previsit, the in-person museum experience, and the postvisit, to fully understand the visitor's experience and address the barriers to communicating the mission and educational objectives.

NOTES

1. Parts of this section first appeared on "Museum Planner, Museum Exhibition Design Part VI," http://museumplanner.org/museum-exhibition-design-part-vi/.
2. http://nsf.gov/funding/.
3. http://www.imls.gov/applicants/available_grants.aspx.
4. http://arts.gov/grants/apply-grant/grants-organizations.
5. http://www.moca.org/.

Chapter Eighteen

Museum Operations

An operational plan is a list of the routine tasks performed at the museum and a description of how these tasks will be performed. Creating this plan is a key step in the development of a new museum. But before an operational plan can be completed, the following items should be designed and created:

1. Vision statement: Often developed by the museum's founder
2. Mission statement: Approved by the board of directors
3. Museum branding document: Developed by the staff and approved by the board
4. Strategic plan: Created by the staff and board and approved by the board
5. Museum feasibility plan: Created with input from staff, approved and accepted by the board

The goal in developing an operational plan is simple but absolutely key: to create an enjoyable visitor experience. Museums are spaces for informal education; the task is to create a memorable, pleasurable learning experience.

When I was at Discovery Science Center, I had an opportunity to work with Disneyland park operations staff. It was an amazing learning experience. The Walt Disney Corporation considers every touch-point between Disneyland park staff and a visitor crucial. At Disney, every staff member—from the parking lot attendant to security positioned at the exit—is given thorough customer service training. They know that every staff and visitor interaction is critical to a pleasant visitor experience. Many museums have sent their museum staffs to the Disney Institute[1] to better understand great customer service.

An issue with some museums is an "inward focus" or an attitude projected by staff members that communicates an irritation with visitors. The key to a great museum visitor experience is an "outward focus," or an attitude that

projects a joy in sharing the experience the museum has to offer. Throughout this book, I refer to this attitude as one of hospitality. I believe it is one of the three core elements of the world's best museums (along with mission and collections). In the Museum Toolbox, I have included an essay on museum hospitality. Before visitors arrive at your door, they had to express an interest to spouses, kids, or friends in visiting the museum, find the location of the museum, and plan a day around visiting the museum. The time that visitors spend commuting to and from the museum is as long or longer than the time they spend inside it. Be grateful for their time and thank them.

Interaction with your visitors begins before they even step into the museum. It is important to consider these ten important touch-points of museum operations, and their impact on the visitor experience.

WEBSITE

Set up the navigation of the museum's website by order of importance of information:

1. Address and phone number of museum
2. Directions to the museum in a printable and emailable format
3. Ticket prices
4. Current exhibitions
5. Membership information
6. "About the Museum"

The website's look and feel should be consistent with the museum's brand and give visitors a sense of what to expect before they arrive. Samples of great museum websites are included in the Museum Toolbox. Plant the seed of museum membership before the visitor gets to the museum. As a good ticketing strategy, the cost of a family membership should be less than the cost of two visits to the museum for a family of four.

Other items to include on the website: a link for donations, links to all social media feeds, and a link to sign up for correspondence, such as a newsletter.

ACCESS

Plan for first-time museum visitors. The visitor will need directions, so be sure to offer information for all transportation types on the website (car, bus, subway, and bicycle). Work with the city to include signage to the museum on highways and subways. Offer services and information for all types of

visitors, including nonsighted (guide dogs, Braille, audio guides, tactile models). If the museum has a charge for parking, include the parking fee on the page with directions and the page with admission prices.

ENTRY/LOBBY/MAPS

Include a printed map of the museum at the entrance to help orient visitors as they navigate the museum (the map should also exist on your website). Erect signage from the street, sidewalk, and parking lot to the museum's entrance. Greet museum visitors at the door or in the main foyer. During operating hours, there should be museum staff at the entrance to answer questions and hand out information about the museum. Once visitors are in the museum building, they should have sufficient space for groups to gather and make plans before ticketing. Design your lobby for peak days. During a peak day (Christmas holidays, summer vacations), estimate the approximate number of people that may be in the lobby at any one time.

BATHROOM AND COAT CHECK

Often, museum visitors will like to use the bathroom before buying their museum tickets. Have bathrooms in the lobby, clearly marked. Have a place for visitors to check their jackets, backpacks, and strollers. At a smaller museum, this may be combined with ticketing.

TICKETING AND CASH HANDLING

Your museum may be small, but have a printed sign that outlines the price of museum tickets that visitors can read before they approach the ticket booth. Many museums have a "pay what you can" policy. Train staff to approach families that may be unable to pay the museum's full admission costs. The museum ticketing staff are often the hardest working staff at a museum. Spend the time to make sure these frontline staff are well trained and friendly. Have systems for cash handling. Have a senior staff member who oversees cash handling. Cash should never be counted at the ticket counter, and there should always be at least two people present when cash and receipts are counted.

WAY FINDING

Provide way finding for different learning styles. I am a believer in having a museum lobby that provides a view of the entire museum. An example might

be the lobby of Children's Museum of Indianapolis, which features a four-story lobby from which visitors can see all of the floors of the museum. Way finding through the museum needs to be consistent. Systems include color coding each floor of the museum's signage and providing maps (printed and tactile) at the entrance and exit of the elevator. Whenever possible, provide information on the recommended ages for each gallery.

EXHIBITS

The two most common elements for visitors to comment on during an exit interview are the interactive exhibits and floor staff. Museum visitors can mistake confusing interactive exhibits as broken. From an operational point of view, if the exhibit can't be used by the visitor, the exhibit is not functioning. In the Museum Toolbox, you'll find a museum exhibit maintenance checklist.

Museum visitors seldom know if museum floor staff belong to the security, education, or maintenance department. All floor staff need to be recognizable as interpreters and educators. Museum employees and volunteers on the exhibition floor should be presentable, wearing a name tag and having access to a walkie-talkie or telephone. It makes no difference if the staff is the director or someone from maintenance; all staff members should be able to provide excellent customer service. If you are asked a question by a visitor and don't know the answer, contact the proper person by walkie-talkie or phone and wait with the visitor until the visitor receives the answer.

The museum's exhibition spaces are the reason the museum exists. If you see a piece of trash on the floor, pick it up. If you see a visitor in need of help, offer your assistance.

CAFÉ

Even if the space is only a picnic bench outside the museum, provide a space to allow visitors to talk about their experience. Some museums have only a vending machine and a small room; others have a high-end restaurant. Both are equally important. We all require time to process and share a museum experience. Provide visitors with a comfortable space to have a simple snack and talk about their museum visit.

CLEANLINESS AND AMENITIES

It may seem obvious, but unclean bathrooms are a frequent complaint. Unclean bathrooms are not a cleaning issue, but an issue in the reporting process.

The cleanliness of a museum's bathroom is a key component of the visitor's impression. The review of bathroom cleanliness requires review of a third party. If maintenance staff are responsible for cleaning, a separate department should review their cleanliness.

Provide the needed amenities for your museum's audience. Examples include prayer rooms, needle disposal for diabetics, diaper-changing stations, and available wheelchairs.

SAY "THANK YOU"

All museums should have a staff member at the exit to say, "Thank you for visiting. Did you have a good time?" This question is the museum's opportunity to gain feedback. After the question is asked, look the visitor in the eye and wait. If there was an issue with the visitor's experience, have the exit staff address the issue. The exit staff should have access to free passes and business cards of senior staff. Issues happen at every museum, but the difference between good and great customer service is addressing them. Make sure the person at the exit invites visitors back for another visit and has membership brochures available and information about becoming a donor. Social media information should also be available at the museum's exit.

During museum planning sessions, I conduct an exercise called "The Parking Lot Talk." Have your floor staff imagine that a family of four (mother, father, eight-year-old girl, and twelve-year-old boy) has just finished spending three hours visiting your museum. Ask the floor staff what the family is talking about. As a group, they can come up with parts of the conversation by each member of the family. What did each family member enjoy the most? What made them excited?

It might seem contrived to script visitor interactions, but the museum should be prepared for different types of visitors' interactions.

Remember that the goal of all museums is a pleasurable, memorable educational experience. The way to achieve this goal is to make sure all museum staff members have an outward, visitor-centric approach. The visitor must come first in all interactions and planning. Create an operational plan that supports the visitor experience.

NOTE

1. http://disneyinstitute.com/.

Chapter Nineteen

Museum Accessibility

When defining the museum visitor, let's start will the term "user." User implies that the visitors are using the museum for their specific needs. Each of us is a different type of museum user and a different type of learner. How do we create a museum experience for all users of the museum that is ecologically sustainable—and that has zero waste?

USERS

We all have traits that make us different. It is useful to think of these traits as differences, not disabilities. Museums provide a safe and secure environment for all users.

I prefer the term universal design rather than the one of "meeting ADA," the federal legislation known as the Americans with Disabilities Act, enacted in 1990.[1] Often people will ask, "Does this exhibit meet ADA?" ADA is currently the strictest standard for "people with disabilities." Words are important. I don't believe anyone wants to be referred to as "disabled."

I am a fan of the Reggio Emilia[2] approach to learning. During World War II, the Italian town of Villa Cella was destroyed. The inhabitants in the town had to start over and rebuild. Before rebuilding, the villagers decided, as a community, that children were their future. As group, the village's inhabitants researched and developed an approach now referred to as the Reggio Emilia approach.[3]

As an example: a teacher might suggest an activity, such as a visit to the local firehouse. The students will then be asked questions. "How are we going to get to the firehouse?" The teacher will discuss different travel options

with the students, but the relationship has changed. The students are now "researchers," involved in a journey to the firehouse. The class might decide with the guidance of the teacher that the best way to go is by public bus. The teacher might ask, "How long will it take to get to the firehouse?" Together, the students will work on the distances and time required. On the day of the trip, parents and friends of the students will gather on the streets of the public bus route and cheer the students on their journey. Parents are part of the journey encouraging the explorer-students. The Reggio Emilia approach encourages the children to be partially responsible for their own education and encourages them to explore in their own ways.

One of the traits of a Reggio Emilia classroom is its beauty. The traits of a Reggio Emilia classroom include:

• Central piazza
• Transformability and flexibility
• The Atelier
• School-as-workshop
• An inside-outside relationship
• Transparency
• Communication

Why am I discussing the Reggio Emilia approach in this section about accessibility and sustainability? It is a philosophy. If you have ever stayed in a "handicapped-accessible hotel room," it is obvious that beauty was never in the mind of the hotel room designer. There is little value to an accessible and ecologically sustainable museum environment that is not inspiring. This is often lost in the effort of meeting "ADA guidelines." That is why I prefer to use universal design as a guideline.

None of this is to say that museums should not be ADA compliant; of course museums need to meet ADA guidelines. I am proposing a higher standard than ADA—that of ADA and universal design combined, meeting all of the guidelines of ADA and creating museums that meet the principles of universal design:

1. Equitable use
2. Flexibility in use
3. Simple and intuitive
4. Perceptible information
5. Tolerance for error
6. Low physical effort
7. Size and space for approach and use[4]

In the last couple of years, there have been several new programs at museums that are good examples of universal design. These include:

1. The Metropolitan Museum of Art's Resources for Visitors on the Autism Spectrum[5]
2. The Smithsonian Institution's Sensory Map: "The tool attempts to rate levels of intensity across the auditory, visual and tactile domains produced by individual exhibits."[6]
3. Children's Discovery Museum of San Jose's "Inspiration Station," an online autism spectrum resource[7]
4. The Museum of Modern Art's Alzheimer's Project: Making Art Accessible to People with Dementia[8]
5. The National Museums of Liverpool, "House of Memories," a training partnership for nursing staff, museums, and those living with dementia[9]
6. The Metropolitan Museum of Art's "A Resource for Dementia Care Partners," an online guide to the museum for caregivers of visitors with dementia[10]
7. The Indianapolis Museum of Art's "Touch & Audio Descriptive Tours" for visitors with low vision or vision loss[11]

Each of these programs goes beyond meeting ADA. They provide a museum experience for all users, which should be a goal for all museums.

ZERO WASTE

When I started working at the Children's Museum of Manhattan,[12] one of my first projects was "Sounds Fun" (1994), a new exhibition on the first floor of the museum. Before we started to design the exhibition, we created a prototyping space. We started by removing the previous exhibition. First, we removed the artifacts and saved whatever exhibition cases we could. Then we rented two dumpsters and demolished the previous exhibition, filling the two dumpsters with waste. This was an eye-opening experience for me. Previously, I worked at Liberty Science Center as part of the "start-up" staff; we installed all the new exhibits and opened the science center. It hit me that the exhibits I worked so hard to install at Liberty Science Center would later become landfill, and one exhibition is enough to fill two dumpsters.

I have been part of creating exhibition shops at three museums. In addition to the Occupational Safety and Health Administration[13] requirements, I became more and more sensitive to the amount of waste a museum exhibition shop creates. I have worked at both museum exhibition shops and contract

shops, and I can say that for-profit shops tend to be more sensitive to waste and recycling than most museum exhibition shops. You would think the opposite: wouldn't a museum with fewer resources be more careful with those resources? Often it is an issue of staffing, as most museums have limited staff resources. It is often easier to throw out than to recycle or reuse.

There are several very good museum exhibit collectives that share old exhibits. One of the largest is the National Park Service (NPS) collective, with a Listserv for NPS sites to share exhibits. Often these exhibits are available to other venues if the NPS sites are unable to use them. In the Museum Toolbox, you will find a link to the NPS Listserv and the other museum exhibit collectives for sharing used exhibits.

The waste elements in a typical museum, in order of maximum waste:

1. Restaurant (paper plates, paper cups, cardboard boxes, napkins, food scrap)
2. Office (paper, cardboard, food waste)
3. Retail (cardboard, packaging, marketing)
4. Exhibitions (used exhibits, exhibit fabrication waste)
5. Public trash and ticketing (exhibit materials, marketing materials, used tickets)

Many cities and communities now require recycling; most of the waste of a museum can be recycled.

1. Composting
2. Cardboard recycling
3. Paper recycling
4. Wood scrap
5. Metal scrap
6. Electronic recycling

Many museums now have bins on their loading docks for each type of recycling. If handled correctly, 100 percent of a museum's waste can be reused or recycled.

A best practice of museums is to create a document to track waste by department and approximate amount, and set a goal of 100 percent reuse or recycling. Setting up and operating such programs can often be handled by volunteers from local high schools.

One of my favorite museums is the City Museum[14] of St. Louis, Missouri, a wonderful museum built almost entirely by artists out of recycled and reclaimed materials. An artistic reuse of an exhibit can sometimes be as interesting as a new exhibit.

CONCLUSION

A goal for all museums should be to create an integrated museum experience for all users that results in zero waste and communicates the museum's educational content. I have found that it is important to start with an inclusive philosophy and work to reach different users with the content. This approach is far easier than trying to make an exhibition accessible after the fact and ending up with the "handicapped-accessible hotel room" effect. The Reggio Emilia approach to inclusion works to apply the principles of universal design and zero waste. The goal is to create a "temple of the muses" for all users— and generate zero waste.

NOTES

1. U.S. Department of Justice, "ADA standards for accessible design," http://www.ada.gov/2010ADAstandards_index.htm.
2. http://reggioalliance.org/.
3. http://reggiochildrenfoundation.org/?lang=en.
4. http://www.ncsu.edu/ncsu/design/cud/about_ud/udprinciplestext.htm.
5. http://www.metmuseum.org/events/programs/programs-for-visitors-with -disabilities/visitors-with-developmental-and-learning-disabilities/for-visitors-with -autism-spectrum-disorders.
6. http://www.si.edu/Accessibility/NMAH-Sensory-Map-Guide.
7. https://www.cdm.org/visit/plan-your-visit/inspiration-station/.
8. http://www.moma.org/momaorg/shared/pdfs/docs/learn/GuideforMuseums.pdf.
9. http://www.liverpoolmuseums.org.uk/learning/projects/house-of-memories/ about.aspx.
10. http://www.metmuseum.org/events/programs/programs-for-visitors-with-dis abilities/visitors-with-dementia-and-their-care-partners/~/media/Files/Visit/dementia resourceforcarepartners.pdf.
11. http://www.imamuseum.org/blog/2013/12/04/making-art-accessible-to-low -vision-visitors-2/.
12. http://cmom.org/.
13. https://www.osha.gov/.
14. http://www.citymuseum.org/.

Chapter Twenty

Museum Research

The doctrine of public trust, dating back to the fifth century and Byzantine Roman Emperor Justinian, applies to museum collections. The objects of the collection are stored, protected, and displayed for the benefit of all. And they are also made available for research.

Visitors to the Ellis Island Immigration Museum,[1] part of the Statue of Liberty National Monument, can research family members who immigrated to the United States through Ellis Island. For a small fee, visitors can view available ship manifests and family photos. The majority of museums in the United States are local history museums that often include historical societies. Local historical societies work in a way similar to Ellis Island, allowing visitors to research their family histories. Museums store and preserve the cultural heritage for the benefit of the public. Ellis Island staff and volunteers have scanned and catalogued thousands upon thousands of documents, and have set up databases and information technology systems to allow the public access to this historic material.

Once an object has been accessioned by a museum, it has passed a test and is deemed of cultural or scientific significance. The object is now worthy of greater understanding. In the process of building a museum's collection, other objects are reevaluated. Objects in a museum's collection may be studied by the public, as well as by curators, conservators, or scientists. The goal is the same: to better understand the artistic merit or the historic or scientific significance of the object.

In the past, museum curators worked in a sort of tenured security. They pursued their career-long research and study free of concern about losing their jobs. Recently, that has changed. There are more instances now of museums hiring nonstaff, contract curators, and researchers whose work for the museum may be temporary or project-based.

Even so, the goals of museum research remain the same: to help the museum understand its collections and their audiences more deeply and thus lay the foundation for producing more successful exhibitions. The types of research can include curatorial research, scientific research, conservation, and preservation research.

The output of museum research is shared with the public in different forms:

- Lectures
- Publications (print and digital)
- Public databases
- Research libraries
- Tours

Although research is vital to museums, sadly enough there is a trend away from research within the museum. Often, the issue is funding. Many museums, especially smaller museums, are challenged to keep the museum financially sustainable in its daily operations. There is insufficient funding for serious research. This can have negative results. A lack of in-house museum research can make exhibition development more difficult, and the exhibitions themselves may lack the necessary scholarly depth.

NOTE

1. National Park Service, "Conducting family history research in Ellis Island," http://www.nps.gov/elis/forteachers/conducting-family-history-research-on-ellis-island.htm.

Chapter Twenty-One

Collections Care

Although the specific policies and procedures for the care and protection of the museum's collection might appear expensive and cumbersome, collections care can be achieved through simple solutions. It is not the specifics of the equipment that is important, but the process and procedures that are at the core of collections care. In the Museum Toolbox is a list of museum collection resources, including many inexpensive solutions.

I highly recommend the American Alliance of Museums' Museum Assessment Program or the American Association for State and Local History's Standard and Excellence Program. Both programs can lead to museum accreditation, the museum profession's seal of approval, and acknowledgment that the highest standards have been met. The programs include peer reviews that can become part of strategic planning for the museum.[1]

At the core of museums are the mission and collection. The collection is used to support the mission of the institution. The museum's mission guides the accession, deaccession, and loans of the collection. The collection is technically owned by the public, but the responsibility for its storage, protection, and care lies with the board of directors in a legally binding agreement. It is of great importance that the members of the board understand their responsibilities. It is considered a best practice to perform background checks on potential board members and ask them to sign an agreement outlining the museum's constitution and bylaws.

It can often seem like a tremendous amount of work to care for and protect the museum's collection. Museums by definition are public organizations, one of the four cornerstones of civil society: civic organizations (clubs, associations), libraries, universities, and museums. These are all nongovernmental organizations in service to society. When a museum accepts an object into its collection (by gift or purchase), the object is to be protected in perpetuity

for current and future generations. The objects are considered beyond value because of their cultural significance.

Most museums have several types of insurance including, officers' errors and omissions, fire, theft, and business liability. Board members are the legal officers of the 503(c)(3) organization. The appointed officers of the board are legally responsible for the museum's collection. With the exception of criminal intent, the museum insurance (errors and omission, business liability) will cover mistakes made during accession or transfer of an object to the museum's care.

Previous ownership, known as provenance, must be satisfactorily established. Provenance is one of the most important issues of a museum. It should prove who had previous ownership of an object—person, institution, or government. This traceable lineage becomes very important.

Here is an example. A painter works in the studio and creates a painting. The painting is signed and dated by the artist. The artist's gallery has an exhibition of the work. Accompanying the exhibition is a catalog with a photograph of the painting, including the date the painting was made, the title, and a description. A collector purchases the painting from the gallery and is given an invoice for the purchase, containing the name of the artist, the artwork title, year the painting was created, dimensions, and medium (such as oil on canvas). The collector also has a copy of the exhibition catalog. It is unusual for an artist to document an artwork; it is most often left to an artist's gallery. On the frame of the painting, the gallery attaches a small label with the name of the gallery, the name of the artist, the title of the artwork, and the year of the artwork. This label is important: it provides part of the lineage of the artwork.

Art galleries are for-profit businesses working on behalf of an artist to promote and sell the artist's work. Art galleries and auction houses serve an important role in the "ecosystem" of museums. Museums often accession and deaccesion art through art dealers or auction houses. Auction houses tend to receive greater attention for the sale of important artworks. Often, art galleries work quietly as intermediaries on behalf of artists, museums, and collectors. Many sales of art happen in private through the intermediary of an art gallery. An example is an art gallery representing the estate of an important artist working as a "match maker" between potential collectors or museums. Often museums or collectors want to keep accessions or deaccessions private. Art galleries and auction houses also adhere to codes of ethics.[2]

Back to our collector who has recently purchased an artwork. He has accepted delivery of the painting and adds it to his insurance plan. Some insurance companies will require an appraisal in addition to the invoice from the gallery to establish the true market value of the artwork. Most responsible

collectors will keep copies of invoices showing the purchase of the artwork. They will also keep the label of the frame of the painting intact and will keep the gallery exhibition catalog as part of the collection. A curator might contact the collector to request that the painting be part of a museum exhibition, or the collector may decide to donate the painting to a museum. This sort of provenance is ideal: the painting went directly from the artist to gallery, to collector, to museum. The collector can show ownership of the painting and, if the painting is deemed to be a good addition to the museum's collection, the museum may decide to accept the painting as a gift. Most likely the painting will include the donor's name when the painting is exhibited. All of this information becomes part of the record detailing the accession of the painting into the collection of the museum.

Many pieces of art and artifacts have less obvious provenance, such as archeological artifacts, art from a secondary or tertiary market, or art that has passed through many hands before arriving at the museum.

Here is the typical life of a museum object/artifact:

1. Object is created (by artist, designer, scientist, or historic event)
2. Object is given importance by its history, artist merit, or cultural significance
3. Object is evaluated by a museum for meeting mission and role within collection
4. Provenance is established, including cost, artist(s), date, materials, significance
5. Current ownership is established
6. Documented with photos and measurements
7. Accession or acceptance of loan
8. Appraisal
9. Insurance
10. Evaluation by conservator
11. Evaluation by historian
12. Quarantine
13. Registration
14. Cataloguing
15. Conservation
16. Photography
17. Nomenclature
18. Storage
19. Display
20. Research
21. Sharing with other institutions through loans

Aside from a museum purchasing artifacts, there are also donations, partial donations, loans, and gifts. The registration number of each artifact will show how it entered the museum. Traveling exhibitions will contain a registration manual with registration numbers and condition reports for every object of the exhibition. The exhibition will not receive a registration number from the host museum, but will use the registration and condition reports of the lending museum(s). Most often, traveling exhibitions are assembled by a museum or by associations such as the Smithsonian's SITES[3] or by for-profit companies.

TRANSPORTATION AND CLIMATE CONTROL

Whether an object is moved ten meters or ten thousand kilometers, there is a risk to the object. Most often, damage to a museum object happens during transport. Objects are safest in storage; the storage conditions can be controlled to the specific requirements of the object. This is referred to as climate-controlled storage, a specific environment created to meet the needs of the object. Most often objects with similar requirements are stored together: paper, paintings, metal, etc. Contamination between objects is a concern. Mold, pests, and diseases such as bronze disease can spread from one object to another. For this reason, objects are held in quarantine before entering the primary museum buildings. The quarantine area is a secure space adjacent to the loading dock for conservators to inspect objects prior to entering the primary museum buildings. A best practice is to have the heating, ventilation, and air conditioning system of the quarantine area on a separate system from the rest of the museum. Mold and bacteria can become airborne and infect a collection through shared vents.

It is also considered a best practice to keep exhibition crates and packing materials separate from collection storage. As crates and packing materials travel from venue to venue, they can contaminate the collection storage.

Transportation can have different requirements for transportation within the museum, limited-use transportation, or multiple-use transportation. The collection storage area should have a small area for inspection. As a best practice, all objects in a museum's collection are inspected at least once a year.[4] The inspection may be a simple review to confirm the location of an object. If the object has not left the building or the threshold of the climate-controlled storage, a full condition report is not necessary. In this case, the object is not touched but will only be confirmed as being in its designated location. A note is placed in the registration document. Whenever an object is touched or moved, there is a chance of damage to the object. All handling and movement should be done as little as possible.

It can be tempting to offer board members or potential donors a tour of the storage area. Storage is considered a controlled space and the fewer people that enter the space, the less the risk of contamination, damage, or theft. Changes in climate can damage art; larger museums will have areas for acclimation of objects. Temperature and/or humidity are adjusted prior to transportation.

When a painting is to be reviewed by a curator for possible inclusion in an in-house exhibition, the curator will make an appointment with the collections manager or registrar. In most museums, curators do not handle art. Only art handlers, registrars, collections managers, or conservators ever touch art or collection objects. The art handler or the collections manager will record in the registration document that a curator is going to view a specific painting. Usually the only people allowed into climate-controlled storage are collections managers, art handlers, conservators, and registrars. A best practice is to have a collections policy that includes specific security guidelines for climate-controlled storage. Often climate-controlled keys (cut keys and electronic keys) are issued only for a limited number of people. Prior to the object leaving climate control, the collections manager, registrar, or art handler will confirm the registration number, artist, and title requested by the curator. The art handler, collections manager, or registrar will review the previous condition report and make note of the object being requested by the curator and any changes from the previous condition report.

The art handler rolls the object to a viewing area outside of the climate-controlled area so the curator can view it.[5] The art handler, collections manager, or registrar will stay with the object while the curator is viewing it. The object is under the control of the art handler, collections manager, or registrar while the curator is viewing it. The curator will not touch it. The art or object is not to be photographed without specific permission; the object can be viewed only. Once the curator is finished with the review, the art is returned to its location and the registration document is updated.

This process sounds expensive and complex, but it is necessary. In small museums, the process and procedures are more important than the specifics of the facility. The climate control may be only a small storage space, such as a closet off the museum entrance, and the inspection area may be the director's office. It is the process that is important.

1. Quarantine
2. Inspection
3. Acceptance
4. Registration
5. Placement in storage
6. Request for review

7. Registration
8. Condition report
9. Movement of object
10. Control of object at all times by trained personnel only
11. Return to storage
12. Update of registration

The same process is extended for limited-use transportation. When an object is leaving the museum to be part of an exhibition at a satellite location, it may be packed in glassine (acid-free paper), plastic, bubble wrap, and cardboard for transportation. All other steps are the same, with the addition of a bill of lading or transfer. Whoever receives the art will sign a document accepting responsibility for the object. Only art handlers, registrars, or collections managers will have permission to handle the object. Once the object is unwrapped, the condition report is updated. As the object is still within control of the same museum (the satellite in this example is part of the museum, but at a different location), the same insurance policy covers the object.

For multiple-use transportation, a curator requests an object to be part of a multicity, multimuseum traveling exhibition. Prior to the loan, the lending museum would request:

1. The names of all participating museums, as well as contact information (typically the art handler, registrar, or collections manager)
2. A facility report from each hosting facility, with specific details on pest control, security, building type, and specifics of heating, ventilation, and air conditioning systems
3. Insurance information—typically the museum hosting the traveling exhibition will create a policy to cover the duration of the exhibition
4. The registrar, collections manager, or director/chief executive officer agrees to the loan and signs the loan agreement

All other steps are the same as the limited-use transportation: quarantine at each venue, condition reports at each venue, and limited handling by art handlers. It is imperative to follow this process. The collection is irreplaceable and needs to last for generations. Records are paramount.

Different systems are occasionally required for multiple-use transportation when the objects and supporting materials are going to multiple museums:

• Crates are built to be opened and closed multiple times.
• A registration system is created for the life of the exhibition, to be updated every time the objects are handled.

- Educational materials are developed and included in the shipment.
- Cases and mounts are built for exhibition display and are transported along with the object.

In the Museum Toolbox, you will find documents specific to traveling exhibitions, including trucking, crating, loan agreement, art handling basics, and insurance.

PRESERVATION AND CONSERVATION

All art and artifacts deteriorate with time. Museums preserve and conserve their collections for future generations.

Preservation: Activities associated with maintaining library, archival, or museum materials for use, either in original physical form or in some other form.
Conservation: The treatment of library or archive materials, works of art, or other museum objects to stabilize them physically, sustaining their survival for as long as possible in original form.

All museums preserve. By using archival materials, limiting the exposure of the objects, and protecting them, you are preserving them for future use. The Smithsonian's Museum Conservation Institute is a center for specialized technical collection research and conservation.[6] Most small museums do not have conservation labs; they contract freelance conservators to work on objects of the collection. Sadly, most museums now outsource conservation. Maintaining conservation staff is an operating expense, not a capital expense, which is more difficult to justify financially.

REGISTRATION

There is no worldwide standard for museum registration. Consistency is most important for registration. If the museum has an existing method, do not change the system without a test program and careful consideration. Even if the museum has a system and it is only partially working, it is better to fix an existing system than try to implement a new one. The International Council of Museums has excellent guidelines for registration, and the American Alliance of Museums publishes the "bible" of museum registration, *Museum Registration Methods*, fifth edition.[7]

A simple system used by many small museums is just a bound notebook, kept in a fireproof lockbox, containing a list of the museum's collection, with locations and condition reports. There is not one system of registration for all museums. I use the National Park Service (NPS) as the standard. Most art museums will adhere to American Alliance of Museums standards; most museums outside of the United States will adhere to the International Council of Museums. Most history museums adhere to American Association for State and Local History or NPS standards, and most zoos and aquariums in the United States to the Associations of Zoos and Aquariums.

As an example, the NPS standard is an eight-digit catalog number, 00-000-000; the first two digits reference the year of accession: (2014) is 14-000-000. The second set of digits is the accession number; if it is the twelfth piece donated or purchased by the museum, the number would be 14-012-000. If the donation is a set of six teacups, each teacup is then assigned a number, one through six, or 14-012-001 through 14-012-006. This is a basic system but thorough enough for most. Of course, registrarial methods become much more complex with larger collections. For greater detail, refer to the bibliography.

PHOTOGRAPHY AND ONLINE

Placing your collection online to provide previsit information is very important for small museums. Many computerized collection management systems offer the ability to place collections online as part of the registrarial process. Small museums can leave the work of digitizing a collection to volunteers and interns. The Museum Toolbox contains a step-by-step guide to placing your collection online. One solution for many museums is crowdsourcing of digitizing the museum's collection. Museums can create an Instagram or a Pinterest account so that visitors to the museum can take photos of themselves and the museum's collection. This is still a very new area and the guidelines are not yet clear. Museums never allow flash within the building, as the flash can deteriorate art, such as works on paper.

Museums can grant permission to photograph works that are fully owned by the museum. Museums cannot grant permission to photograph works they don't own, unless the lender allows it. This has become a difficult issue for museums. The "museum selfie" is a craze. There are worldwide "museum selfie days" on Twitter, with tens of thousands of participants.

On one hand, these types of photographs create a sense of community and involvement with the museum. On the other hand, people have accidently

bumped into art while taking a photo. It is clear that this can be a risk to the collection.

I would consider the Cleveland Museum's Gallery One[8] a model of best practice for photography. The museum has digitized parts of the collection and visitors can curate their own collection, either online or from a smartphone app prior to the museum visit. Then during their visit they can use their collection app to gain greater information about each piece of the collection. With systems like Gallery One, there is less desire to photograph the collection in the gallery, because visitors already own it on their phones. The collection is safer and the visitor can gain greater information and connection to the collection. Similar systems are now available online for museums to create such apps. Please see the Museum Toolbox for links.

The world of online museum collections is changing very quickly. For all additional information regarding museums online, visit my website (www. museums101.com), updated regularly. Purchasers of this book will have free access to updates using the password museumtoolbox.

DISASTER PLANNING

Disasters do happen. I have been at museums when water pipes have cracked or when fires have broken out. Sometimes the damage is limited to walls or spaces without artifacts and collections will remain undamaged. A written disaster plan is considered a best practice and is a requirement for museum accreditation. A museum disaster plan includes contingencies for natural and manmade disasters, including fire, flood, earthquake, tornado, civil unrest, and security. A recent issue facing museums is terrorism. The Federal Bureau of Investigation has now created training programs for this concern. Information resources are available in the Museum Toolbox.

CONCLUSION

The process of collections care can be very expensive and time-intensive. The majority of museums are small history and general museums that operate with one or two staff, and often with all-volunteer staff.

Following these procedures may require only simple solutions, such as metal shelving, low-cost paper registration methods, simple thermometers, and hygrothermographs (versions can be bought for about twenty dollars, see the Museum Toolbox). Policies are important to put into place and

obey. An unknowing board member or donor might ask to borrow an artifact. You should understand why it would be considered unethical to lend an artifact frivolously. The responsibility of the care and protection of the collection is the role of the entire museum community, including the visitor, museum volunteers, museum staff, and board members. All who enter the museum also enter into an agreement of public trust. The rules of the museum are to be respected.

NOTES

1. http://www.aam-us.org/resources/assessment-programs/MAP, and http://tools.aaslh.org/steps/.
2. http://www.artdealers.org/.
3. http://www.sites.si.edu/.
4. http://www.nps.gov/index.htm.
5. An A-frame is a wheeled cart covered in carpet for the transportation of flat work within a museum.
6. http://www.si.edu/mci/english/about_mci/index.html.
7. http://icom.museum/professional-standards/standards-guidelines/, and https://www.aam-us.org/ProductCatalog/Product?ID=226.
8. http://www.clevelandart.org/gallery-one.

Chapter Twenty-Two

The Museum of the Future

The Internet is the technical innovation that has had the most profound effect on museums today. Museums now have staff Wikepedians,[1] and they host "Ask Me Anything" sessions on Reddit.[2] Visitors can curate their own collections[3] online and print three-dimensional duplicates of objects in a museum's collection.[4] Indoor global positioning systems will allow visitors to navigate the interior of museums via their smartphone.[5] Innovations are happening quickly.

Since the Great Recession that began in 2008, we have lived in a state of uncertainty. Many people feel that today's lower employment rate is the new norm for the United States and Europe. The speed of globalization has increased since 2008; people were forced to relocate to countries where they could find jobs.[6] In the United States, we have a shrinking middle class, while in Asia and Latin America there is a quickly expanding middle class.[7] In the United States, Latin America, and Europe, businesses struggle to find workers with science, math, and logic skills.[8] Many jobs such as architectural drafting, engineering, medical diagnosis, and data analysis are now outsourced to foreign firms.[9]

The once-majority blue-collar worker is becoming a minority, while a Spanish-speaking creative class is quickly expanding.[10] We also see dramatic changes in how different generations view the world. The interests and motivations of millennials are different from those of Generation X. Millennials, it is said, tend to have an inward sense of entitlement and even narcissism,[11] with a strong sense of community and a desire to make the world a better place. As the millennials mature, they are finding fewer job opportunities than their parents.

We are seeing a split between the first world decline of manufacturing and an increase of service sector jobs, whereas in developing countries we are

seeing a rapidly growing middle class that is interested in the same amenities enjoyed by the United States' baby-boomer generation. All the while, we see a decrease in natural resources. As David Suzuki explains, "using a simple analogy of bacteria in a test tube: the consequences of exponential growth of our society."[12] Although many of the consequences of this exponential growth are not all visible today, the effects could very well yield dramatic consequences.

As globalization matures, a new demographic has emerged: the "global citizen." They often work for multinational corporations. Because of the outsourcing of different divisions of their global companies, these workers travel often and tend to blend business trips with personal trips. Extending business trips by a couple of days allows them to shop and visit museums while abroad.

As the American and European middle class shrinks, the gap between the poor and the wealthy expands.[13] Simultaneously, there is a quickly expanding Asian and Latin middle class. These groups understand that education can greatly affect their children's ability to stay in the middle class or reach the upper-middle class with jobs such as doctors, lawyers, engineers, architects, and business owners.

Worldwide, couples are having children at an older age[14] and more marriages end in divorce, resulting in more blended families: couples sharing children from previous marriages.[15] Families now struggle to cover the increasing costs of living with stagnant wages.[16]

With the economic difficulties facing museums, some turn to corporations or other for-profit entities for partnerships that can blur the boundary between donor and content provider. Museums are facing greater challenges as greater technological innovations arise.

New estimates place the number of museums in the United States at thirty-five thousand, with the overwhelming majority (48 percent) being historical societies, historic houses, and sites,[17] with the second largest concentration of museums being general museums (33.1 percent) and history museums (7.5 percent). The categories of history and general account for some totaling 88 percent of museums. Art museums make up only 4.5 percent of U.S. museums. These data are fascinating. If you use the word "museum," most of the public will conjure up an image of the Metropolitan Museum of Art or another large art museum.[18]

We have an unbalanced museum landscape: the majority of museums are the "unseen" history museums or those falling under a general interest category. The United Kingdom has gone through a similar boom-and-bust scenario with the Heritage Lottery Fund Museum Projects.[19] To summarize the opinion of a panel at the University College London Institute of Archae-

ology[20]: "In general, museums are failing the public they are intended to serve."[21] Other comments include the following[22]:

In the era of stringent funding cuts, museums walk a fiscal tightrope, with many falling into the abyss and closing due to lack of funding and investment in the sector. It is, therefore, vital that new life and excitement are injected into museums if they are to survive, especially at a local level.

Museums need to stay up-to-date in areas such as digital technology, and give people the opportunity to engage with and question archaeologists' interpretations of the past.

Bob Bewley, Director of Operations at the Heritage Lottery Fund, highlighted the disconnection between museums and their local community, who do not see the museum as representing their past.

On the formal educational system in the United States:

In 2006, American students ranked [twenty-first] out of [thirty] in science literacy among students from developed countries, and [twenty-fifth] out of [thirty] in math literacy. In 2009, [U.S. fourth] graders showed no signs of progress for the first time in many years, and [eighth] graders tallied only modest evidence of progress.[23]

I believe we need to address the issues of the already operating museums while we continue to imagine and work toward the future of museums. Efforts to address the current issues of museums include the following:

- Greater collaboration between museum associations, creating standards between the International Council of Museums, the Canadian Museum Association, the American Alliance of Museums, the American Association for State and Local History, the Association of Science Technology Centers, and the Association of Zoos and Aquariums.
- International standards for museum accreditation.
- As part of the greater collaboration between organizations, an international agreement to co-promote museums. Museums often compete in markets instead of collaborating and co-marketing.
- An International Association of Museum Workers. The museum industry needs to create a system of mentorship and support for the staff of all museums. The Art Directors Guild[24] is one example of a similar interest group.

The future of museums should feature a community-based approach to the task of exciting the public about art, history, and science.

In 2005 [the Institute of Museum and Library Servces], together with Heritage Preservation, released the Heritage Health Index. The report was an in-depth look at the state of collections in U.S. libraries, archives, museums, historical societies, and scientific organizations. The results were sobering:

- 190 million objects held by archives, historical societies, libraries, museums, and scientific organizations in the United States are in need of conservation treatment.
- 65 percent of collecting institutions have experienced damage to collections due to improper storage.
- 80 percent of collecting institutions do not have an emergency plan that includes collections, with staff trained to carry it out.
- 40 percent of institutions have no funds allocated in their annual budgets for preservation or conservation.[25]

More than ever, museums need to provide safe places for intellectual experimentation and excitement. I am a believer in the power of technology, but the current issues of informal education are not ones of technology. We are living in an expanding global economy with stark differences between the haves and the have-nots. Museums can provide places for those who learn differently, while those who excel at school can put to practice their formal school experiences. Whether sketching in an art museum, being part of museum history research, or engaging in a science experiment at a museum, these activities are at the core of the family museum experience. I am a strong believer in small, community-based museums that are inexpensive to build and operate. When the new California Academy of Sciences opened in San Francisco in 2008 at a cost of $488 million, I estimated that the same funds could have built thirty community-based museums instead of one destination museum with admission costing $34.95 for adults and $24.95 for children aged four to eleven.[26]

I love the quote from Richard Feynman: "I couldn't do it. I couldn't reduce it to the freshman level. That means we don't really understand it."[27] Sometimes I wonder to whom the museum speaks or whether the museum itself understands a topic well enough to communicate the content to the public. It is a complex topic; museums need to meet their financial goal of sustainability but also need to attract visitors. In truth, the trend I am seeing is an increase in large, destination-based museums while smaller community-based museums struggle. There is a greater reliance on corporate sponsors and higher ticket prices. This could lead to a future of museums catering primarily to a wealthy clientele as they deliver content that has been provided by corporate sponsors with their own agendas. I would like to avoid this future.

A more hopeful example is Reno, Nevada. Nevada is a state with a large gaming industry. The Reno-Sparks-Carson City area has a population of less

than five hundred thousand.[28] Reno is home to the Nevada Art Museum[29] and The Discovery Children's Museum,[30] while the Nevada State Museum[31] and the Nevada Historical Society[32] are in nearby Carson City. The success of the Reno area museums is arguably due to a visitor-centric, community approach. The Nevada Art Museum makes efforts to include local and Nevada-born artists and even boasts a museum school.[33] I credit the success of Reno area museums to an "overlap approach." When I visited the Nevada State Museum, they made a point of directing me to visit the Nevada Art Museum, whose staff made a point of encouraging me to visit The Discovery Children's Museum. While I was in Carson City, I visited the Nevada State Railroad Museum,[34] and they directed me to the Historical Society. All of these museums are nonprofits working to bolster each other. I have referred to museums working together to create a synergy as an overlap approach or a "hub museum" approach. This approach is different from the destination approach, or the "world-class" museum approach, in which visitors to a region expect to visit one museum only. Others have referred to this as the Bilbao Effect, where the Guggenheim created a destination museum in the once-sleepy industrial city of Bilbao, Spain.

A number of these large, newly built destination museums are now suffering. Having been in this field for more than twenty years, I have witnessed how a surge of new museums creates a saturation point, resulting in the public and businesses failing to support these museums adequately.

The future of museums will likely be very different from today's museum experience.

Gamification: Museums are using high-tech computer games to engage visitors with museum content. Examples include the Tate Museum's "Race Against Time"[35] and "Artist Rooms,"[36] and the Detroit Historical Museum's "Building Detroit."[37]

Contacting the shallows: Author Nicholas Carr theorizes that we are losing our ability to think deeply due to instant access via the Internet (*The Shallows: What the Internet Is Doing to Our Brains*).[38] Will museums be able to compensate?

Maker movement: The Maker Movement has caught on at museums: there are maker spaces at the New York Hall of Science,[39] the Newark Museum,[40] and the Exploratorium.[41] Maker spaces are places where kids can "make and remake the physical and digital worlds."[42]

Selfie: A picture of yourself at a museum. January 22, 2014, was deemed Museum Selfie Day. Museum visitors used the hashtag #MuseumSelfie to post pictures on Twitter. That day 11,143 people participated and 5,591 photos of people at museums were posted to Twitter.[43]

Philanthropy: I believe that corporations, governments, and major donors will continue to provide the majority of museum funding. But there will be a shift to membership models, with a museum's community helping to financially support operations through crowd-funding.

Museum 4.0: The smart museum, through a previsit orientation, will be customized for the visitor through smartphone guides.

Technology: In conjunction with customized museum experiences through a smartphone will be iBeacons[44] and learning algorithms[45] that react to visitors' usage, as well as a continuation of "The Internet of Things."[46]

Research: Staff scientists, historians, and curators are in decline at museums. This trend needs to be reversed to keep museums fresh and to maintain their reputations as the most trusted source of information.[47]

Previsit, visit, postvisit: Home becomes part of the museum visit. The museum experience is extended and prolonged.

Community: Pinterest, Four Square, Yelp, Trip Advisor, Facebook, Twitter, Instagram, and newly developed smartphone apps will continue to be part of the changing landscape of museum communities, onsite and online.

Object significance: Genuine artifacts will have greater significance within the museum despite new technologies such as augmented reality. See the American Museum of Natural History's impressive selection of free apps.[48]

Intellectual property: This has been an interesting topic within the field recently. Although there are codes of ethics for museums, there is no code of how to treat intellectual property as it relates to museum exhibits.

Smaller, cheaper, faster: all museums have difficulty with these. The museum experience of sitting on a bench in a gallery, looking deeply at a painting and letting your mind wonder is the traditional and fantastic way to enjoy a museum. For this type of experience, the environment is one of whispers and hushed tones. It is a popular metaphysical meditation on art and its meaning. The museum is among the few remaining meditative experiences in modern life, and it is important to continue this tradition in the future. As more participatory experiences are on the rise, I see the art center model as a response. Art centers will create event-driven art experiences, history, or science events by quickly utilizing a community of enthusiasts. The New Museum[49] is a great example of using an art center approach applied to a collecting museum. Other examples are the Mattress Factory[50] and Big Car[51]; small, local art centers that attract international attention through a well-curated approach.

I don't see the "bricks and mortar" museum of the future being much different from the museum of today. Paintings will still be hung on walls, artifacts will be placed in cases, and interactive science exhibits and early

childhood experiences will remain primary. The differences I see are more about adding layers of content, facilitating access to that content and building community around it. In the future, the visitor will have much greater involvement in the creation of the exhibition through crowdsourcing and crowd-funding, and visitors will have a greater access to other visitors who share their interests. The museum itself will also meet the visitor at their interest level and within their demographic. The larger change will be seen in the "museum without walls" concept, where the museum experience will start at home or at school and will continue online anywhere a mobile device can be used. The visitor experience then becomes circular—repeat visitation will be driven by online communities.

NOTES

1. Choen, Noam, (2010), "Venerable British museum enlists in the Wikipedia revolution," http://www.nytimes.com/2010/06/05/arts/design/05wiki.html.
2. http://www.reddit.com/r/IAmA/comments/1n8w43/iama_anna_dhody_cura tor_of_the_mutter_museum_a/.
3. https://www.rijksmuseum.nl/en/rijksstudio.
4. http://3d.si.edu/explorer?modelid=27.
5. Vanhemert, Kyle, (2013), "4 reasons why Apple's iBeacon is about to disrupt interaction design," http://www.wired.co.uk/news/archive/2013-12/12/apple-ibeacon.
6. Alden, Edward, (2012), "Changing views of globalizations impact," http://economix.blogs.nytimes.com/2012/08/29/changing-views-of-globalizations-impact/.
7. Schwartz, Nelson D., (2014), "The middle class is steadily eroding. Just ask the business world," http://www.nytimes.com/2014/02/03/business/the-middle -class-is-steadily-eroding-just-ask-the-business-world.html; The World Bank, (2014), "Latin America no longer views Asia with envy," http://www.worldbank.org/en/ news/feature/2014/04/11/latinoamerica-ya-no-mira-con-envidia-a-asia.
8. Krugman, Paul, (2014), "Jobs and skills and zombies," http://www.nytimes .com/2014/03/31/opinion/krugman-jobs-and-skills-and-zombies.html.
9. New York State Department of Labor and Empire State Development, (2010), "The offshore outsourcing of information technology jobs in New York State," https://labor.ny.gov/stats/PDFs/Offshore_Outsourcing_ITJobs_NYS.pdf.
10. Florida, Richard, (2003), *The Rise of the Creative Class*, New York: Basic Books.
11. Taylor, Paul (2014), *The Next America: Boomers, Millennials and the Looming Generational Showdown*, New York: Public Affairs.
12. http://testtube.nfb.ca/.
13. Desilver, Drew, (2014), "5 facts about economic inequality," http://www .pewresearch.org/fact-tank/2014/01/07/5-facts-about-economic-inequality/; Desilver, Drew, (2013), "Global inequality: How the U.S. compares," http://www.pewresearch .org/fact-tank/2013/12/19/global-inequality-how-the-u-s-compares/.

14. Lewis, Jemima, (2013), "Are older parents putting our future at risk?" http://www.telegraph.co.uk/health/healthnews/9928198/Are-older-parents-putting-our-future-at-risk.html.

15. Kreider, Rose M., and Renee Ellis, (2011), "Living arrangements of children: 2009," http://www.census.gov/prod/2011pubs/p70-126.pdf.

16. Greenhouse, Steven, (2013), "Our economic pickle," http://www.nytimes.com/2013/01/13/sunday-review/americas-productivity-climbs-but-wages-stagnate.html.

17. Institute of Museum and Library Sciences, "Distribution of museums by discipline, FY 2014," http://www.imls.gov/assets/1/AssetManager/MUDF_TypeDist_2014q3.pdf.

18. Institute of Museum and Library Sciences, "Distribution of museums by discipline, FY 2014," http://www.imls.gov/assets/1/AssetManager/MUDF_TypeDist_2014q3.pdf.

19. University College London, (2012), "Are museums failing us?" https://blogs.ucl.ac.uk/events/2012/03/09/are-museums-failing-us/.

20. http://www.ucl.ac.uk/archaeology.

21. University College London, (2012), "Are museums failing us?" https://blogs.ucl.ac.uk/events/2012/03/09/are-museums-failing-us/.

22. University College London, (2012), "Are museums failing us?" https://blogs.ucl.ac.uk/events/2012/03/09/are-museums-failing-us/.

23. Institute of Museum and Library Sciences, (2014), "Talking points: Museums, libraries, and makerspaces," http://www.imls.gov/assets/1/AssetManager/Maker spaces.pdf .

24. http://www.adg.org/.

25. Institute of Museum and Library Sciences, (2010), "Performance and accountability report: Fiscal year 2010," http://www.imls.gov/assets/1/workflow_staging/AssetManager/910.PDF.

26. Museum Planner, (2012), "Museums are for the rich," http://museumplanner.org/museums-are-for-the-rich/.

27. Goodstein, David L., and Judith R. Goodstein, (1996), "Feynman's lost lecture: The motion of planets around the sun," http://calteches.library.caltech.edu/3822/1/Goodstein.pdf .

28. http://www.bestplaces.net/city/nevada/reno.

29. http://www.nevadaart.org/.

30. http://www.nvdm.org/.

31. http://museums.nevadaculture.org/index.php?option=com_content&view=article&id=486&Itemid=406.

32. http://museums.nevadaculture.org/index.php?option=com_content&view=article&id=446&Itemid=122.

33. http://www.nevadaart.org/learn/e-1-card-museum-school/. Accessed March 16, 2015.

34. http://museums.nevadaculture.org/index.php?option=com_content&id=412&Itemid=440.

35. http://www.tate.org.uk/context-comment/apps/race-against-time.

36. http://collectives.tate.org.uk/content/artist-rooms.

37. http://detroithistorical.org/buildingdetroit/; Edwards, Susan, (2013), "What museums learn by building games," http://www.slideshare.net/jolifanta/what-museums -learn-by-making-games-serious-play-conference-2013.

38. Carr, Nicholas, (2011), *The shallows: What the Internet is doing to our brains*, http://www.theshallowsbook.com/nicholascarr/Nicholas_Carrs_The_Shallows.html.

39. http://makerspace.nysci.org/.

40. http://www.newarkmuseum.org/makerspace.html.

41. http://tinkering.exploratorium.edu/about.

42. Institute of Museum and Library Sciences, (2014), "Talking points: Museums, libraries, and makerspaces," http://www.imls.gov/assets/1/AssetManager/Makerspaces .pdf.

43. https://twitter.com/hashtag/MuseumSelfie; MarDixon, (2014), "Going viral with #MuseumSelfie," http://www.mardixon.com/wordpress/2014/01/going-viral -with-museumselfie/.

44. Apple, (2015), "iOS: Understanding iBeacon," http://support.apple.com/kb/ HT6048.

45. Manaugh, Geoff, (2014), "The algorithms at the heart of the new September 11 Memorial Museum," http://gizmodo.com/the-algorithm-at-the-heart-of-the-new -september-11-memo-1576067926.

46. http://www.autoidlabs.org/.

47. American Association of Museums, (2008), "Museums working the public interest," http://www.wolfconsulting.us/files/Museums%20Working%20in%20the%20 Public%20Interest.pdf.

48. http://www.amnh.org/apps.

49. http://www.newmuseum.org/.

50. http://www.mattress.org/. Accessed March 16, 2015.

51. http://www.bigcar.org/.

Chapter Twenty-Three

Putting Your Museum Online

I am a firm believer in creating an integrated museum approach for the entire museum experience—previsit, visit, and postvisit—where all parts of the visitor experience are consistent with the museum's voice. The museum's "voice" is comprised of all the elements of the visitor experience—mission, collection, and hospitality.

First, is the mission of the museum made apparent at every touch-point with the visitor? Museum touch-points include website, social media, and museum graphics. Second, is the museum's collection clearly in support of the museum's mission? Third, does the museum welcome and serve as a host to the visitor at every touch-point?

Before creating or changing your online presence, clearly state:

1. How does your museum implement its mission?
2. How does your museum use its collection to support its mission?
3. How does your staff welcome and include the visitor in implementing the museum's mission?

The voice of the online presence and the in-person experience need to be consistent. We are all very sensitive to incongruity, consciously or unconsciously looking for parts of an experience that are consistent. The objective of all museum experiences is to create an aligned experience, with all of the pieces of the user experience adding up to a unified whole.

When creating your online presence, start with the basics:

- Address of the museum and hours of operation
- Admission price for adults, children, seniors, and any discounts (teachers, Automobile Association of America, students, military)

- Planning your visit (map of the museum, current and past exhibitions)
- Membership: Show the advantages of becoming a member, with a link to membership

Here are a few examples of favorite online museum voices:
Art Museums

- The Cleveland Museum of Art: http://www.clevelandart.org/
- Rijksmuseum: https://www.rijksmuseum.nl/en
- The Dallas Museum of Art: http://dma.org/
- The New Museum: http://www.newmuseum.org/

History Museums

- Reynolda House Museum of American Art: http://reynoldahouse.org/
- Temple Mayor: http://www.templomayor.inah.gob.mx/
- U.S. Holocaust Museum: http://www.ushmm.org/

Science Centers

- Exploratorium: http://www.exploratorium.edu/
- The Science Museum, London: http://www.sciencemuseum.org.uk/
- Liberty Science Center: http://lsc.org/

Natural History Museums

- American Museum of Natural History: http://www.amnh.org/
- Denver Museum of Nature and Science: http://www.dmns.org/
- Smithsonian National Museum of Natural History: http://www.mnh.si.edu/

Children's Museums

- Minnesota Children's Museum: http://www.mcm.org/
- Nevada Discovery Museum: http://www.nvdm.org/
- Bay Area Discovery Museum: http://www.baykidsmuseum.org/

For each of the above, the online presence is consistent and aligned with the in-person user experience.

ONLINE VISITOR EXPERIENCE

In the process of putting a museum online, it is helpful to think in holistic terms—the whole visitor experience. I find it useful to take a visitor-centric approach and to think of the visitor "stepping stones."

The visitor stepping stones include the following:

1. **Awareness:** Letting people know that the museum exists or will exist in the future. I am a proponent of a very visible location for a museum. If the museum is yet to be opened, create a preview facility in a well-trafficked mall. How will people find you online? Do you have something to promote? The world's largest? The world's first? The only?
2. **Knowledge:** Different from awareness, a person needs to know the content area of the museum. "They are going to open a history museum on Main Street." People should know the content of the museum and the location. Can you get others to write about you and follow you online? Create talking points and ways for others to blog and write about your museum.
3. **Understanding:** Do you have activities online for visitors before they visit? Are parts of your collection online? The website and social media should have enough content for a person to become interested and make plans to visit the museum in person.
4. **Visitation:** A person's visit to a museum has three parts. (1) Welcome and overview. (2) The visit. (3) Reason for a return visit. The third part is often lacking in museums. Give people a reason to return. "On November 15, we will open our new Native American Gallery to the public. Become a member and visit the gallery early at our members-only event November 10!" This does two things: it gives people a reason to return for a specific event, and you are encouraging people to become members.
5. **Build community:** Museums are a form of community. The community exists online and in person. Be sure to connect visitors to visitors, and museum to visitor, and allow ways to interact and build community, in-person and online. Instagram, Twitter, Facebook, Pinterest, and Tumblr are all great ways to build community and let visitors share photos and content about the museum.
6. **Membership:** Once a visitor feels vested in your museum, the next step is membership. Visitors can pay a yearly fee to be included in special events, special mailings (postal and email), and have greater access to museum information.
7. **Volunteering:** Once a museum member has attended a few events and enjoyed being involved, he or she may be interested in volunteering. Create opportunities for volunteering.

8. **Donor:** Museum membership is a form of a donation to the museum. A percentage of the membership goes to underwrite the museum and a portion covers the services the member receives. Give members and visitors ways to donate to the museum on a regular basis.

ONLINE BASICS

After you have created a list of your museum's basic information, consider your keywords. The Google algorithm is now valued as the world's most valuable "object." Many people will start with a search for museum information. Museum websites are ranked by how they meet the Google algorithm, time on website, accuracy of search, and number of pages visited. Be clear on your museum type. People will search for words, such as "fun educational kids San Antonio," "art museum Orange County," or "history museum Philadelphia." Make sure your website uses your keywords.

Next create a map of the website and social media, creating a hierarchy of content. Think about each type of museum visitor: family visitor (two parents and two kids arriving at the museum by car), senor visitor (an older couple arriving by car may need wheelchair access), and school group (thirty-five students arriving by bus with a teacher and four chaperones). Then navigate through the website as each of these visitor types and make sure the navigation is clear and all of the needed information is included. Social media needs to be incorporated into the content of the website so that visitors can share and personalize content. For small museums or museums still in the planning stages, there are many free options such as Wordpress, Tumblr, and Typepad. Each allows you to create a temporary website quickly until your final website is completed.

Be flexible. I am a strong believer in testing many different layouts and methods of website navigation before deciding upon a final layout. Google Analytics is a great tool for trying out different layouts. In Google Analytics, you can create several different models and test how people "click through" your website. A well-planned and -designed museum website becomes the online face of the museum.

NUTS AND BOLTS OR ZEROES AND ONES

Most museum websites provide at least an overview of the collection. The process of creating your online presence needs to become part of the overall process of accepting loans and objects into the collection, creating program-

ming, having events, and raising funds. It is helpful to think of each step as it relates to the museum functions.

The process of getting your museum includes the following:

1. Acceptance of object, including copyright permission, condition report, and registration; required to share images online.
2. Photographs, research, and content writing for online collection
3. Creating database either local (within museum) or cloud-based
4. Selection of public/private content; decide how to separate your database(s) into those that the public can view online and those only for use by museum staff
5. Posting photographs and content online
6. Social media and engaging audience
7. Driving audience to event-based activities at the museum
8. Repeat

For a small museum, all of the above steps can be accomplished at very low cost using online platforms such as Wordpress and volunteer labor. Often a less polished approach can be helpful in a fundraising by using a crowdsourcing approach: using many people, each one completing a small part of a larger activity.

In the past, museums received objects into their collection through a process of condition report, photography, registration (assigning a number), and location of the object. The database was stored on a network computer either at the museum location and or off-site. With the spread of social media and connectivity, museums now share at least some of their collections online. This can be a complex process, as first the museum must have permission to share reproductions of the artwork online. Many of today's collection software allows for the ability to share selected pieces of the collection online, removing the need for double entry of objects. Some of the museum collection systems are now cloud-based, allowing for multiple back-up copies of the database.

Examples of museum collection management software include the following:

ArtSystems: http://www.artsystems.com/
Past Perfect: http://www.museumsoftware.com/
Microsoft Access (customized to the museum's collection): http://office
.microsoft.com/en-us/access/
The Museum System: http://www.gallerysystems.com/collection-manage
ment-software-museums-visual-resources-and-cultural-collections

There is a trend in museums to use a "cloud-based" system, but this is a relatively new practice and museums are hesitant to place their collection information in a cloud. There are many advantages to cloud-based systems, however, including easily pushing collection information to mobile devices (iPad, iPhone, smartphones).

Two current systems were part of an Institute of Museum and Library Sciences grant:

Collective Access: http://www.collectiveaccess.org/
CollectionSpace: http://www.collectionspace.org/

Other cloud-based systems[1]:

Vesica: http://vesica.ws/
Art Systems: http://www.artsystems.com/
My Art Collection: http://www.my-artcollection.com/

Often, reproduction of photography is a sensitive issue. Some collectors and museums will not allow the reproduction of photographs because of concern about unauthorized reproductions and about the use of flash by visitors damaging the photographs. As many museums now allow photography in the galleries, museums need to have a clear policy regarding photography by visitors. Many museums will allow for photographs in public areas such as lobbies and restaurants, while not allowing photographs in galleries. Some museums allow for photographs in specific galleries, others in all galleries. I don't know of any museums that allow flash photography in the galleries, due to the damage that high light levels can cause to the art. Whatever the policy, it needs to be stated on the museum website, at museum ticketing, and at the entry to each museum gallery.

Recently, the taking of "selfies"[2] has resulted in museum visitors accidently damaging artwork. Even when a museum allows for photography, the same rules of keeping a safe distance from the art need to be maintained.

Placing a museum's collection online is a balancing act. Once images are placed online, it is close to impossible to control the use of the images. Many museums only allow low-resolution images, some with a digital watermark, but this does not restrict how the image will be used. Several museums have incorporated creative commons copyright as their copyright standard.[3]

Many museums now use Instagram and Tumblr as a way for students to "interact" with a museum's collection by taking photos of art and collection objects, then working with museum staff to document their thoughts about the art and objects. This has become a great way to engage a younger museum audience.

There are integrated systems that will handle all of the visitor experience steps, including museum membership, tracking museum donations, museum ticket sales, and museum accounting. For the purposes of this book, a discussion of such systems is out of place. Many small museums function with a system for accounting and a customer resource management system for donors, both of which are off-the-shelf database systems.

A relatively new online activity for museums has been crowd-funding. The results have been mixed thus far. Crowd-funding uses the Internet to promote and take donations for new projects in exchange for donors receiving acknowledgment and a memento of their participation. There are several crowd-funding platforms used by museums:

Rockethub: http://www.rockethub.com/
Kickstarter: https://www.kickstarter.com/
Indiegogo: http://www.indiegogo.com/
Razoo: http://www.razoo.com/

To date, I do not know of any museum or exhibition that has secured 100 percent of its funding from crowd-funding.[4]

Another new development for museums is interior maps and navigable online images, such as Google Art Project.[5] Google has worked with several major museums to create videos and high-resolution images of art and exhibition galleries and make them available online. Google Art Project is beyond the reach of most small museums, although interior global positioning systems are quickly becoming affordable for small museums. With interior global positioning systems such as iBeacon,[6] museums can create exhibition iPhone tours that are triggered by iBeacons throughout the exhibition.

Using the Internet to test and receive feedback is a useful advance. Museums can now use a combination of online tools to gather visitors' email addresses and have visitors "opt-in" to be part of visitor surveys and newsletters. Museums can then keep contact and monitor visitor feedback for events, exhibitions, and programs.

A museum's online presence is an embodiment of an integrated museum approach that creates a seamless experience, from online to in-person to creating a reason for a return visit. The museum's online presence is very often the face of the museum.

NOTES

1. Online discussion by Mark Walhimer Museum Planning Group, https://www.linkedin.com/groups/Online-art-collection-management-4346566.S.109407662.

2. Trianni, Francesca, (2014), "Student breaks 19th century Greco-Roman statue while taking a selfie," http://time.com/28679/student-breaks-statue-selfie/.

3. https://wiki.creativecommons.org/GLAM.

4. LinkedIn discussion by Mark Walhimer, https://www.linkedin.com/groups/ Best-Museum-Crowdfunding-platform-4346566.S.5849595369930899457.

5. https://www.google.com/maps/views/streetview/art-project.

6. https://developer.apple.com/ibeacon/.

Chapter Twenty-Four

Working in Museums

In 1985, I walked into the Phoenix Art Museum and asked to speak to the curator of the contemporary collection. A woman came out to greet me. I said that I was from New York City and had worked as a studio assistant to American artist Judy Pfaff, and I was interested in meeting the curator. A few minutes later, the woman returned and gave me the curator's business card. I called and made an appointment. The next day I was escorted into the curator's office. I introduced myself and said that I was new to Phoenix and was interested in the museum. It turned out that the curator was also from the East coast and was familiar with Judy Pfaff's work. I asked if the museum had internships or any work they could offer. It so happened that the museum was in the middle of reinstalling the permanent collection. The curator asked if I would be willing to help with the installation on a volunteer basis. A week later, I was installing James Turrell sculptures with the curator.

He and I got along very well and had similar tastes in art. I continued volunteering at the museum until they offered me a job working in the museum store. I continued working as a volunteer preparator (installer of art, "preparing" the gallery for exhibitions). The entire experience was wonderful. I became friends with the curator, and I had a chance to work at a major museum and become familiar with the collection. I was sleeping on a friend's couch while working at the museum. I was young, and I loved museums. The curator saw that I was trustworthy, that I knew my art, and that I knew how to install art. We became friends. My story is more familiar than you might think. Most directors of exhibits have a story similar to mine. The museum world is surprisingly open and welcoming.

Before I asked to speak to the curator, I visited the museum and became familiar with the collection. The Phoenix Art Museum (now the Arizona Art

Museum) has a very large collection of Remington bronzes. I am not a fan of Remington, but the museum also had an excellent small collection of contemporary art, including James Turrell, a favorite artist of mine. While visiting the museum, I looked to see how the staff was dressed. They wore a sort of "desert casual"—dress pants and collared shirts. Before I spoke to anyone at the museum, I knew the basics of the museum, I knew the museum's collection, and I knew the name and outlook of the curator, having read an article about him in a local magazine.

Some advice when approaching a museum about a position:

- Know the collection of the museum
- Know the mission of the museum
- Know the organizational structure of the museum
- Know the attire of the museum staff, which tells you something about the tone of the workplace

By doing my homework, I was able to understand how I could help the museum. I was very clear about wanting to help, and I understood the mission. With the right outlook and preparation, it is much easier to gain access to museum work.

I have worked for for-profit companies. Museums are mission-based nonprofit organizations; profit is not their motivation. When talking to a museum, you need to show that your actions and interests are in the interests of the museum, not your own or your business's interests.

First, think about your own interests and personality. Are you an outgoing, sociable person? Are you someone who prefers quiet activities? Are you a person who is good at working with your hands? There are many entry-level jobs at museums:

- Summer intern. Can include digitizing images of the collection, registrarial work entering objects of the collection in a museum database, or working with museum summer camps.
- Preparator. Assist with preparing galleries for exhibitions. Skills include painting, mount-making, installing light fixtures and lighting, installing graphics, installing art. Most often only curators or more trusted preparators can handle art.
- Fundraising. Helping to organize gala events, mailings, events, making phone calls.
- Collections management. Registration of collection objects, photography, description of collection objects. Knowledge of basic computer software and databases.

- Administration. Help with writing letters, filing, mailing, and correspondence with the board of directors and board subcommittees.
- Docent. Familiar with the content of the museum (art, history, science), able to speak with the public in public settings.
- Information desk. A love for working with the public and sharing the museum with visitors.
- Security. An interest in protecting the museum's collection.
- Floor staff. Enjoy working with kids, have high energy level and an interest in the subject matter of the museum.

Most important is an understanding of the museum's mission and a desire to support the museum. Most people who work at museums love museums and have a desire to share knowledge of the museum with others.

Before writing a resume for a museum position, sit down and do a self-assessment. Include the following:

- What are your skills that can be directly applied to a museum? Examples include database entry, writing abilities, party planning and event management, carpentry skills, fundraising, experience working with children.
- Whom do you know involved in the art world, science world, history world? Would any of them be willing to serve as a reference?
- Have you passed any tests of trustworthiness? Examples might be Transportation Security Administration Precheck,[1] a contractor's license, or a Federal Bureau of Investigation background check. Most museums will do a basic background check before hiring a person for paid or volunteer work.
- Do you know anyone who works at a museum?

Try your best to make your resume fact-based and oriented to museum work. State your skills and mention any experience that directly applies to museum work. For example, "experience with database entry of items at XYZ Store," "led Boy Scout group on tour of Statue of Liberty," or "organized and fundraised for parent-teacher association gala for public school 123." List the names of references that might be known to museum staff. Keep your resume to one page.

Sometimes the most difficult part of working in museums is keeping the job. I have been an employee of five museums,[2] and changes can happen very quickly. Most often the changes happen soon after a museum's opening or expansion. A museum may "staff up" before an opening or expansion only to find that operating costs are higher than expected. The result can be a staff layoff. Often a new director will reorganize the staff. My best advice is to be flexible. Museum staff are great at "wearing many hats." In times of

transition, let supervisors know that you are eager to stay with the museum in any capacity.

I have worked at two for-profit companies that provide services to museums.[3] Museums often outsource exhibition design and fabrication to for-profit companies. These companies can be another source of employment for those interested in working with museums. Personally, I have learned more working for for-profit companies than I learned working at museums. Working on several projects at different museums is a great learning experience.

Here are some advantages and disadvantages of working at museums versus for-profit companies that provide services to museums.

MUSEUM

Advantages:

- Mission-based
- A priority of authenticity
- Service to the public
- Dedicated coworkers

Disadvantages:

- Lower pay than for-profit companies
- Lack of job security

FOR-PROFIT COMPANIES

Advantages:

- Working on multiple projects
- Greater job security
- Greater opportunity for growth
- Higher pay

Disadvantages:

- Can be very stressful
- Profit-based
- Often based on contract projects and work can be uncertain

Nobody goes into museum work to get rich. If that is your primary goal, look elsewhere. Some museum directors, however, are paid very well. I have mixed feelings about some of their current salaries. Director of the Museum of Modern Art Glenn D. Lowry is reported to earn $1.8 million per year and lives rent-free in a Museum of Modern Art apartment.[4] He is said to be among the highest paid museum directors in the world.[5] But such high salaries are the exception. The norm, taking into account all the small and volunteer-run museums, is closer to the $12,500 per year described in "The Museum Sacrifice Measure."[6] The article theorizes that most people who work in museums accept low salaries as the cost of working in museums. It also states that because of low pay, many museum staff "are resistant to change."

I started working in museums thirty years ago. I have been through many changes; museums as a whole have changed. Today's museums are doing more with less money than in the pre-Recession days before 2008.[7] But as a whole, I see museums as more approachable than ever. In general, if you understand a museum's mission and culture, and you have a trustworthy and honest approach, museums are very welcoming places to work. Be sure to have realistic expectations and keep the museum's interests above your own.

NOTES

1. http://www.tsa.gov/tsa-precheck.

2. Liberty Science Center (New Jersey), Children's Museum of Manhattan (New York), Discovery Science Center (Santa Ana, California), Children's Museum of Indianapolis (Indiana), and The Tech (San Jose, California).

3. Group Delphi (Alameda, California) and Academy Studios (Novato, California).

4. Kennedy, Randy, (2014), "MoMA's expansion and director draw critics," http://www.nytimes.com/2014/04/21/arts/momas-expansion-and-director-draw-critics.html.

5. CultureGrrl, (2008), "Who are the highest-salaried art museum directors?" http://www.artsjournal.com/culturegrrl/2008/09/who_are_the_highestsalaried_ar.html.

6. Center for the Future of Museums, (2014), "The museum sacrifice measure," http://futureofmuseums.blogspot.mx/2014/09/the-museum-sacrifice-measure.html.

7. Cave, Damien, (2010), "In Recession, Americans doing more, buying less," http://www.nytimes.com/2010/01/03/business/economy/03experience.html.

Part V

THE MUSEUM TOOLBOX

The Museum Toolbox

The following sample documents are included for your use and reference. Feel free to adapt these to the specific needs and situation of your museum, wherever you may be in your process—thinking about starting a museum, in the planning stages, or involved in a renovation or expansion.

All of the following documents can be found at at http://museums101.com. Sample documents:

Documents for reference only, not legally binding documents. Please consult legal counsel.

AMERICAN ALLIANCE OF MUSEUMS: CODE OF ETHICS FOR MUSEUMS

American Alliance of Museums[i]
Code of Ethics for Museums
Adopted 1991, amended 2000.

Please note that the Code of Ethics for Museums references the American Association of Museums (AAM), now called the American Alliance of Museums (AAM).

Ethical codes evolve in response to changing conditions, values and ideas. A professional code of ethics must, therefore, be periodically updated. It must also rest upon widely shared values. Although the operating environment of museums grows more complex each year, the root value for museums, the tie that connects all of us together despite our diversity, is the commitment to serving people, both present and future generations. This value guided the creation of and remains the most fundamental principle in the following Code of Ethics for Museums.

Code of Ethics for Museums

Museums make their unique contribution to the public by collecting, preserving and interpreting the things of this world. Historically, they have owned and used natural objects, living and nonliving, and all manner of human artifacts to advance knowledge and nourish the human spirit. Today, the range of their special interests reflects the scope of human vision. Their missions include collecting and preserving, as well as exhibiting and educating with materials not only owned but also borrowed and fabricated for these ends. Their numbers include both governmental and private museums of anthropology, art history and natural history, aquariums, arboreta, art centers, botanical gardens, children's museums, historic sites, nature centers, planetariums, science and technology centers, and zoos. The museum universe in the United States includes both collecting and non-collecting institutions. Although diverse in their missions, they have in common their nonprofit form of organization and a commitment of service to the public. Their collections and/or the objects they borrow or fabricate are the basis for research, exhibits, and programs that invite public participation.

Taken as a whole, museum collections and exhibition materials represent the world's natural and cultural common wealth. As stewards of that wealth, museums are compelled to advance an understanding of all natural forms and of the human experience. It is incumbent on museums to be resources for humankind and in all their activities to foster an informed appreciation of the rich and diverse world we have inherited. It is also incumbent upon them to preserve that inheritance for posterity.

Museums in the United States are grounded in the tradition of public service. They are organized as public trusts, holding their collections and information as a benefit for those they were established to serve. Members of their governing authority, employees and volunteers are committed to the interests of these beneficiaries. The law provides the basic framework for museum operations. As nonprofit institutions, museums comply with applicable local, state, and federal laws and international conventions, as well as with the specific legal standards governing trust responsibilities. This Code of Ethics for Museums takes that compliance as given. But legal standards are a minimum. Museums and those responsible for them must do more than avoid

legal liability, they must take affirmative steps to maintain their integrity so as to warrant public confidence. They must act not only legally but also ethically. This Code of Ethics for Museums, therefore, outlines ethical standards that frequently exceed legal minimums.

Loyalty to the mission of the museum and to the public it serves is the essence of museum work, whether volunteer or paid. Where conflicts of interest arise—actual, potential or perceived—the duty of loyalty must never be compromised. No individual may use his or her position in a museum for personal gain or to benefit another at the expense of the museum, its mission, its reputation and the society it serves.

For museums, public service is paramount. To affirm that ethic and to elaborate its application to their governance, collections and programs, the American Alliance of Museums (AAM) promulgates this Code of Ethics for Museums. In subscribing to this code, museums assume responsibility for the actions of members of their governing authority, employees and volunteers in the performance of museum-related duties. Museums, thereby, affirm their chartered purpose, ensure the prudent application of their resources, enhance their effectiveness and maintain public confidence. This collective endeavor strengthens museum work and the contributions of museums to society—present and future.

Governance

Museum governance in its various forms is a public trust responsible for the institution's service to society. The governing authority protects and enhances the museum's collections and programs and its physical, human and financial resources. It ensures that all these resources support the museum's mission, respond to the pluralism of society and respect the diversity of the natural and cultural common wealth.

Thus, the governing authority ensures that:

* all those who work for or on behalf of a museum understand and support its mission and public trust responsibilities
* its members understand and fulfill their trusteeship and act corporately, not as individuals
* the museum's collections and programs and its physical, human and financial resources are protected, maintained and developed in support of the museum's mission
* it is responsive to and represents the interests of society
* it maintains the relationship with staff in which shared roles are recognized and separate responsibilities respected
* working relationships among trustees, employees and volunteers are based on equity and mutual respect
* professional standards and practices inform and guide museum operations
* policies are articulated and prudent oversight is practiced
* governance promotes the public good rather than individual financial gain.

Collections

The distinctive character of museum ethics derives from the ownership, care and use of objects, specimens, and living collections representing the world's natural and cultural common wealth. This stewardship of collections entails the highest public trust and carries with it the presumption of rightful ownership, permanence, care, documentation, accessibility and responsible disposal.

Thus, the museum ensures that:

- collections in its custody support its mission and public trust responsibilities
- collections in its custody are lawfully held, protected, secure, unencumbered, cared for and preserved
- collections in its custody are accounted for and documented
- access to the collections and related information is permitted and regulated
- acquisition, disposal, and loan activities are conducted in a manner that respects the protection and preservation of natural and cultural resources and discourages illicit trade in such materials
- acquisition, disposal, and loan activities conform to its mission and public trust responsibilities
- disposal of collections through sale, trade or research activities is solely for the advancement of the museum's mission. Proceeds from the sale of nonliving collections are to be used consistent with the established standards of the museum's discipline, but in no event shall they be used for anything other than acquisition or direct care of collections.
- the unique and special nature of human remains and funerary and sacred objects is recognized as the basis of all decisions concerning such collections
- collections-related activities promote the public good rather than individual financial gain
- competing claims of ownership that may be asserted in connection with objects in its custody should be handled openly, seriously, responsively and with respect for the dignity of all parties involved.

Programs

Museums serve society by advancing an understanding and appreciation of the natural and cultural common wealth through exhibitions, research, scholarship, publications and educational activities. These programs further the museum's mission and are responsive to the concerns, interests and needs of society.

Thus, the museum ensures that:

- programs support its mission and public trust responsibilities
- programs are founded on scholarship and marked by intellectual integrity
- programs are accessible and encourage participation of the widest possible audience consistent with its mission and resources
- programs respect pluralistic values, traditions and concerns
- revenue-producing activities and activities that involve relationships with external entities are compatible with the museum's mission and support its public trust responsibilities
- programs promote the public good rather than individual financial gain.

Promulgation

This Code of Ethics for Museums was adopted by the Board of Directors of the American Association of Museums on November 12, 1993. The AAM Board of Directors recommends that each nonprofit museum member of the American Association of Museums adopt and promulgate its separate code of ethics, applying the Code of Ethics for Museums to its own institutional setting.

A Committee on Ethics, nominated by the president of the AAM and confirmed by the Board of Directors, will be charged with two responsibilities:

- establishing programs of information, education and assistance to guide museums in developing their own codes of ethics
- reviewing the Code of Ethics for Museums and periodically recommending refinements and revisions to the Board of Directors.

Afterword

Each nonprofit museum member of the American Alliance of Museums (AAM) should subscribe to the AAM Code of Ethics for Museums. Subsequently, these museums should set about framing their own institutional codes of ethics, which should be in conformance with the AAM code and should expand on it through the elaboration of specific practices. This recommendation is made to these member institutions in the belief that engaging the governing authority, staff and volunteers in applying the AAM code to institutional settings will stimulate the development and maintenance of sound policies and procedures necessary to understanding and ensuring ethical behavior by institutions and by all who work for them or on their behalf.

The Code of Ethics for Museums serves the interests of museums, their constituencies, and society. The primary goal of AAM is to encourage institutions to regulate the ethical behavior of members of their governing authority, employees and volunteers. Formal adoption of an institutional code promotes higher and more consistent ethical standards.

[1] http://www.aam-us.org/resources/ethics standards-and-best-practices/code-of-ethics

Sample Bylaws

BYLAWS OF THE BOARD OF DIRECTORS[1]
(Insert Name of Non-Profit)
(Date of last revision)

Article I: Legal Authority
The (Insert Name of Non-Profit) is chartered as a nonprofit corporation under and by virtue of the laws of the State (Insert Name of State), as contained in (Insert State Statue). In accordance with Internal Revenue Code of 1986 Section 501(c)(3), the purposes of this corporation are limited to educational and public, not-for-profit activities.

Article II: Name and Location
Section 1: Official Name - The (Insert Name of Non-Profit).

Section 2: Assumed Name - For purposes of advertising and promotion, the corporation may at times utilize the assumed name of (Insert Name of Museum); however, the official name shall remain the binding corporate name to transact its official business.

Section 3: Location - The principal office of the corporation and its registered agent shall be located in the (Insert City and State). This designation may be changed from time to time only by official action of the Board of Directors with the filing of an appropriate certificate with the (Name of State).

Article III: Purpose
Section 1: Mission – (Insert Mission Statement)

Section 2: Restrictions - No activity of the corporation shall support political campaigns on behalf of any candidate for public office; restrict membership on the basis of race, religion, gender or national origin; or do anything to disqualify its tax-exempt status pursuant to Section 170(c)(2) of the Internal Revenue Code.

Article IV: Membership
Section 1: Eligibility - Any person expressing an interest in (Insert purpose of museum) shall be eligible for membership in the corporation.

Section 2: Membership Fees - Membership shall be for a period of (length of membership, one year is a good suggestion), commencing (the month dues are to be paid) when the membership fee is received. The membership fee is (Insert Membership Fee).

Section 3: Fund Raising - In addition to Membership Fees, members will actively work to identify and cultivating prospective donors to (Insert name of Museum) and secure an additional $(insert amount) from other donors and/or event participation.

Based on the Bylaws of the Burke Museum, 201 West Meeting St., Morganton, NC 28655, http://www.thehistorymuseumofburke.org/?page_id=43 website accessed March 14, 2015

Section 3: Voting Privileges - Upon application, payment of annual fees, and acceptance by the Board of Directors, each member shall have one vote on motions before regular and special scheduled meetings of the corporation. Membership is not transferable and does not allow any rights or interest in the assets or income of the corporation. No proxy votes are permitted.

Section 4: Honorary Life Member - Upon motion and approval by the Board of Directors, an Honorary Life Membership may be conferred upon a member or nonmember who has rendered singular and extraordinary service to The (Insert Name of Non-Profit). Honorary Life Members shall enjoy all privileges and benefits of regular members without further payment of individual annual membership fees.

Article V: Board of Directors
Section 1: Governance - The business, property and programs of this corporation shall be managed and controlled by a Board of Directors consisting of not less than (Insert Minimum Number a good suggestion (10)) and not more than (Insert Maximum, a good suggestion is twenty five (25)) duly elected voting members. The Board of Directors retain those powers granted under (Insert Name of State) Statutes which permit all necessary and convenient actions to effect all the approved purposes for The (Insert Name of Non-Profit).

Section 2: Executive Committee - The Board of Directors may create an Executive Committee consisting of the Officers of the Board and three (3) additional Board members following the procedure outlined for officers in Article VII: Section 2 of these Bylaws. The Executive Committee shall meet, as the need occurs to carry out those tasks stated in the Board's Policy Manual or other specific tasks assigned by the Board. In addition, the Executive Committee shall develop an annual work plan; conduct an annual performance review of the Museum Executive Director no later than the end of each fiscal year and review all compensations for the Museum Executive Director with a recommendation to the Board of Directors; review annually and recommend updates to the (Name of Museum's) Policy Manual and corporate procedures. The creation of an Executive Committee and the delegation thereto of authority shall not operate to relieve the Board of Directors nor any individual Director of responsibility or liability imposed by law. Minutes of actions taken by the Executive Committee shall be recorded and reported to the Board of Directors at its next meeting. All actions taken by the Executive Committee shall be subject to review with final approval reserved to the corporation's Board of Directors.

Section 3: Terms of Office - Directors elected at Annual Meetings shall serve a term of (Insert length of term three (3) is a good suggestion) years and the Board shall maintain staggered terms of service for each third of its membership. A full term commences with the date of election and ends at the subsequent, third Annual Meeting of the corporation. Directors are limited to two consecutive three-year terms with an ineligibility period of one year following the expiration of a second full term; provided however, the ineligibility period of one year following the expiration of a second full term clause in this section may be waived by a two thirds (2/3) vote of the Board members that are present, if extraordinary circumstances exists and good cause has been shown. Each Director must remain a member in good standing during their entire term of office.

Section 4: Vacancies - Vacancies which occur on the Board shall be filled by the Board of Directors upon recommendation of the Chair for the remaining, unexpired term of an absent Director. Such appointments commence on that date and end at an appropriate and subsequent Annual Meeting of the corporation. Such Directors appointed for a term of less than two years shall then be eligible for an additional two full terms as defined in these Bylaws.

Section 5: Ex Officio Board Members - The Museum Executive Director, as manager of the museum's operations, shall serve as a nonvoting, ex officio member of the Board of Directors. It is, therefore, a responsibility of the Board to periodically publish those policies which set forth personnel rules, duties, responsibilities and compensation of the Museum Executive Director, as well as for other temporary and permanent staff and volunteers. Under certain circumstances, as determined by the Board, individuals and representatives of local agencies and civic groups may be invited to advise the Board for a specified period of time as nonvoting, ex officio members.

Section 6: Meetings & Notice - As a minimum, regular meetings of the Board of Directors shall be held at least each calendar quarter according to a schedule announced by the Board Chair at the Annual Meeting. Special called meetings of the Board shall be held at the discretion of the Chair or by a majority vote of the Board of Directors or upon written request by ten (10) percent of the membership. Notices for such special meetings shall be provided by telephone, posted mail or email at least seven (7) days before the announced time, date and place.

Section 7: Quorum & Voting - A simple majority of Directors being present shall constitute a quorum for the conduct of business with, thereafter, a simple majority vote required for action on motions. Each duly elected Director shall have one vote. Proxy shall not be permitted.

Section 8: Character and Attendance Rules - Each person serving as a member of the Board of Directors of (Insert Name of Museum) or as a candidate for membership on the Board must be recognized as a person of good character and reputation in their community. A person convicted of a felonious crime or a serious misdemeanor shall not be eligible to serve as a member of the Board and if they are a member they shall be removed by a simple majority vote of the Board members present. If a Board member is indicted for a felonious crime or a serious misdemeanor he or she shall be placed on a leave of absence until the matter has been cleared. After the matter has been cleared, the Board will determine if the member may be re-instated as a member of the Board.

If the Board of Directors determines that a member of the Board is not attending Board meetings on a regular basis and fails to submit to the Board a reasonable excuse, The Board may dismiss the member with a majority vote of the members present at a regular scheduled or a special called meeting. The Board may grant a leave of absence to any Board member when the member submits a request for such leave.

Section 9: Compensation - Directors shall be volunteers and receive no compensation for their services, except on occasion for certain expenses directly related to the mission and purposes of the corporation as may be approved by the Board of Directors.

Section 10: Commitment and Ethics Rule - Each Director must maintain a high commitment to the stated mission and goals of The (Insert Name of Non-Profit), and exhibit the highest ethical standards in the conduct of business as suggested in the most recent American Alliance of Museums (AAM) "Code of Ethics for Museums." Those Directors brought into question under this rule shall have a hearing before a special committee of the Board and, when their behavior is judged to be in conflict with the AAM Code of Ethics or incompatible with the best interest of the corporation, shall be removed from the Board of Directors.

Article VI: Meetings
Section 1: Annual Meeting - An Annual Meeting of the membership shall be held each year with no less than fourteen (14) days and no more than twenty-one (21) days published notice of the place, date and time. The date of the Annual Meeting shall be set by the Board of Directors at its (month of) meeting.

Section 2: Special Meetings - Upon request of the Chair, a majority of the Board of Directors or ten (10) percent of the membership, a special meeting shall be held when deemed necessary and beneficial to the corporation. Published notice of the agenda shall be mailed to all members not less than seven (7) days before the designated place, date and time for the special meeting.

Section 3: Quorum - Upon action by the Chair, a quorum for the conduct of business shall be declared at each official corporate meeting. A simple majority of those voting members present shall suffice for action on any motion presented, unless otherwise stipulated in these Bylaws.

Section 4: Rules of Order - Robert's Rules of Order (current edition) shall be followed in all meetings of the corporation and its committees, unless otherwise modified herein by these Bylaws. Minutes of actions taken and members present at such meetings shall be recorded and maintained.

Section 5: Agenda for Regular Meetings. The agenda or order of business for each Regular meeting shall include the following.
 (a) Call to order
 (b) Roll Call
 (c) Approval of Minutes
 (d) Financial report
 (e) Reports of Regular Committees
 (f) Reports of any other Committees
 (g) Report of the Director
 (h) Old business
 (i) New business
 (j) Adjournment

Article VII: Officers
Section 1: Officers - Officers of the corporation shall include a Board Chair, a Vice Chair, a Secretary and a Treasurer. All such officers must be duly elected from among voting members of the Board of Directors. No individual shall concurrently hold more than one office.

172

The Museum Toolbox

Section 2: Election and Term of Office - Election of officers shall occur each year following the Annual Meeting. Recommendations shall be presented by a Nominating Committee appointed by the Board Chair. Each officer shall be elected by the Board of Directors and serve for a period of one year. All vacancies in these offices shall be appointed by the Board Chair, or when absent the Board of Directors, for the remainder of that year.

Section 3: Duties of Board Chair - The Chair shall preside at all meetings of the Board of Directors, appoint committee members, exercise general oversight of corporate business and perform such other duties as may from time to time be assigned by the Board of Directors. The Chair, or a designee, may serve as an ex-officio member of those standing and special committees established by the Board. By invitation of the Board, the immediate past Board Chair may serve as a voting member on the Board of Directors for a period of one year.

Section 4: Duties of Vice Chair - Upon disability or absence of the Chair, the Vice Chair shall perform the duties of the Board Chair and such other duties as may be assigned by the Board of Directors. The Vice Chair organizes the corporation's Annual Meeting and may serve as an ex-officio member of all committees.

Section 5: Duties of the Secretary - The Secretary shall record the minutes of all meetings of the Board of Directors, maintain records of committee meetings, oversee the maintenance of membership lists, provide for the safe keeping of all official contracts and records of the corporation, and publish notices of scheduled meetings as required in these Bylaws.

Section 6: Duties of the Treasurer - The Treasurer shall be responsible for the prompt deposit of all receipts, an accurate accounting of income and expenditures, and shall present a written financial report to the Board of Directors at quarterly meetings. The Treasurer shall maintain the financial records of the corporation using acceptable accounting practices and shall perform those other duties inherent to the office of Treasurer.

Section 7: Honorary Titles - The Board of Directors may from time to time award certain friends of the corporation with honorary titles as it may deem prudent to advance the mission and goals of The (Insert Name of Non-Profit). Such honorary titles shall not carry any obligations, powers or duties within this corporation.

Article VIII: Standing and Special Committees
Section 1: Membership Committee - shall have a responsibility to identify and encourage others to join The (Insert Name of Non-Profit), and keep the membership informed about ongoing activities. Therefore, an important function of this committee, or its subcommittee, shall be to periodically publish a newsletter, brochures and related promotional materials.

Section 2: Finance Committee - shall have a responsibility to advise the Board on appropriate budgeting and accounting practices as a nonprofit corporation. Other functions of this Committee shall be to propose an annual budget, monitor income and expenditures and recommend an auditor to conduct the annual audit as specified in these Bylaws. The Treasurer of the corporation shall serve as a voting member of this committee.

Section 3: Resource Development Committee - shall have the responsibility of seeking funds necessary for the operation and maintenance of The (Insert Name of Non-Profit). This function may be accomplished through governmental budgets, grants, corporate sponsors, personal contributions, in-kind services, special fundraising events and similar resources.

Section 4: Facilities & Property Committee - shall assist staff, officers, Directors and Executive Director with the acquisition and maintenance of corporate properties and facilities and conduct an annual equipment inventory. The committee shall also submit recommendations to the Board on leases, licenses, insurance, real property purchases and similar related matters.

Section 5: Acquisitions & Collections Committee - shall be responsible for those policies, procedures and forms that provide for the acquisition, preservation, storage, security, cataloging and display of items donated or loaned to the museum. Other duties include oversight of an annual inventory of collections and the periodic assessment of preservation and conservation needs.

Section 6: Special Committees - Administrative, managerial, advisory and special project committees or subcommittees may be established by the Board Chair as deemed necessary for the efficient operation of the museum. Each committee thus created shall advise the Board of Directors and the Executive Director on matters related to achieving the stated mission and goals of The (Insert Name of Non-Profit).

Section 7: Committee Membership - The Board Chair shall appoint committee membership from among the corporation's members and designate the chair for each committee thus appointed, unless stipulated otherwise in these Bylaws. The Museum's Executive Director, or a designee, may serve as a nonvoting, ex officio member of all standing committees. Committee Chairs shall be responsible for recording minutes of each meeting and providing a copy to the corporation Secretary.

Section 8: Terms of Committee Membership - Members of standing committees shall serve one year or until the next Annual Meeting of the corporation which ever occurs first. At the discretion of the Board Chair, members of Standing Committees may continue to serve until a successor is appointed. Members of Special Committees shall serve for one year or less, as specified when the committee is established.

Article IX: Finance and Audits

Section 1: Fiscal Year - The Corporation's financial year shall commence on the first day of January and end on the thirty-first day of December in each calendar year.

Section 2: Funds and Property - All funds and property held by the corporation are maintained in trust for the purposes authorized in its charter and only in accordance with its official Mission and Goals. Bequests, gifts, loans and donations must first meet published corporation "Guidelines for Donations." Each officer, employee, volunteer or its agent, having custody of corporation funds or property, is to be covered by an appropriate fidelity and forgery insurance bond carried at the expense of the corporation.

The Museum Toolbox

Section 3: Records and Reports - Finances of the corporation shall be maintained in accordance with generally accepted accounting principles and its records shall be kept in such manner as to facilitate the preparation of quarterly financial reports for the Board of Directors and membership.

Section 4: Deposits & Disbursements - All cash, restricted and reserve funds of the corporation shall be deposited in banks or depositories under the name of The (Insert Name of Non-Profit). Any and all disbursements from such accounts shall be made only by checks or similar money orders signed by the Treasurer or Museum Executive Director and another designated person. Only banks or depositories that are members of the Federal Deposit Insurance Corporation or the Federal Savings and Loan Insurance Corp may be used, unless the Board of Directors consent to use another investment or depository.

Section 5: Audits - The accounts of this corporation shall be audited within 180 days of the end of each fiscal year provided, however, an additional ninety (90) days may be granted by a vote of the Board. Such audit shall be made by a competent, certified public accountant of recognized standing who is not an officer of the corporation. Upon written request, audit reports shall be made available to corporation members and to any appropriate judicial authority.

(Article X, No Longer Required and Optional)
Article X: Corporate Seal
The official seal of the corporation shall consist of the words "The (Insert Name of Non-Profit)." and "(Name of State)" inscribed within two concentric circles with the words "CORPORATE SEAL" inscribed inside the innermost circle.

Article XI: Dissolution of the Corporation
Section 1: Dissolution Rule - Following an affirmative vote in favor by two-thirds (2/3) of the corporation membership, the Board of Directors shall call a special meeting for the sole purpose to voluntarily dissolve this corporation. At that time all assets and funds, along with all minutes and records, shall be promptly transferred into the custody of an organization or agency designated by the Board of Directors. In this rule, every attempt will be made to satisfy the corporation's mission.

Section 2: Optional Rule - In the event no Board of Directors exist, or the Board of Directors refuse or fail in a reasonable period to dissolve the corporation, upon application by any officer or member, the Superior Court (Insert Name of County) shall dissolve the corporation in a manner consistent with the above rule and in accordance with Section 501(c)(3) of the Internal Revenue Code of 1986.

Article XII: Amendments
Amendments may be adopted at any meeting at which a quorum is declared present, provided appropriate notice of the amendment is provided all members at least ten (10) days prior to said meeting. Amendments to these Bylaws require two-thirds (2/3) approval by those members present and voting. Such amendments take effect as stated in the original motion.

HISTORICAL NOTES:

7

(Insert Date) - First Community Meeting and Location
(Insert Date) - Articles of Incorporation granted.
(Insert Date) - Board of Directors adopts Bylaws, Mission and Goals.
(Insert Date - IRS 501(c)(3) status approved.
(Insert Date) - first Annual Meeting (number in attendance) at (Location)

REVISIONS TO BYLAWS:
(Insert Date) – (List any revisions to Bylaws, including new committees, changes to annual fees or amendments

American Alliance of Museums: Developing a Mission Statement

American
Alliance of
Museums

ALLIANCE REFERENCE GUIDE

Developing a Mission Statement

This guide aims to help a museum develop and refine its mission statement, the foundation on which a museum's operations and impact stand. This guide will explain the purpose and importance of a mission statement, provide some examples of them and identify considerations for creating or revising one. It reflects national standards and is in line with the requirements of the Alliance's Core Documents Verification and Accreditation programs.

What It Is

A mission statement is the beating heart of a museum. It articulates the museum's educational focus and purpose and its role and responsibility to the public and its collections. Some museums choose to also develop vision and value statements as a way of extending the concepts expressed in the mission statement. These are different but related guiding documents for the museum: mission is purpose; vision is future; and values are beliefs.

Why It Is Important

A mission statement drives everything the museum does; vision, policy-making, planning and operations are all extensions of a museum's mission. The mission gives the governing authority a foundation from which it can strategize. The governing authority sets the museum's strategic direction through the mission, which impacts the policies and plans influencing staff actions and behaviors.

American Alliance of Museums
1575 Eye Street NW, Suite 400, Washington, DC 20005
202-289-1818
www.aam-us.org

American
Alliance of
Museums

What to Consider

Museums are encouraged to take the time to explore their circumstances and articulate them accurately in their mission and other policies and plans. Each of the museum's official documents should speak to one another consistently and comprehensively to support mission. Therefore, it is important that policies and planning be integrated in order to be effective.

Anatomy of a Mission Statement

There are as many different ways to create mission statements as there are museums. That should be the case, as each museum has its own distinct history, community and set of challenges. Typically, a mission statement explains the museum's purpose and reason for existing. Sometimes, it will address audience and impact. A museum may look to other mission statements as a helpful starting point for drafting and discussing its own, but in order to create a strong foundation for everything the museum does, mission must be specific to each museum.

A good mission statement leans toward societal impact rather than simply an explanation of operations, "transitioning from being *about* something to being *for* someone." –Stephen Weil (*Daedelus*, 1999).

Here are a few examples of mission statements from accredited museums:

» **Museum of Science, Boston**

The Museum's mission is to play a leading role in transforming the nation's relationship with science and technology.

» **Aldrich Contemporary Art Museum**

The Aldrich Contemporary Art Museum advances creative thinking by connecting today's artists with individuals and communities in unexpected and stimulating ways.

» **Missouri History Museum**

The Missouri History Museum seeks to deepen the understanding of past choices, present circumstances, and future possibilities; strengthen the bonds of the community; and facilitate solutions to common problems.

American Alliance of Museums
1575 Eye Street NW, Suite 400, Washington, DC 20005
202-289-1818
www.aam-us.org

Where to Begin

Creating or reviewing a mission statement is not easy, but it can be a stimulating and enlightening process. Missions may evolve as the museum does and therefore need to be reviewed from time to time. Most importantly, missions must be practiced; mission statements are only useful if they are being realized every day.

A museum reviewing its mission statement might consider reasons for review and how long it has been since the mission was changed. A mission statement is usually revisited or revised when change arises (e.g., institutional planning, applying for accreditation, shift in audiences served). Since it can evolve over time, it is important for it to be nimble enough to bend and move with change.

While this process can vary from museum to museum, here are some steps to take in revising a mission statement:

>> *Create a review team and outline the review process.* Museums might consider who will be involved and how they will contribute to the review. This team can consist of people from different functions of the museum. Many times, the team incorporates members of the governing authority and staff, but a smaller group is usually more productive than a larger one. Greater feedback is encouraged, but the team's responsibility is to facilitate the process, identify key stakeholders and use feedback to shape what will eventually become the mission. Those leading the review must ensure that the development and end result are effective. The team should be authorized by the governing authority and report to the governing authority.

>> *Do research.* Museums may find it helpful to do research on the origins and history of the museum to explore how purpose has evolved over time.

>> *Look at the current mission statement.* Missions do not always need to change, but it is important to recognize when they have to. The strengths and weaknesses of the current statement can be considered in order to determine what types of revisions are required. Does it need just a few tweaks or a complete rewrite?

>> *Get feedback.* While the mission statement review team will lead the process, feedback from other stakeholders is essential. Broad input from board, volunteers, staff and other stakeholders can push thinking to explore why the museum is a vital part of its community. It is wise to capture this feedback verbatim. Input from many people can build excitement and passion, which a mission statement should reflect.

American Alliance of Museums
1575 Eye Street NW, Suite 400, Washington, DC 20005
202-289-1818
www.aam-us.org

American Alliance of Museums

» *Refine the mission.* The team can use the feedback collected to start drafting the statement. Drafts can go to stakeholders to refine the mission, making it more succinct and powerful over time. However, writing the mission cannot become the mission. It is important that museums strike the fine balance between getting the necessary input needed to create a strong mission, and moving forward to acknowledging, believing and living the mission.

» *Consider also writing vision and value statements at this time.*

» *Send the final draft of the mission statement to the board for formal approval.* This can be accompanied by an explanation of the process and the decisions made throughout.

» *Integrate the new mission statement into planning efforts, policies, documents and publications.* At this point, it would be prudent for the museum to consider documents needing revision in order to reflect this new mission. Those documents can be revised as needed and distributed to key stakeholders.

Core Documents Verification

The Core Documents Verification program verifies that an institution has an educational mission and the policies and procedures in place that reflect standard practices of professional museums, as articulated in *National Standards and Best Practices for U.S. Museums* and used in the Accreditation program.

A mission statement is one of five core documents that are fundamental for basic professional museum operations and embody core museum practices. Listed below are required elements of a mission statement for museums participating in the program.

Mission Statement Required Elements

» Educational in scope

» Describes the institution's unique purpose/focus/role

» Is approved by the governing authority

American Alliance of Museums
1575 Eye Street NW, Suite 400, Washington, DC 20005
202-289-1818
www.aam-us.org

American
Alliance of
Museums

Where to Find Out More

» *National Standards and Best Practices for U.S. Museums*, edited by Elizabeth E. Merritt (AAM Press, 2008)

 This guide is an essential reference work for the museum community, presenting the ideals that should be upheld by every museum striving to maintain excellence in its operations. An introductory section explains how virtually anyone associated with museums will find the book valuable, from trustees to staff to funders and the media. It is followed by a full outline of the standards, including the overarching Characteristics of Excellence for U.S. Museums and the seven areas of performance they address. Throughout the book is commentary by Elizabeth E. Merritt, director of the Alliance's Center for the Future of Museums. This publication is available as a free PDF for all museum members.

» *Museum Mission Statements: Building a Distinct Identity*, edited by Gail Anderson (AAM Press, 1998)

 This book provides step-by-step guidance in writing or evaluating a museum mission statement and how to use it effectively. Generously supplemented with 79 outstanding mission statements from a wide variety of museums, the report is useful to museums of any size or type.

» *Small Museum Toolkit* by Cinnamon Catlin-Legutko and Stacy Klingler (AltaMira Press, 2011)

 This collection of six books serves as a launching point for small museum staff to pursue best practices and meet museum standards. These brief volumes address governance, financial management, human resources, audience relations, interpretation and stewardship for small museums and historic sites. Book One addresses mission.

» Sample Documents

 The Information Center's sample document collection is a unique and valuable resource for Tier 3 member museums. The collection contains more than 1,000 samples of policies, plans and forms from museums of all types and sizes, most of which were written by accredited museums. Tier 3 museum members can request sample documents from the Information Center in order to stimulate a conversation about issues and challenges facing the museum and to explore how different museums approach different issues. Using the sample documents should not replace the process of joining staff, governing authority and stakeholders in fruitful and thoughtful planning and policy-making.

American Alliance of Museums
1575 Eye Street NW, Suite 400, Washington, DC 20005
202-289-1818
www.aam-us.org

**American
Alliance of
Museums**

Standards

The Alliance's standards address "big picture" issues about how museums operate. For the most part, they define broad outcomes that can be achieved in many different ways and are flexible enough to accommodate a diverse museum field. These standards can be achieved in tandem with standards issued by other organizations that address aspects of museum operations or the museum profession.

Adhering to standards is achievable by all types of museums.

Standards provide a common language that enables museums to self-regulate, demonstrate professionalism and increase accountability. Policy-makers, media, philanthropic organizations, donors and members of the public use standards to assess a museum's performance and evaluate its worthiness to receive public support and trust. Simply stated by Elizabeth Merritt in *National Standards and Best Practices for U.S. Museums*, "Standards are fundamental to being a good museum, a responsible nonprofit and a well-run business."

Having a strong mission statement helps museums adhere to standards. For more on standards, visit the Alliance's website at www.aam-us.org.

American Alliance of Museums
1575 Eye Street NW, Suite 400, Washington, DC 20005
202-289-1818
www.aam-us.org

Sample Museum Constitution

(Sample) Museum Constitution

ARTICLE I

Name
The name of this museum shall be (Insert Name of Museum).

ARTICLE II

Purposes
The purposes of this museum shall be:
[Copy the corporate purposes exactly from the provisional charter petition, provisional charter, or absolute charter. Include any amended language.]
a.
b.
c.
d.

ARTICLE III

Trustees
The number of trustees constituting the board of trustees is to be not less than (Least number ten (10) nor more than a good suggestion is twenty-five).

ARTICLE IV

Election of Trustees
The manner in which trustees are to be elected is as follows:
In accordance with procedures set forth in the by-laws, trustees shall be elected by a vote of two-thirds of the board of trustees.

If any trustee shall fail to attend three consecutive meetings without written excuse accepted by the trustees, he or she shall be deemed to have resigned. Vacancies shall be filled for the unexpired term by a two-thirds vote of the full board of trustees.

ARTICLE V
Appointment and Function of Museum Director

The Chief Executive and operating officer of the museum appointed by the trustees and serving at their pleasure shall be the Museum Director, whose duties shall be those as defined by the bylaws of the institution.

ARTICLE VI

Membership
Voting members of the institution shall be the trustees. The trustees may establish other classes of members, who shall be non-voting.

ARTICLE VII
Distribution of Assets Upon Dissolution

In the event of dissolution of the museum, assets shall be distributed for one or more exempt purposes within the meaning of Section 501 (c) (3) of the Internal Revenue Code, or corresponding section of any future Federal tax code, or shall be distributed to the Federal government, or to a State or local government for a public purpose.

ARTICLE VIII

Amendments
These articles may be amended at any time by a two-thirds vote of the board of trustees then in office.

1. Sample Museum Constitution, New York State Museum, 260 Madison Avenue, Albany, NY 12230, http://www.nysm.nysed.gov/charter/musconstitution.html, website accessed March 14, 2015

Sample Museum Feasibility Template

(Insert Name of Museum)
Museum Feasibility Template

(Components of a Museum Feasibility Study)

Introduction:
Site the need for the museum

Executive Summary:
Describe the feasibility of the museum in a brief statement. Discuss the SWOT analysis.

Recommendations:
Summarize the recommendation to the Board of Directors

Supporting Research

Area Demographics: Research the area demographics and population trends, i.e. "Is the local population growing or shrinking?", "What is the education level of the local population?", "Who are the largest employers in the area?", and "What is the city/area's socio-economic status?"

Business Model: Describe the possible institutional business models. For instance, "Admission Based", "Donor / Sponsor Based", "Rental Income", etc. and percentage of overall visitation. Visitor Demographics: Define Visitor types, i.e. "Seniors", "Families with young children", "Singles", etc. and percentage of overall visitation.

Area Partners / Competition: Describe the list of major institutions in the surrounding area as potential partners and/or competitors with information such as location, website, admission prices, and annual visitation.

Area Tourism: Summarize the major attractions and areas of interests for tourists including historic sites, museums, outdoor recreation, shopping, agriculture, and so forth.

Visitor Trends: Look at various age ranges, durations of stay, accommodations, areas visited, and reasons (for vacation, business, or to see family or friends).

Benchmark Case Studies: Consider the business models of three to five comparable or varied institutions by researching their founding history, programs, organizational structure, admission prices, partners, and operating budget over several years.

Best Practices:
Summarize the Best Practice of Museums and how the museum analyzed will or will not meet the Best Practices in the field of museums.

Draft Mission: I don't think it is possible to create a realistic museum feasibility study without at least a draft of the mission statement. The mission can be very simple, but at least it is a starting point for a Board of Directors to review.

1. Naper Settlement, Board Member Responsibilities and Commitments, 523 S. Webster St., Naperville, IL 60540, http://www.napersettlement.org/FormCenter/Board-of-Directors-Forms-2/Board -Member-Responsibilities-and-Commit-36/ website accessed March 13, 2015

Plan for the Visitor: Visitors are not numbers. It seems simple, but a possible high attendance without a supportive visitorship is of little value, creating a second year dip. Museum visitorship should grow in the second year, not shrink. If your visitorship is decreasing in the second year, you are not connecting with your visitor base.

Future Planning: Best case scenario is that the plan of the feasibility study will be in place in three years – one year for planning, one year for fundraising, and one year for construction. Plan for at least five years out.

Recommendations: Outline the strengths, weaknesses, opportunities, and threats facing the organization with consideration of mission/vision and the community profile.

Conclusion: In greater detail discuss the summary of the findings, from evaluations to recommendations, and offer next steps.

Appendix

Supplemental Materials: Include all relevant visual aids or appendices for presentations by the Board of Directors.

Bibliography: List all sources used throughout the study, i.e. demographic data from the U.S. Census, organization websites, articles, etc.

Letters of Support: Include any letters of support for the project

Peer Review: Politely ask Directors of your benchmark case studies if they would be willing to review your feasibility study and make comments. The data of the feasibility study may be of help with their planning.

Sample Board Member Responsibilities

Board Member Responsibilities and Commitments

As a duly elected or appointed member of the (Insert Name of Non-Profit) Board of Directors, I am committed to carrying out the basic responsibilities listed below. I agree to:

- Understand and support the mission, purpose and goals of the (Insert Name of Non-Profit and Museum).
- Participate in setting the strategic direction for the (Insert Name of Non-Profit and Museum).
- Responsibly manage director's fiduciary duties including financial oversight, fundraising participation and provision for preservation of physical assets.
- Approve overall policy direction of the organization. Endorse standards of operation. Set forth ethical criteria by which the organization will be managed.
- Subscribe to the Institutional Code of Ethics.
- Be a community ambassador; assisting with the identification and recruitment of people to become active volunteers with the (Insert Name of Non-Profit and Museum).
- Actively participate at board meetings and on a committee(s) of the board, including advance review of all materials prior to meetings.
- Assume an active role in fund raising programs including identifying and cultivating prospective donors, making a personal annual contribution to the (Insert Name of Non-Profit and Museum) of no less than $(Insert Amount), and securing an additional $(insert amount) from other donors and/or event participation.
- Actively support events as a worker or attendee, including attendance and support at (Museum) fund raising event(s).
- Complete a Conflict of Interest statement annually.
- Actively participate in board retreats or workshops as scheduled.
- Assume additional responsibilities as my time permits.
- I further agree that (Insert Name of Non-Profit and Museum) may use my likeness in any brochure or promotional materials that will be used to advertise or promote (Insert Name of Non-Profit and Museum).

Naper Settlement, Board Member Responsibilities and Commitments, 523 S. Webster St., Naperville, IL 60540, http://www.napersettlement.org/FormCenter/Board-of-Directors-Forms-2/Board-Member -Responsibilities-and-Commit-36/ website accessed March 13, 2015

In exchange for the opportunity to participate in the (Insert Name of Non-Profit and Museum) efforts to (insert short description of purpose of Non-Profit), I agree to release and hold harmless the (Insert Name of Non-Profit and Museum), its agents, employees, volunteers and the City of (Insert Name of City) from all damages, judgments, expenses (including attorney's fees), costs or liabilities suffered because of the injury to, or because of damage to property that may arise out of, or as a consequence of any volunteer work which I may perform, except injury or damage caused by direct negligence of the (Insert Name of Non-Profit and Museum).

I agree to all statements above.

Signature

Name

Date

Sample Policy for Donations of Objects

(Sample) Policy for Donations of Object[1]

While the permanent collections of the (Name of Museum) contain nearly (insert number) objects, we do still accept written requests for donating items to the collections and we review these on a monthly basis.

The large number of objects already under our care dictates that we follow strict criteria when determining whether to accept new pieces. Factors include not only storage but long-term management costs and potential for research and exhibition use. Please read our Acquisition Guidelines below. Once you are satisfied that your potential donation meets our criteria please submit our Donation Questionnaire for review.

Acquisition Guidelines
Thank you for considering a donation to the Museum. Please review the following guidelines for Museum acquisitions:

1. The item(s) must be consistent with and relevant to the stated purpose, scope, and activities of the Museum.

2. Primary consideration will be given to the Museum's ability to provide proper care and storage for any artifact. No item(s) will be considered for acquisition if future care and preservation needs exceed the Museum's resources. Donations that include financial support for long-term storage and preservation are encouraged.

3. Items must have clear title and be free of copyright restrictions.

4. Donors must provide verifiable record of authenticity and provenance for all proposed donations. The Museum will make every effort to ascertain that items offered are not stolen, wrongfully converted, or acquired under false pretenses. The Museum is bound by international antiquities laws. Foreign antiquities must have documentation indicating that they were exported from their country of origin prior to the 1970 UNESCO Convention on the Protection of the World Cultural and Natural Heritage. The provenance of acquired items shall be a matter of public record.

5. If the Museum discovers that it has acquired item (s) in violation of the above statement, the Museum shall seek to return the item(s) to the legal owner or shall seek to determine the proper means of disposition through recognized authorities.

6. A 30-day examination period may be requested for any proposed acquisition.

7. All acquisitions are to be outright and unconditional. The Museum cannot guarantee that objects donated will be placed on exhibition, or that they will be exhibited or stored intact as a single collection. In addition, please be aware that curatorial decisions made during cataloging of new collections may result in objects being deemed more appropriate for use in our education department or to be offered for sale to benefit the Museum.

8. All donations to the Museum's collections are irrevocable upon the formal and physical transfer to the Museum.

9. All legal instruments of conveyance and warranty of title, signed by the donor/seller/agent setting forth an adequate description of the items involved and the precise conditions of the transfer shall accompany all acquisitions.

10. All acquisitions by gift or bequest to the Museum will remain in the possession of the Museum for as long as they retain their physical integrity and authenticity, and as long as they remain useful for the purposes of the Museum.

11. Federal law prevents the Museum from providing identification services or appraisal values for donated items. Donors are responsible for appraisals of value. Please contact the regional branch of the Appraisers Association of America or the American Society of Appraisers directly. The Museum is in no way affiliated with these organizations.

Donations are fully tax deductible within IRS guidelines. Please consult your tax advisor.

"Policy for Donations of Objects" from Phoebe A. Hearst Museum of Anthropology, 103 Kroeber Hall, Berkeley, CA 94720, http://hearstmuseum.berkeley.edu/about/policies/donations Website accessed March 13, 2015

Sample Donor Questionnaire

DONOR QUESTIONNAIRE

Thank you for your interest in donating artifacts to the (Insert Name of Museum).

To offer items for donation to the (Insert Name of Museum), please:
Complete the following Donor Questionnaire form.
- **List each item**, attaching an itemized list and photographs.
- **Give detailed history for the item(s):** who owned it/used it, where was it used, any important stories, anecdotes, or other information. The background of the item is as important as the item itself. Please include documentary evidence of an object's history including, but not limited to: a dated bill of sale or sales receipt, will, inventory, auction catalogue, published reference, exhibition record, correspondence, photograph or, in exceptional cases, if documentary evidence cannot be obtained, a signed statement from the donor or vendor that confirms the accuracy of the account. Proof of such documentation will be needed before the acquisition review process can be initiated
- **Do not send items at this time.** All collection offers must be made in writing. We cannot accept actual artifacts for review without prior consultation.

Thank you for taking the time to fill out this questionnaire.

Please return to: Head of Registration, (Insert Name of Museum and Address)

Please note

- The (Insert Name of Museum) recognizes the Nov. 17, 1970 UNESCO *Convention on the Means of Prohibiting and Preventing the Illicit Import, Export, and Transfer of Ownership of Cultural Property* for the acquisition of archaeological materials and ancient art. The Museum will therefore not acquire archaeological materials and ancient art unless research substantiates that the work was outside its country of probable modern discovery before Nov. 17, 1970, or was legally exported from its country of probable modern discovery on or after Nov. 17, 1970.

- Due to conflict of interest laws, the Museum may not provide an appraised value for donated artifacts. If a value is need for tax purposes, please consult an independent appraiser.

- The Museum appreciates monetary support for the care and management of your donation in perpetuity. Please indicate the amount you wish to donate: $

Donor Information

Donor's Name: _____Today's Date_____

Address:_____

Email:_____

Telephone: (home) _____(work) _____

1. Based on the "Donor Questionnaire" Phoebe A. Hearst Museum of Anthropology, 103 Kroeber Hall, Berkeley, CA 94720, http://hearstmuseum.berkeley.edu/sites/default/files/documents/PAHMA_donor_questionnaire_2014-05-04.pdf Website accessed March 14, 2015

Artifact Information

Please attach list and photographs (digital link, disk, or hardcopies)

Are there any documents (such as photographs, letters, bill of sale, or newspaper articles) related to the item that you would like to include in the donation, or allow the museum to copy? The more information and documentation, the better use the Museum would be able to make of your donation:

If the item is a photograph or collection of photos, is it captioned (the event or the people it depicts and/or the place and date it was taken)?""Yes" "No"

Do you hold copyright?""Yes" "No"

Previous/Original Owner's Information

Was there any previous owner? "No"

"Yes" Relationship to you:

Previous/original owner's name:

Birth Date: _____ Place of Birth: _____

Death Date: _____ Place of Death: _____

How did you acquire the artifact(s)?:

Additional comments, memories, recollections, etc.:

Please attach any further comments, photographs/photocopies of items, or other relevant information.

Sample Museum Exhibit Sponsorship Agreement

MUSEUM EXHIBIT SPONSORSHIP AGREEMENT

This Sponsorship Agreement (the "Agreement") is made effective as of _____ ____, 200_ by and between ABC Museum located at _____ (the "Museum") and XYZ Company located at _____ ("XYZ" or "Sponsor"). (The Sponsor and the Museum together are referred to as the "Parties".)

Recitals

WHEREAS, The ABC Museum depends on the enlightened support of major corporations such as XYZ Company to continue to develop and present exhibitions of the highest quality in keeping with the Museum's standards of excellence and as a means of furthering one of the finest cultural programs in the visual arts; and

WHEREAS, XYZ Company wishes to support the ABC Museum and its programs.

NOW THEREFORE, in consideration of the mutual covenants and agreements contained herein, and intending to be legally bound, the Parties hereto agree as follows:

1. Exhibition Description.

 a. The Museum intends to present an exhibition entitled [Exhibition Title] (the "Exhibition") at the ABC Museum located in [Location] over a period of approximately [Time Frame].

 b. The Exhibition will consist of [Describe Exhibition].

 c. Nothing in this Agreement shall give Sponsor any rights of any kind whatsoever with respect to the content of the Exhibition.

2. Contribution of Sponsor.

 a. Sponsor agrees to support the Museum and the Exhibition by contributing to the Museum the sum of US$ _____ (the "Sponsorship Funding Amount"). The Sponsorship Funding Amount will be paid by Sponsor directly to the Museum by check or wire transfer according the following schedule: [Specify Payment Schedule]

 b. [Specify any special considerations such as restrictions on use of funds, contributions by affiliates towards total amount, etc.]

 c. Sponsor agrees to provide the following goods and services (the "In-Kind Donation") in connection with the Exhibition: [Specify in detail the nature and amount of any In-Kind donations, including the delivery schedule and who will bear any related costs.]

 d. [Specify any other payment terms, such as wire transfer instructions, interest on late payments, collection policies, etc.]

3. Sponsor Credit Line.

 a. Sponsor's sponsorship of the Exhibition will be reflected in the following Exhibition credit line (hereinafter "Exhibition Credit Line"):

 This Exhibition is supported by Sponsor 1 (logo) Sponsor 2 (logo)

 Sponsor 3 (logo) Sponsor 4 (logo)

 [Sponsor will be listed in the Exhibition Credit Line (with logo) according to the amount of its commitment relative to other Exhibition sponsors.]

 b. [Where Credit Line is already designated: The Exhibition Credit Line will be designated as indicated in Exhibit A, and will be included in certain placements as indicated in Section 4 below.] [If Credit Line has not been designated: The Exhibition Credit Line will be included in certain placements as indicated in Section 5 below.] The Sponsor's logo/logo font will appear as set forth in Exhibit A and only in the placements specified in Section 5.

 c. The Museum will have the right to change the Exhibition Credit Line prior to the opening of the Exhibition in consultation with Sponsor. The Museum will retain ultimate control over the content and appearance of the Exhibition Credit Line subject to any commitments it has made with respect to relative placement of Sponsor's name and logo herein.

"Museum Exhibit Sponsorship Agreement", Lehmann Strobel PC, 3613 Anton Farms Road, Baltimore Maryland 21208, (tel) 443-352-8635, http://www.lehmannstrobel.com/file_download/14/museum-agreement.pdf Website accessed March 14, 2015.

4. Sponsorship Acknowledgement.

 a. The Museum will carry the Exhibition Credit Line as follows: [Specify all placements and whether logo or text only.]

 b. The Museum will provide additional acknowledgement of Sponsor's sponsorship by verbally acknowledging the Sponsor at [Specify events such as press previews and conferences, opening receptions, etc.] organized for the Exhibition.

 c. Sponsor may provide a one-page sponsor statement about its sponsorship of the Exhibition to be included in Exhibition press kits, subject to the advance approval of the Museum. Sponsor may also provide a fact sheet describing its other museum sponsorship activities and the company, subject to the advance approval of the Museum, for inclusion in Exhibition press kits. While the Museum will retain ultimate discretion over the content and appearance of the sponsor statement and fact sheet, it is understood and agreed that any changes made by the Museum to these materials shall also be approved by Sponsor prior to their release.

 d. The Museum will provide Sponsor with an advance copy of all materials containing the Exhibition Credit Line for Sponsor's approval a minimum of fifteen (15) days prior to the printing or creating of such materials, which approval shall be limited to use of the Sponsor's name and/or logo in the Exhibition Credit Line and which will not be unreasonably withheld. The Museum will retain full discretion over the content and appearance of such materials.

5. Additional Exhibition Publicity Created by Sponsor.

 Sponsor shall have the right, at its own expense, to supplement the Museum's publicity for the Exhibition by developing its own public relations campaign promoting the Exhibition in conjunction with the Museum's public relations efforts and using the Museum's name, the Exhibition Credit Line and images from the Exhibition, subject to any third-party rights; provided, however, that all materials produced in connection with such campaign are reviewed and approved by the Museum in advance of their distribution. The Sponsor must provide all such materials or details of such activities to the Museum for its approval a minimum of fifteen (15) business days prior to distributing such materials. Upon notice by the Museum, the Sponsor will immediately withdraw any advertising or promotional material that is not in a form approved by the Museum pursuant to this Section.

6. Museum Access Opportunities.

 Sponsor will receive the following museum access opportunities as part of its sponsorship of the Exhibition: [Specify invitations to openings, tickets to educational events, catalogues, posters, merchandise discounts, use of Museum facilities for entertainment opportunities, etc. If entertaining opportunities are provided, include the following language: All event venues are subject to availability. Sponsor must pay all fees and direct costs for the event, including but not limited to security, catering, decorating, etc. in accordance with the Museum's standard event policies.] Any benefits provided hereunder will not be subject to resale.

7. [Optional] Additional Activities.

 a. Sponsor may co-sponsor with Museum an opening event for the Exhibition at Sponsor's sole cost and expense. The event will be subject to Museum's special events policies. In the event that Sponsor elects not to fund the opening event, Museum may obtain other funding for the opening event.

 b. Museum will offer Sponsor the first opportunity to fund additional activities that are related to the Exhibition and proposed by the Museum. Museum may seek funding from Additional Sources if Sponsor chooses not to fund any additional activity proposed by the Museum.

8. Additional Sponsors.

 As indicated in Section 3(a) hereof, the Museum will recognize Sponsor as a corporate sponsor of the Exhibition. This will not preclude the Museum from obtaining additional funding from other sources, including corporations, governmental agencies, foundations and individuals, and such additional funders may also be credited in the Exhibition Credit Line and in Exhibition materials. Sponsor will be informed without undue delay of any further sponsors. [If Sponsor requires exclusivity: Notwithstanding the foregoing, this Sponsorship is intended to be exclusive as to [Describe in detail the scope of exclusivity, e.g. the provision of beverages in connection with Exhibition].] [Note: If the Exhibition is contingent on securing additional funds, indicate the amount and source of those funds and what will happen if those funds are not obtained.]

9. Intellectual Property.

 Sponsor acknowledges that the Museum is the sole and exclusive owner of the name "ABC Museum" and its logo, as well as all derivatives thereof. The Museum grants to Sponsor a non-exclusive license to use the name "ABC Museum" and derivatives thereof and the Museum's logo, throughout the world, subject to the Museum's rights of approval as specified herein, solely in connection with the promotion of the Exhibition; provided however that no printed or electronic material using the name 'ABC Museum" or any derivative thereof or the Museum logo may be distributed without the Museum's prior written approval of the form, nature, presentation and context of such usage. All right, title and interest in and to the name "ABC Museum" and any derivative thereof and the Museum logo, including goodwill associated with and symbolized by the name "ABC Museum" and any derivative thereof, shall remain vested in and inure to the benefit of the Museum. Sponsor's rights under this Section shall terminate thirty (30) days after the close of the Exhibition.

10. Cancellation.

In the unlikely event that the Exhibition is cancelled or does not open by [insert date], the Parties agree to work in good faith to reschedule the Exhibition on a mutually acceptable future date or allocate the Sponsorship Funding Amount or In-kind Donation to another mutually acceptable project of the Museum. Such cancellation shall not be considered a breach of this Agreement. If the Parties cannot agree on another project and the cancellation is due to a reason within the reasonable control of the Museum, the Museum shall refund without undue delay all payments made by Sponsor to the Museum under this Agreement. If the Parties cannot agree on another project and the cancellation is due to a reason beyond the reasonable control of the Museum (including but not limited to a force majeure event), the Museum will refund any portion of the funds that have not already been spent or irrevocably committed. Where some portion of the Sponsorship Funding Amount has been irrevocably committed, upon the Sponsor's request the Museum will provide evidence of the irrevocable commitment of the funds.

11. Termination.

Either Party will be entitled to terminate this Agreement by giving written notice to the other party in the event such other party commits a material breach of this Agreement, and, in the case of such a breach that is capable of remedy, does not remedy such breach within the required time. Museum will also be entitled to terminate this Agreement if Sponsor engages in activity, or there is a change in Sponsor's business practices, ownership, or products or services, that is not consistent with Museum's mission, policies or reputation or is not in the best interest of the community the Museum serves. The required time (except for the payment of money or the obligation to withdraw promotional materials produced pursuant to Section 7) will be within thirty (30) days of being given notice in writing specifying the breach or other reason for termination. In the case of an obligation to pay money, the required time will be within seven (7) days following service of a written demand to pay any sum due, and in the case of materials produced in violation of Section 7, the required time for remedying such breach will be within twenty-four (24) hours of being given written notice of breach. If the Museum terminates this Agreement based on a material breach by Sponsor, in addition to any other remedy it may have in law or equity, Museum shall not be obligated to refund any portion of the Sponsorship Funding Amount or any In-kind Donation received by it prior to the date of termination.

12. Confidentiality.

In consideration of the public nature of Museum and in order to protect its public image and the public trust, Sponsor acknowledges that Museum will not treat this Agreement or its contents as confidential information. This Agreement and its contents will be released if requested by organizations or individuals with a legitimate interest in the matter or who make such request in a manner consistent with Museum policy or applicable law.

[Alternate Confidentiality Provision: The terms of this Agreement will be confidential and will not be disclosed by either Party to any third-party (other than to a legal and accounting advisor, as required by law, or to enforce this Agreement) without the other Party's consent. This paragraph will survive the termination of this Agreement.]

13. Successors and Assigns.

The provisions of this Agreement will inure to the benefit of, and be binding upon, the successors (including successor trustees, in the case of a trustee), assigns, and administrators of the Parties hereto. Notwithstanding the foregoing, no party to this Agreement may assign this Agreement in whole or in part without the prior written consent of the other party.

14. Payments.

All payments to be made to the Museum hereunder (including reimbursement of expenses) will be made free and clear of and without deduction for any present or future taxes, fees, duties, withholding or other charges of any nature whatsoever imposed by any taxing authority and all interest and penalties, (other than any taxes imposed on or measured by net income or receipts of the Museum) (hereafter referred to as "Taxes"). In the event that any withholding or deduction from any payment to be made to the Museum hereunder is required in respect of any Taxes pursuant to any applicable law, rule or regulation, then the Sponsor will withhold or deduct the full amount required from such payment and (a) promptly notify the Museum that such deduction or withholding is required, (b) pay to the relevant authority the full amount required to be so withheld or deducted before penalties attach thereto or interest accrues thereon, (c) then immediately pay to the Museum such additional amount or amounts as are necessary to ensure that the net amount actually received by the Museum free and clear of any required deduction or withholding (including any required deduction or withholding on such additional amounts) on such additional amounts will equal the full amount that would have been received had no such withholding or deduction been required.

15. Force Majeure.

If, by any reason of any event of force majeure, either of the Parties is delayed in or prevented from performing any of the provisions of this Agreement (other than the payment of money), then such delay or nonperformance will not be deemed a breach of this Agreement and no loss or damage will be claimed by either of the Parties hereto by reason thereof; provided that the affected Party shall notify the other Party of the force majeure event within five (5) days of its occurrence. In the event of a force majeure event, the Parties will promptly agree on a mutually acceptable schedule for performance of their respective obligations (to the extent affected by the force majeure event), taking into account the nature of the force majeure event. The term "force majeure" includes, but is not limited to, war, terrorism, fire, flood, or other casualty, labor disputes, the enactment of any law or regulation imposing a substantial material impediment to the performance of any of the obligations of the Parties hereunder, or any other cause or event (whether of a similar or dissimilar nature) beyond the reasonable control of either of the Parties.

16. Charitable Contribution.

The Internal Revenue Service requires that donors obtain specific acknowledgments from donees, including a valuation of goods and services provided by the donee in return for the gift if the donor intends to take a charitable contribution tax deduction for the gift. The amount of the charitable contribution that is deductible for federal income tax purposes is limited to the excess of the value of the cash or property contributed over the value of the goods or services provided. Sponsor will notify the Museum in writing if it intends to characterize the Sponsorship Funding Amount or the In-Kind Donation as a charitable contribution.

17. Sponsor's Representations and Warranties.

Sponsor acknowledges that Museum is relying in good faith and to its potential detriment on the commitments made by Sponsor in this Agreement. Sponsor represents and warrants that it is a corporation in good standing, that it has the authority to enter into this Agreement and to grant the rights hereunder, and that any materials supplied by it pursuant to this Agreement will not violate any rights of any third parties.

18. Association.

The Parties, by this Agreement, do not intend to create a partnership, principal/agent, master/servant, or joint venture relationship, and nothing in this Agreement will be construed as creating any such relationship between the Parties.

19. Assignment.

This Agreement and the rights granted hereunder will not be assigned by either Party, except with the prior written consent of the other Party.

20. Indemnification.

a. The Museum agrees to indemnify and hold Sponsor harmless from all claims or damages asserted by third parties cause by or arising out of Museum's creation and presentation of the Exhibition.

b. Sponsor agrees to indemnify and hold Museum harmless from all claims or damages asserted by third parties except those asserted to be caused by the negligence of Museum, caused by or arising out of Sponsor's exercise of the benefits granted to it pursuant to this Agreement.

21. Governing Law.

The terms and conditions of this Agreement shall be governed by and construed and enforced in accordance with the laws of the Commonwealth of Pennsylvania.

22. Entire Agreement

This document contains the entire understanding of the Parties on the subject matter hereof and all prior written and oral discussions or agreements are merged herein. This Agreement may not be altered, amended or modified except by a written instrument executed by both Parties. The invalidity of any one provision in this Agreement shall not be deemed to render the whole agreement invalid.

23. Authorized Representatives.

For the purposes of liaison, direction and coordination of daily operational matters, the Parties shall be represented by the following individuals:

Museum Representative:

Sponsor Representative:
Each Party will notify the other party in writing of any substitution for said representatives.

24. Adherence to Museum Policies.

Sponsor agrees to adhere to all policies and guidelines adopted by Museum.

In Witness Whereof, the authorized representatives of the parties hereto have duly executed this Agreement as of this ____ day of _____, 200_.

XYZ Company ABC Museum

_____ _____

By: By:

Its: Its:

Attachments:

Exhibit A (sample Exhibition Credit Line or Sponsor logo)

Timing and Tracking Study

Timing and Tracking Study: Name of Exhibition: _____

Observer: Date: Time:

# Adult Males		# Boys		(ages)
# Adult Females		# Girls		(ages)

Time Entered Exhibition: _____Time Left Exhibition: _____
Mark on the plan below with a C where group has conversation, R where they stop to read
any text and I where they engage in interactions. Later, tally up your 3 behaviors below.

Note any conversations or interesting behavior.
(Insert Plan of Your Exhibition Below)

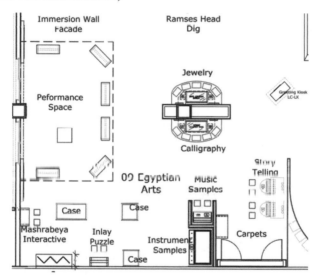

	Reading	Interactions	Conversations
Adults			
Males			
Females			
Children			
Males			
Females			

Timing and Tracking Study Form, USS Constitution Museum, Charlestown Navy Yard, Building 22,
Charlestown, MA 02129, the form can be found at http://www.familylearningforum.org/evaluation/
types-of-evaluation/timing-tracking.htm Website accessed March 14, 2015.

Visitor Exit Interview

(Insert Name of Exhibition) exhibition evaluation

Thank you for participating in the exhibition evaluation of "(Insert Name of Exhibition)".

We want to make sure the exhibition meets the expectations of visitors. Please answer the **(15)** fifteen questions below:

1. Please enter your email address below to be entered to win an Apple Nano. Your email will only be used to notify winners of the prize.

Email Address:	

2. Why are you visiting the exhibition today?

☐ Curious about the exhibition
☐ Curious about the content
☐ Curious about the (name specific content)
☐ Curious about the (name specific content)
☐ Curious about the (name specific content)

Other?

3. How far did you travel to visit the exhibition today?

☐ 0-10 Miles
☐ 10-20 Miles
☐ 20-50 Miles
☐ More than 50 miles

4. Does the introduction to "(Insert Name of Exhibition)", meet your expectations?

☐ Does not meet my expectations
☐ Meets my expectations
☐ Exceeds my expectations

Suggestions?

5. Does the "(Insert Name of Exhibition Area)" exhibition area meet your expectations?

☐ Does not meet my expectations
☐ Meets my expectations
☐ Exceeds my expectations

Suggestions?

6. Does the "(Insert Name of Exhibition Area)" exhibition area meet your expectations?

□ Does not meet my expectations
□ Meets my expectations
□ Exceeds my expectations

Suggestions?

7. Does the "(Insert Name of Exhibition Area)" exhibition area meet your expectations?

□ Does not meet my expectations
□ Meets my expectations
□ Exceeds my expectations

Suggestions?

8. Does the "(Insert Name of Exhibition Area)" exhibition area meet your expectations?

□ Does not meet my expectations
□ Meets my expectations
□ Exceeds my expectations

Suggestions?

9. Does the "(Insert Name of Exhibition)" theater meet your expectations?

□ Does not meet my expectations
□ Meets my expectations
□ Exceeds my expectations

Suggestions?

10. One a scale of one (1) to ten (10) with ten (10) being Excellent and one (1) being poor how would you rate the exhibition overall?

□ 1 **Poor**
□ 2
□ 3
□ 4
□ 5
□ 6
□ 7
□ 8
□ 9
□ 10 **Excellent**

11. Do you feel the exhibition changes your overall impression of the museum?

> ☐ For the Better
> ☐ No Difference
> ☐ For the Worse

12. Would you be willing to recommend this exhibition to your friends?

☐ Yes

☐ No

13. Do you feel the exhibition has a sufficient number of artifacts (historic objects)?

> ☐ Too many artifacts
> ☐ Just Right
> ☐ Not enough artifacts

14. Overall does the "(Insert Name of Exhibition)" meet your expectations?

> ☐ Does not meet my expectations
> ☐ Meets my expectations
> ☐ Exceeds my expectations

15. Do you have any additional comments or suggestions?

> Comments or Suggestions?

Thank you for taking the time to review the exhibition and complete the evaluation form

Museum Job Descriptions

Museum Job Descriptions

It takes many, many people to run a museum. Here are some of the museum jobs people do, and some of the skills it takes to be good at that job. What job would you like best? Which one would you be good at?

Director
- in charge of the whole museum and its workings
- represents the museum in contacts with the public
- works with the entire staff to make sure museum runs smoothly
- assists wherever needed in any department
- <u>Skills:</u> enjoy working with people, flexible and organized worker; comfortable public speaker, enjoy doing a variety of different things, good problem-solver
- You could be a Director if you are very good at persuading all different kinds of people to work together.

Curator
- expert in charge of one type of the collection (drawings, paintings, Egyptian objects, etc.)
- oversees the care, display and information about the objects in their areas
- assists the Registrars and Graphic Designers in assembling the museum catalog
- <u>Skills:</u> good writer, enjoys reading and researching
- You could be a Curator if you love reading and learning new information.

Registrar
- keeps track of all museum objects
- maintains records of ownership and borrowing
- carefully watches the safety and condition of objects on display
- works with the Curators and the Graphic Designers in assembling the museum catalog
- <u>Skills:</u> organizational skills, good record keeper, careful with details
- You could be a Registrar if you are good at keeping things in your desk and your room very neat and organized.

Museum Educator
- plans tours and other programs for museum visitors of all ages
- works with the Curators to develop exhibits
- oversees the docents
- <u>Skills:</u> good writer, creative, good with people
- You could be a Museum Educator if you love sharing new ideas and information with lots of different types of people.

Docent
- welcomes visitors to the museum
- guides and teaches visitors on tours of the museum
- answers questions about the objects in the museum
- <u>Skills:</u> good public speaker, enjoy research, good with people
- You could be a Docent if you like meeting new people and telling stories.

Graphic Designer
- designs posters and brochures about the museum, both by hand and on the computer
- assists the Public Relations Officers in creating advertisements for the museum
- helps with the creation of the museum catalog
- <u>Skills:</u> enjoys drawing, creative with color and shape, good writer and designer
- You could be a Graphic Designer if you enjoy drawing and working with color and shapes.

"Museum Job Descriptions" from the Memorial Art Gallery of the University of Rochester, 500 University Ave., Rochester, NY 14607 http://mag.rochester.edu/plugins/acrobat/teachers/Museum Careers.pdf Website accessed March 14, 2015.

Exhibit Designer
- plans layout and display of objects in the space provided for the museum
- decides on wall colors and arrangements of objects
- helps Preparators to hang and install artwork properly
- <u>Skills:</u> creative with colors and space, good at math
- You could be an Exhibit Designer if you enjoy math and creative problem-solving with shapes and space.

Preparator
- assist the Exhibit Designers in the installation of the museum's objects
- carefully handles objects
- helps to construct and arrange displays
- <u>Skills:</u> good with math, enjoy building things, good sense of space, very careful with details
- You could be a Preparator if you enjoy math and are good at working with your hands.

Public Relations Officer
- writes and distributes press releases and announcements to inform the school and the community about events and activities at the museum
- contacts local television stations and newspapers with information about the museum
- works with the Graphic Designer to create posters, brochures, and advertisements
- assists with assembling the museum catalog
- <u>Skills:</u> good vocabulary, creative writer, comfortable public speaker
- You could be a Public Relations Officer if you are creative with words and are good at public speaking.

Museum Shop Manager
- runs the museum gift shop, which sells postcards and other small souvenirs
- arranges and displays the merchandise for easy shopping
- handles money and helps visitors to the museum shop
- in charge of other shop clerks
- <u>Skills:</u> good with people, enjoys math and money counting, good organizational skills
- You could be a Museum Shop Manager if you like meeting people and working with money.

Museum Protection Staff (Security Officers)
- in charge of safety for all museum objects and visitors
- ensures that all museum rules are followed
- assist visitors with questions
- stationed throughout the museum during visiting hours
- <u>Skills:</u> knowledge of rules, good with people
- You could be on the Museum Protection Staff if you recognize the importance of following rules and enjoy dealing with all kinds of people.

There are other Museum Jobs too!
- Librarian – in charge of the museum's library of books and historical archives, where members and staff can borrow books and do research.
- Slide Librarian – in charge of the museum's slide library, where images of the museum's collection and related objects and images are filed for use by docents, lecturers and teachers.
- Building and Grounds Staff – in charge of maintaining the building and grounds of the museum in good condition, including repairing walls and roofs, mowing lawns, cleaning floors and clearing ice and snow.
- Development Officer – in charge of raising the money necessary to running the museum by contacting businesses, government agencies and charitable foundations.
- Membership Officer – in charge of the museum's membership programs, aimed at individuals and companies who pay a yearly fee to enjoy special benefits from their support of the museum.
- Business Officer – in charge of the museum's financial affairs such as making sure bills are paid on time, keeping the museum's expenses from exceeding income, and paying staff their salaries.

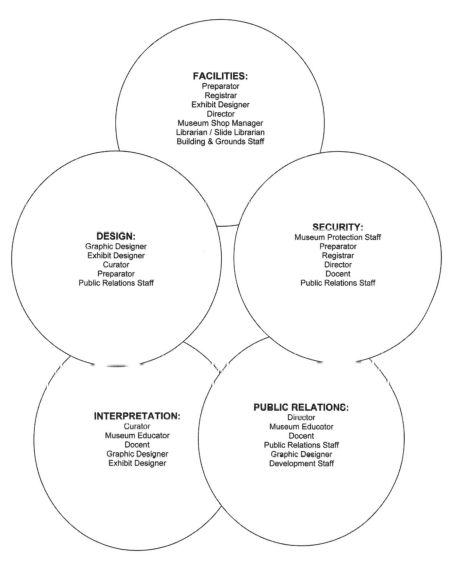

FACILITIES:
Preparator
Registrar
Exhibit Designer
Director
Museum Shop Manager
Librarian / Slide Librarian
Building & Grounds Staff

DESIGN:
Graphic Designer
Exhibit Designer
Curator
Preparator
Public Relations Staff

SECURITY:
Museum Protection Staff
Preparator
Registrar
Director
Docent
Public Relations Staff

INTERPRETATION:
Curator
Museum Educator
Docent
Graphic Designer
Exhibit Designer

PUBLIC RELATIONS:
Director
Museum Educator
Docent
Public Relations Staff
Graphic Designer
Development Staff

Museum Job Application

Name: _____

What is your favorite subject in school?
Why?_____

What is your favorite thing to do outside of school? Do you keep a collection, play sports, enjoy reading, or......... ?

What special skills or interests do you have? Do you sing, practice art, know another language, or?

Do you have any ideas about your future career? Would you like to be a police officer, run a business, teach school, build buildings, paint pictures, or?

"Museum Job Application" from the Memorial Art Gallery of the University of Rochester, 500 University Ave., Rochester, NY 14607 http://mag.rochester.edu/plugins/acrobat/teachers/Museum Careers.pdf Website accessed March 14, 2015

Museum Job Application

Name: _____ Teacher: _____

Read the attached sheets of Museum Job Descriptions carefully.
Which museum jobs would you enjoy the most? Choose three jobs and list them here, your favorite first.

1._____ 2._____ 3. _____

Tell why you would be the best choice for your #1 museum job choice.

What skills do you think are especially useful for a person to have in order to do this job well?
(circle them)

Math Public Speaking Good Organizer Good with People Like to Write

Creative Thinker Good with Shapes and Colors Enjoy Tools and Machines Art

Love to Read Computers Attention to Details Flexible/Adaptable

Good Vocabulary Enjoy Building Things Good Problem-Solver Science

The Museum Toolbox

Writing about Art: the Object Label

Here are 2 examples of object labels, the information cards made for every object on display in the museum.

<table>
<tr>
<td>

Maxfield Parrish
American (1870-1966)

Interlude: The Lute Players, 1922
Oil on canvas, 6'11" x 4'11"

On permanent loan from the Eastman School
of Music, University of Rochester, 5.97L

</td>
<td>

Egyptian, from Saqqara,
 New Kingdom, 18th Dynasty
Late 14th century B.C.

Tomb Relief, Standing Figure
Limestone

R.T. Miller Fund, 42.55

</td>
</tr>
</table>

Is all this information needed for object labels for your school museum exhibit?
What information do you need to include about your artworks and artists?
What changes should be made to this object label to fit your needs?

"Writing about Art: the Object Label" from the Memorial Art Gallery of the University of Rochester, 500 University Ave., Rochester, NY 14607 http://mag.rochester.edu/plugins/acrobat/teachers/Museum Careers.pdf Website accessed March 14, 2015

Object Cataloguing Record

Object Cataloging Record

(Name of Museum)

Catalogue or Accession No: (00-0000-000)

(NPS standard is an eight-digit catalog number, 00-000-000; the first two digits reference the year of accession, as an example (2015) is 15-000-000. The second two digits the accession number, if it is the twelfth piece donated or purchased by the museum, the number would be 15-012 000. If the donation is a set of six teacups, each teacup is then assigned a number one through six or 15-012-001 through 15-012-006.

Storage Location: _____**Date: (Date Placed in Storage)**

Catalogued by: (Name of person that catalogued the object)

Object Name: _____

Description:

Maker / artist / manufacturer: _____

Material(s): _____

Place of origin: _____

Condition:

Value: _____

Dimensions (H" x W" x D")_____

Documents accompanying acquisition:

Object Keywords: (Words to be used in a searchable database)_____

Bibliographic, photographic and documentary cross-references

Restrictions: (conservation restrictions)

<u>Cataloguing Checklist</u>

❑ Object Accessioned

❑ Object Catalogued

❑ Object Appraised

❑ Object Added to Insurance

❑ Accession added to Board of Directors Meeting Minutes

❑ Yearly Visual Inspection

❑ Object Conditioned Before and After Display

Accessioned by *: (Name of Curator or Collections Manager that accepted the object as par of the museum's collection)

Date of Accession: (Date Object Enters the Museum's Collection)

Gift of: (Name and Address)

Purchase Date: (Date of Purchase)

Source of Purchase: (Name of person, gallery or source of purchase and address)

Purchase Amount $: (Amount Paid)

Exchange: (If the object was an exchange for another object, include the object exchanged and Accession No. and the museum or gallery for which the object was exchanged)

Field Collection: (If a Field Collection Object, Note Here)

Loan: (Catalog Number)

Dates of ownership:

Previous Owner: _____ Dates: _____

Previous Owner: _____ Dates: _____

Donor Information (use, age, association with places, individuals or events):

Remarks:

*Include recent accessions as part of Board of Directors meeting minutes

The above worksheet is a great place to start for the cataloguing of museum collections; the same information can then be entered in a computer spreadsheet such as Excel or a database such as Filemaker. There are several "off the shelf" museum collection software systems. The most commonly used software are:

- ArtSystems - http://www.artsystems.com/
- Past Perfect - http://www.museumsoftware.com/
- Microsoft Access (Customized to the Museum's Collection) - http://office.microsoft.com/en-us/access/
- TMS - http://www.gallerysystems.com/collection-management

There is a trend in museums to use a "Cloud Based" systems, but this is a relatively new practice and museums are hesitant to place their collection information in a cloud. There are many advantages to cloud based systems, including easily pushing collection information to mobile devices (ipad, iphone, Smart Phones):

Two systems were part of an ILMS grant:

Collective Access - http://www.collectiveaccess.org/(of the two ILMS grant systems this seems to be more readily used)

CollectionSpace - http://www.collectionspace.org/

The cloud based systems are less developed than the server based systems.

Other "Cloud" based systems:

Vesica - http://vesica.ws/

Art Systems - http://www.artsystems.com/

Mv Art Collection - http://www.mv-artcollection.com/

Two free online collection systems:

http://omeka.org/about/contact/

http://openexhibits.org/

Paid:

http://www.contentdm.org/ (Minimum $4,300 per year plus annual contract $2,000,

Museum Exhibition Design Process

Museum Exhibition Design Process

The exhibition design process can be divided into five distinct phases:

- **Conceptual Development**

- **Schematic Design**

- **Design Development**

- **Final Design**

- **Construction Documents**

Exhibition Design Process - Concept Development

Concept Development provides the "road map" for the project. Where is the project going? How

will it get there? What are the resources available to complete the project? Concept Development

culminates with the signing of a Project Charter outlining all of the components of the project.

Project Objectives

Project Charter

Initial Budget

Initial Schedule

Project Narrative, included in the Project Charter

Front-end Evaluation

Umbrella Concept

"Look and Feel" – Early Sketches

Design Process - Schematic Design

The goal of Schematic Design is to flesh out the scope and character of the project. This enables all parties involved to confirm themes, interpret goals and review spatial arrangements, appearance, artifact use, materials and cost. By the end of the Schematic Design phase, the team will have visuals, narratives, "look and feel" boards and layouts to review the allocation of space, traffic flow, audio visual components, interactive displays, lighting and special effects. An overall graphic identity should be prepared for the exhibit at this stage of design.

Typical Deliverables for Schematic Phase

Content: Description of project goals and messages

Content: Visitor experience narrative

Content: Outline of major components

Design: Rough plan view w/content

Design: Diagrams of content relationships

Design: Traffic-flow diagrams

Design: Sketches of key points in exhibition

Design: Perspective sketches (for fundraising and exhibit naming opportunities)

Graphic Design: Collage of look & feel for exhibits & graphics

Schedule: Fabrication and Installation schedule

Schedule: Budget development

Schematic Design Phase deliverables: (3) bound booklets + electronic master copy

Design Process - Design Development

During Design Development, section and elevation drawings of exhibits in the space are created. Content research is compiled into draft text along with descriptions of the exhibits and the interactives and the functions of audio-visuals and computer programs that will be part chartered.

The family of graphic elements is complied and a graphic schedule of all the graphics is created. Graphic directional and identification signage for interior and exterior spaces of the exhibit area become part of the program.

Typical Deliverables for Design Development Phase

Final content outline

Draft text

Initial image and object list

Interactives and audio/visual outlines

Plan w/content (CAD drawings), elevations and sections (CAD drawings)

Preliminary electrical plan (CAD draft)

Preliminary mechanical plan (CAD draft)

Preliminary lighting plan (CAD draft)

Exhibit component database

Interactive sketches

Graphic Design: exhibit graphic design

Graphic Design: inventory/matrix

Graphic Design: layout & design of typical panels

Graphic Design: directional signage (way-finding), locations plan and elevations with specifications for interior spaces

Schedule: Revised fabrication and installation schedule

Schedule: Revised fabrication budget

Database of graphics

Prototyping of interactive exhibits

Design Process - Final Design

By the conclusion of the Final Design phase, a complete package that illustrates the full exhibit design and how it will be built, where every component is located and how each works within the larger space. This package includes exhibition identification, exhibition descriptions, a database of exhibit components, measured CAD plans with content, floor plans, elevations, artifact lists, measured graphic design elements and samples, draft scripts with details for audio visual components, interactive exhibits, final text, sound and lighting systems specifications, production schedules and a fabrication cost estimate.

Once this phase is completed and has been approved by the team, the team can transition into fabrication.

Typical Deliverables for Final Design Phase

Content: Final text

Content: Draft scripts of interactives & A/V

Design: Plan with content (measured CAD drawing)

Design: Elevations with graphics & dioramas/murals (measured CAD)

Design: Sections/details (measured CAD)

Design: Electrical plan/schedule (measured CAD)

Design: Mechanical plan/schedule (measured CAD)

Design: Lighting plan (measured CAD)

Design: A/V Signal plan (measured CAD)

Design: Finish schedule

Design: Interactive operation diagrams

Design: Audiovisual concept sketches

Architectural Permit documents (as required)

Graphic Design: Exhibit graphic design (measured drawings)

Graphic Design: Image management & acquisition

Exhibit component database with product and material specifications

Schedule: Final fabrication and installation schedule

Design Process - Construction Documents (CD, also called Contract Documents)

The construction documents are most often completed by the people who will build the
exhibition. The construction documents are often part of a fabrication contract that governs how
each component will be built. Often the Project Manger is required to sign each of the CD
drawings to confirm acceptance of the planned fabrication.

Typical Deliverables for Final Design Phase

Content: Final text

Content: Final scripts: interactives & A/V

Design: Final Drawings with all specifications (measured CAD drawing)

Design: Elevations w/graphics & dioramas/murals (measured CAD)

Design: Demolition plan

Design: Exiting path for Fire Marshall

Electrical plan/schedule (measured CAD)

Mechanical plan/schedule (measured CAD) (if required)

Design: Lighting plan (measured CAD)

Design: A/V signal plan (measured CAD)

Design: Finish schedule

Design: Interactive operation diagrams

Design: Audiovisual specification sheets

Design: Exhibit operational manual

Graphic Design: Ready for print design

Graphic Design: Signed permissions

Schedule: Contractor final fabrication and installation schedule

Schedule: Contractor final fabrication budget

Resources

MUSEUM ASSOCIATIONS

International Council of Museums
Maison de l'UNESCO
1 rue Miollis
75732 Paris Cedex 15
France
Phone: +33 (0) 1 47 34 05 00
Fax: +33 (0) 1 43 06 78 62
http://icom.museum

U.S. National Committee of the International Council of Museums
1025 Thomas Jefferson Street, NW, Suite 500 East
Washington, DC 20007
Phone: (202) 452-1200
Fax: (202) 833-3636
http://network.icom.museum/icom-us

American Alliance of Museums
1575 Eye Street NW, Suite 400
Washington DC 20005
Phone: (202) 289-1818
http://www.aam-us.org

Association of Academic Museums & Galleries
7211 5th Ave NW
Seattle, WA 98117
http://aamg-us.org

Association of Art Museum Directors
120 East 56th Street, Suite 520
New York, NY 10022
Phone: (212) 754-8084
https://aamd.org

HISTORY MUSEUM ASSOCIATION

American Association for State and Local History
1717 Church Street
Nashville, TN 37203-2991
Phone: (615) 320-3203
Fax: (615) 327-9013
http://aaslh.org

CHILDREN'S MUSEUM ASSOCIATION

Association of Children's Museums
2711 Jefferson Davis Highway
Suite 600
Arlington, VA 22202
Phone: (703) 224-3100
Fax: (703) 224-3099
http://www.childrensmuseums.org

CURATOR ASSOCIATION

Independent Curators International
401 Broadway
Suite 1620
New York, NY 10013
http://curatorsintl.org

NATURAL HISTORY MUSEUM ASSOCIATION

The Society for the Preservation of Natural History Collections
Planetarium Station
P.O. Box 526
New York, NY 10024-0526
http://www.spnhc.org

SCIENCE CENTER ASSOCIATIONS

UNITED STATES

Association of Science-Technology Centers Incorporated
818 Connecticut Avenue, NW
7th Floor
Washington, DC 20006-2734
Phone: (202) 783-7200
Fax: (202) 783-7207
www.astc.org

CANADA

International Committee of Science and Technology Museums
c/o Paul F. Donahue, President
Canada Science and Technology Museum Corporation
2421 Lancaster Road
P.O. Box 9724, Station "T"
Ottawa, ON K1G 5A3
Canada
Phone: +1 (613) 993-8365
Fax: +1 (613) 990-3635
www.cimuset.net

Canadian Association of Science Centres
PO Box 3443, Station D
Ottawa, ON K1P 6P4
Canada
Phone: (613) 566-4247
Fax: (613) 364-4020
http://canadiansciencecentres.ca

ASIA

Asia Pacific Network of Science and Technology Centres
c/o Questacon—The National Science and Technology Centre, King Edward
 Terrace
Canberra ACT 2600
Australia

Phone: +61 2 6270 2811
Fax: +61 2 6273 4346
http://www.aspacnet.org/index.html

Australasian Science and Technology Exhibitors Network
c/o Scienceworks
2 Booker Street
Spotswood VIC 3015
Australia
Phone: +61 3 9392 4801
Fax: +61 3 9392 4848
www.astenetwork.net

National Council of Science Museums
Sector V, Block GN
Bidhan Nagar
Calcutta 700091
India
Phone: +91 033 2357-9347
Fax: +91 033 2357-6008
www.ncsm.org.in

EUROPE

European Collaborative for Science, Industry & Technology Exhibitions
70 Coudenberg, 5th Floor
B-1160 Brussels
Belgium
Phone: +32 2 649-7383
Fax: +32 2 647-5098
www.ecsite.eu

The Association for Science and Discovery Centres
The Watershed
1 Canon's Road
Harbourside
Bristol BS1 5TX
United Kingdom
http://sciencecentres.org.uk

Austrian Science Center Network
Association Science Center Network
Landstrasser Hauptstrasse 71/1/309
1030 Vienna
Austria
Phone: +43 1 710 19 81
office@science-center-net.at
www.science-center-net.at

Irish Science Centres Association Network
c/o Annette McDonnell
Royal Dublin Society
Ballsbridge
Dublin 4
Ireland
www.iscan.ie

Nordisk Science Center Forbund
NSCF Administration 2001-2003
Experimentarium
Tuborg Havnevej 7
Box 180
DK-2900 Hellerup
Denmark
Phone: +45 3927-3333
Fax: +45 3927-3395
www.nordicscience.org

LATIN AMERICA AND THE CARIBBEAN

Associação Brasileira de Centros e Museus de Ciência
José Ribamar Ferreira, President
Espaço Museu da Vida
Fundação Oswaldo Cruz
Av. Brasil, 4365 - Manguinhos
21045-900 Rio de Janeiro RJ
Brazil
Phone: +55 21 3865-2121
Fax: +55 21 3865-2131
www.abcmc.org.br

Red de Popularización de la Ciencia y la Tecnología para América Latina y
 el Caribe
c/o UNIVERSUM
Museo De Las Ciencias
UNAM - Universidad Nacional Autónoma De México
Edif. Universum, 2 Piso
Zona Cultural De Ciudad Universitaria
CP 04510, México
Distrito Federal
Phone: +52 5 6654136 / 6227265
Fax: +52 5 6654652
www.redpop.org

Asociación Mexicana de Museos y Centros de Ciencia y Tecnología
Dirección General de Divulgación de la Ciencia, UNAM
Universum, edificio C, Tercer piso, Circuito Cultural
C.U. 04510, Coyoacán
México
Distrito Federal
Phone: +52 5 622-7277
www.ammccyt.org.mx

AFRICA

North Africa and Middle East Science Centers Network
Bibliotheca Alexandrina
P.O. Box 138
Chatby
Alexandria 21526
Egypt
Phone: (203) 4839999 x1769
Fax: (203) 4820464
Maissa.Azab@bibalex.org

The Southern African Association of Science and Technology Centres
Alfred Tsipa, President
Unizul Science Centre
Richards Bay
South Africa
Phone: (035) 797-3204
Fax: (035) 797-3204
www.saastec.co.za

ZOO ASSOCIATIONS

Association of Zoos and Aquariums
8403 Colesville Road, Suite 710
Silver Spring, MD 20910-3314
Phone: (301) 562-0777
Fax: (301) 562-0888
https://www.aza.org

European Association of Zoos and Aquaria
c/o Artis Zoo - Amsterdam
P.O. Box 20164
1000 HD Amsterdam
The Netherlands
http://www.eaza.net/

BOTANIC GARDEN ASSOCIATION

Botanic Gardens Conservation International
c/o Chicago Botanic Garden
1000 Lake Cook Road
Glencoe, IL 60022
http://www.bgci.org/usa/

ONLINE DOCUMENTS AND RESOURCES

International Council of Museums: Code of Ethics
http://icom.museum/fileadmin/user_upload/pdf/Codes/code_ethics2013_
eng.pdf

American Alliance of Museums: Code of Ethics
http://www.nemanet.org/files/3413/8552/9233/Standards_and_Best_Prac
tices_Compilation_-_Fact_Sheet.pdf

American Alliance of Museums: Museum Accreditation
http://www.aam-us.org/resources/assessment-programs/MAP

United Nations Educational, Scientific and Cultural Organization: Cultural
 Property Ethics
http://www.unesco.org/new/en/culture/themes/illicit-trafficking-of-cultural
 -property/legal-and-practical-instruments/unesco-international-code-of
 -ethics-for-dealers-in-cultural-property/

Canadian Museum Association: Reports and Guidelines
http://www.museums.ca/Publications/Reports_and_Guidelines/?n=15-23

Museums Association (United Kingdom): Code of Ethics
http://www.museumsassociation.org/ethics/code-of-ethics#.U7nETo1dW9U

Association of Museum Directors: Code of Ethics
https://aamd.org/about/code-of-ethics

Institute for Museum and Library Services: Code of Ethics
http://www.imls.gov/about/imls_ethics_statement.aspx

Smithsonian: Museum Resources
http://museumstudies.si.edu/resources.html

Alberta Museums Association: Document Library
http://www.museums.ab.ca/document-library.aspx

American Alliance of Museums: List of Accredited Museums
http://www.aam-us.org/docs/default-source/accreditation/list-of-accredited
 -museums.pdf

HISTORY MUSEUM ASSOCIATIONS'
DOCUMENTS AND RESOURCES

American Association for State and Local History: Code of Ethics
http://resource.aaslh.org/view/sample-code-of-ethics-guidelines/

American Association for State and Local History: Accreditation
http://tools.aaslh.org/steps/

SCIENCE CENTER ASSOCIATIONS'
DOCUMENTS AND RESOURCES

European Network of Science Centers and Museums: Association Gover-
 nance
http://www.ecsite.eu/about

The Asia Pacific Network of Science & Technology Centres: Constitution
http://aspacnet.org/ns/about/constitution

SMALL MUSEUM ASSOCIATION

Small Museum Association
http://www.smallmuseum.org/

CHILDREN'S MUSEUM ASSOCIATIONS' DOCUMENTS AND RESOURCES

Hands On International Association of Children's Museums: Strategic
Framework
http://www.hands-on-international.net/home.asp?p=1-0

Association of Children's Museums: Strategic Framework
http://www.childrensmuseums.org/aboutacm/strategic-framework.html

ZOOS AND AQUARIUMS ASSOCIATIONS' DOCUMENTS AND RESOURCES

Association of Zoos and Aquariums: Code of Ethics
https://www.aza.org/Ethics/

Association of Zoos and Aquariums: Accreditation
https://www.aza.org/uploadedFiles/Accreditation/AZA-Accreditation-Stan
dards.pdf

World Association of Zoos and Aquariums: Code of Ethics
http://www.waza.org/en/site/conservation/code-of-ethics-and-animal-welfare

UNIVERSITY ART GALLERY ASSOCIATION DOCUMENTS AND RESOURCES

American Association of University Galleries
http://www.aamg-us.org/files/memberdocs/MuseumCodeOfEthics.pdf

INTERNATIONAL MUSEUM STANDARDS

International Organization for Standardization: Standards for Museums
http://www.iso.org/iso/catalogue_detail?csnumber=34424

International Organization for Standardization: Standards for Libraries
http://www.iso.org/iso/iso_catalogue/catalogue_tc/catalogue_detail.htm
?csnumber=57332

Universal Design, for learning standards
http://www.udlcenter.org/aboutudl/udlguidelines

MUSEUM FINANCIAL INFORMATION

Applying for an Employer Identification Number
http://www.irs.gov/Businesses/Small-Businesses-&-Self-Employed/Apply
-for-an-Employer-Identification-Number-(EIN)-Online

Internal Revenue Service (IRS) Publication 557 "Tax-Exempt Status for Your
Organization" regarding Articles of Incorporation for Non Profits PDF
http://www.irs.gov/pub/irs-pdf/p557.pdf

IRS Publication 4220 "Applying for 501(c)(3) Tax-Exempt Status"
http://www.irs.gov/pub/irs-pdf/p4220.pdf

IRS Form 1023 Instructions
http://www.irs.gov/pub/irs-pdf/i1023.pdf

IRS Form 1023, Application for 501(c)(3) Status
http://www.irs.gov/pub/irs-pdf/f1023.pdf

IRS Form 1023EZ, Application for 510(c)(3) Online Pay.gov
http://www.irs.gov/pub/irs-prior/f1023ez--2014.pdf

IRS Form 990
http://www.irs.gov/pub/irs-pdf/f990.pdf

Nolo 501(c)(3)
http://www.nolo.com/legal-encyclopedia/form-nonprofit-501c3-corpora
tion-30228-2.html

ART CONSERVATION RESOURCES

The Foundation of the American Institute for Conservation of Historic and Artistic Works
http://www.conservation-us.org/foundation#.U7nFkY1dW9U

Conservation OnLine
http://cool.conservation-us.org/

MUSEUM COLLECTION CARE

National Park Service: Publications
http://www.nps.gov/history/museum/publications/

MUSEUM SOCIAL MEDIA ASSOCIATION

Museums and the Web: Organizational Change
http://www.museumsandtheweb.com/mw2011/papers/social_media_and_organizational_change

MUSEUM FUNDRAISING ASSOCIATION

Association of Fundraising Professionals: Code of Ethics
http://www.afpnet.org/Ethics/EnforcementDetail.cfm?ItemNumber=3261

MUSEUM REGISTRAR ASSOCIATION

American Alliance of Museums Registrars Committee: Code of Ethics
http://0338c93.netsolhost.com/cms/wp-content/uploads/2011/05/CodeofEthicsforRegistrars.pdf

ART HANDLING

Preparation, Art Handling, Collections Care Information Network
http://www.paccin.org/content.php

Smithsonian Facilities Design Standards
http://www.ofeo.si.edu/ae_center/pdf/SI%20Standards_Jan2012.pdf

Smithsonian Institution Traveling Exhibition Services Crate Specifications
http://www.elyinc.com/crating/pdf/sitescratespec.pdf

ART APPRAISAL ASSOCIATION

International Society of Appraisers: Code of Ethics
https://www.isa-appraisers.org/members/isa-policies/code-of-ethics

MUSEUM COLLECTION RESOURCE

Institute of Museum and Library Sciences, Technology Digitization PDF
http://www.imls.gov/assets/1/AssetManager/Technology_Digitization.pdf

MUSEUM INSURANCE RESOURCES

American Association of Insurance Services: Museum Collection Coverage
http://www.aaisonline.com/AAISContent/tabid/86/ArticleID/514/Museum-
Collection-Coverage.aspx

American Association of Insurance Services: Inland Marine
http://www.aaisonline.com/AAISFrame/ProductsFrame/InlandMarine-
Frame/tabid/142/ArticleID/61/Inland-Marine-Guide.aspx

MUSEUMS AND THE INTERNET

Museums and the Web
http://www.museumsandtheweb.com/

The Association for Computers and the Humanities
http://ach.org/

EXHIBITION RESOURCES

National Association for Museum Exhibition ListServ
https://groups.yahoo.com/neo/groups/name-aam/info

National Association for Interpretation
http://www.interpnet.com/

BOTANIC GARDEN RESOURCE

Botanic Gardens Conservation International
http://www.bgci.org/resources/1528/

SAMPLE REGISTRAR DOCUMENTS

American Alliance of Museums, Registrars Committee: Sample Documents
http://www.rcaam.org/resources/sample_documents/

VISITOR STUDIES ASSOCIATION

Visitor Studies Association
http://www.visitorstudies.org/

Bibliography

ESSENTIAL MUSEUM READING

Ambrose, Timothy, and Crispin Paine. *Museum Basics*. New York: Routledge, 2012.
Anderson, Gail, ed. *Reinventing the Museum: The Evolving Conversation on the Paradigm Shift*. Lanham, MD: AltaMira Press, 2012.
Falk, John H. *Identity and the Museum Visitor Experience*. Walnut Creek: Left Coast Press, 2009.
George, Gerald W., and Carol Maryan-George. *Starting Right: A Basic Guide to Museum Planning*. Lanham, MD: AltaMira Press, 2012.

BIBLIOGRAPHY

Alexander, Edward P. *Museums in Motion: An Introduction to the History and Functions of Museums*. Second edition. Lanham, MD: AltaMira Press, 2008.
Ambrose, Tim, and Crispin Paine. *Museum Basics*. Third edition. London: Routledge, 2012.
Anderson, Gail. *Reinventing the Museum: The Evolving Conversation on the Paradigm Shift*. Lanham, MD: AltaMira Press, 2012.
Balsamo, Anne Marie. *Designing Culture: The Technological Imagination at Work*. Durham, NC: Duke University Press, 2011.
Bautista, Susana Smith. *Museums in the Digital Age: Changing Meanings of Place, Community, and Culture*. Lanham, MD: AltaMira Press, 2014.
Beall-Fofana, Barbara A. *Understanding the Art Museum*. Upper Saddle River, NJ: Pearson Education, 2007.
Beck, Paul. *Science Center Know-How: Exhibits, Demonstrations, Discovery Carts, Special events, Workshops, Marketing*. Washington, DC: Association of Science-Technology Centers, 1996.

Bennett, Tony. *The Birth of the Museum: History, Theory, Politics*. London: Routledge, 1995.

Bergeron, Anne, and Beth Tuttle. *Magnetic: The Art and Science of Engagement*. Washington, DC: The AAM Press, 2013.

Black, Graham. *Transforming Museums in the Twenty-First Century*. Milton Park, Abingdon, Oxon: Routledge, 2012.

Bogart, Benjamin David Robert, and Philippe Pasquier. "Context Machines: A Series of Situated and Self-Organizing Artworks." *Leonardo*, Summer 2013.

Borun, Minda, Randi Korn, and Roxana Adams. *Introduction to Museum Evaluation*. Washington, DC: American Association of Museums, Technical Information Service, 1999.

Bruman, Raymond. *Exploratorium Cookbook I: A Construction Manual for Exploratorium Exhibits*. Revised 1984 edition. San Francisco, CA: The Exploratorium, 2005.

Buck, Rebecca A., and Jean Allman Gilmore. *Museum Registration Methods*. Fifth edition. Washington, DC: The AAM Press, 2010.

Burcaw, George Ellis. *Introduction to Museum Work*. Third edition. Lanham, MD: AltaMira Press, 1997.

Carr, Nicholas G. *The Shallows: What the Internet is Doing to Our Brains*. New York: W.W. Norton, 2011.

Collins, James C., and Jerry I. Porras. *Built to Last: Successful Habits of Visionary Companies*. New York: HarperBusiness, 2002.

Covina, Calif. *The Museum of Jurassic Technology: Primi Decem Anni, Jubilee Catalog*. Los Angeles: Published by the Trustees, 2002.

Cress, Polly, and Janet Kamien. *Creating Exhibitions: Collaboration in the Planning, Development and Design of Innovative Experiences*. Hoboken, NJ: Wiley, 2013.

Csikszentmihalyi, Mihaly. *Flow: The Psychology of Optimal Experience*. New York: Harper & Row, 1990.

Diamond, Judy. *Practical Evaluation Guide: Tools for Museums and Other Informal Educational Settings*. Second edition. Walnut Creek, CA: Left Coast Press, 2009.

Dierking, Lynn D., and Wendy Pollock. *Questioning Assumptions: An Introduction to Front-end Studies in Museums*. Washington, DC: Association of Science-Technology Centers, 1998.

Edson, Gary. *Museum Ethics*. London: Routledge, 1997.

Falk, John H. *Identity and the Museum Visitor Experience*. Walnut Creek, CA: Left Coast Press, 2009.

Falk, John H., and Beverly Sheppard. *Thriving in the Knowledge Age: New Business Models for Museums and Other Cultural Institutions*. Lanham, MD: AltaMira Press, 2006.

Fishman, Stephen. *Nonprofit Fundraising Registration: The 50-State Guide*. Berkeley, CA: Nolo, 2010.

Gardner, Howard. *Multiple Intelligences: New Horizons*. New York: BasicBooks, 2006.

Garrett, Jesse James. *The Elements of User Experience: User-Centered Design for the Web and Beyond*. Second edition. Berkeley, CA: New Riders, 2011.

Genoways, Hugh H., and Lynne M. Ireland. *Museum Administration: An Introduction*. Walnut Creek, CA: Altamira Press, 2003.

Genoways, Hugh H., and Mary Anne Andrei. *Museum Origins: Readings in Early Museum History and Philosophy.* Walnut Creek, CA: Left Coast Press, 2008.

George, Gerald, and Carol Maryan-George. *Starting Right: A Basic Guide to Museum Planning.* Third edition. Walnut Creek, CA: AltaMira Press, 2012.

Gladwell, Malcolm. *Blink: The Power of Thinking Without Thinking.* New York: Little, Brown and Co., 2013.

Grinell, Sheila. *A Place for Learning Science: Starting a Science Center and Keeping It Running.* Revised edition. Washington, DC: Association of Science-Technology Centers, 2003.

Hannah, Gail Greet. *Elements of Design: Rowena Reed Kostellow and the Structure of Visual Relationships.* New York: Princeton Architectural Press, 2002.

Heyman, Darian Rodriguez. *Nonprofit Management 101: A Complete and Practical Guide for Leaders and Professionals.* San Francisco, CA: Jossey-Bass, 2011.

Hipschman, Ron. *Exploratorium Cookbook III: A Construction Manual for Exploratorium Exhibits.* Revised edition. San Francisco, CA: Exploratorium, 1993.

Hofstede, Geert H. *Cultures and Organizations: Software of the Mind.* Third edition. London: McGraw-Hill, 2010.

Holler, Carsten, and Massimiliano Gioni. *Experience.* New York: Skira Rizzoli, 2011.

Houtgraaf, Dirk, and Vanda Vitali. *Mastering a Museum Plan: Strategies for Exhibit Development.* Leiden: Naturalis, 2008.

Hoving, Thomas. *Making the Mummies Dance: Inside the Metropolitan Museum of Art.* New York: Simon & Schuster, 1993.

Humphrey, Thomas, and Joshua P. Gutwill. *Fostering Active Prolonged Engagement: The Art of Creating APE Exhibits.* San Francisco, CA: Exploratorium, 2005.

Iwamoto, Lisa. *Digital Fabrications: Architectural and Material Techniques.* New York: Princeton Architectural Press, 2009.

Janson, H. W., and Penelope J. E. Davies. *Janson's History of Art: The Western Tradition.* Eighth edition. Upper Saddle River, NJ: Pearson Prentice Hall, 2011.

Keirsey, David. *Please Understand Me II: Temperament, Character, Intelligence.* Del Mar, CA: Prometheus Nemesis, 1998.

Klanten, Robert, Sven Ehmann, Verena Hanschke, and Lukas Feireiss. *A Touch of Code: Interactive Installations and Experiences.* Berlin: Gestalten, 2011.

Kuniavsky, Mike. *Observing the User Experience: A Practitioner's Guide to User Research.* Second Edition. San Francisco, CA: Morgan Kaufmann Publishers, 2012.

Legutko, Cinnamon. *The Small Museum Toolkit.* Lanham, MD: AltaMira Press, 2012.

Li, Charlene, and Josh Bernoff. *Groundswell: Winning in a World Transformed by Social Technologies.* Cambridge, MA: Harvard Business Press, 2011.

Lidwell, William, Kritina Holden, and Jill Butler. *Universal Principles of Design.* Gloucester, MA: Rockport, 2010.

Lord, Barry. *Manual of Museum Planning: Sustainable Space, Facilities, and Operations.* Third edition. Lanham, MD: AltaMira Press, 2012.

Lord, Barry, and Gail Dexter Lord. *The Manual of Museum Management.* Second edition. Lanham, MD: AltaMira Press, 2009.

Lord, Gail Dexter, and Kate Markert. *The Manual of Strategic Planning for Museums.* Lanham, MD: AltaMira Press, 2007.

Lukas, Scott A. *The Immersive Worlds Handbook: Designing Theme Parks and Consumer Spaces.* Burlington, MA: Focal Press, 2013.

Lukas, Scott A. *The Themed Space: Locating Culture, Nation, and Self.* Lanham, MD: Lexington Books, 2007.

Malaguzzi, Loris, Giulio Ceppi, and Michele Zini. *Children, Spaces, Relations: Metaproject for an Environment for Young Children.* Reggio Emilia, Italy: Reggio Children, 1998.

Malaro, Marie C. *Museum Governance: Mission, Ethics, Policy.* Washington, DC: Smithsonian Institution Press, 1994.

Mancuso, Anthony. *How to Form a Nonprofit Corporation.* Eleventh edition. Berkeley, CA: Nolo, 2013.

Marstine, Janet. *Routledge Companion to Museum Ethics: Redefining Ethics for the Twenty-first Century Museum.* Milton Park, Abingdon, Oxon: Routledge, 2011.

McLean, Kathleen, Wendy Pollock, and Peter S. Samis. *Visitor Voices in Museum Exhibitions.* Washington, DC: Association of Science-Technology Centers Inc., 2007.

Merritt, Elizabeth E. *National Standards and Best Practices for U.S. Museums.* Washington, DC: The AAM Press, 2008.

Mulder, Steve, and Ziv Yaar. *The User is Always Right: A Practical Guide to Creating and Using Personas for the Web.* Berkeley, CA: New Riders, 2007.

Norman, Donald A. *The Design of Everyday Things.* Revised and expanded edition. New York: Basic Books, 2013.

Orselli, Paul. *The Cheapbook: A Compendium of Inexpensive Exhibit Ideas.* Washington, DC: Association of Science-Technology Centers Inc., 1996.

Paul, Carole. *The First Modern Museums of Art: The Birth of an Institution in 18th- and Early-19th-Century Europe.* Los Angeles, CA: J. Paul Getty Museum, 2012.

Pine, B. Joseph, and James H. Gilmore. *The Experience Economy: Work Is Theatre and Every Business a Stage.* Boston, MA: Harvard Business School Press, 2011.

Quinn, Stephen C. *Windows on Nature: The Great Habitat Dioramas of the American Museum of Natural History.* New York: Harry N. Abrams, 2006.

Rainie, Harrison, and Barry Wellman. *Networked: The New Social Operating System.* Cambridge, MA: MIT Press, 2014.

Raymond, Martin. *The Trend Forecaster's Handbook.* London: Laurence King, 2010.

Robert, Henry M., and Sarah Corbin Robert. *Robert's Rules of Order Newly Revised.* Eleventh edition. Philadelphia, PA: Perseus Pub., 2013.

Sauber, Colleen M. *Experiment Bench: A Workbook for Building Experimental Physics Exhibits.* St. Paul, MN: Science Museum of Minnesota, 1994.

Serrell, Beverly. *Exhibit Labels: An Interpretive Approach.* Lanham, MD: AltaMira Press, 1996.

Serrell, Beverly. *Judging Exhibitions: A Framework for Assessing Excellence.* Walnut Creek, CA: Left Coast Press, 2006.